Web Design Index
by Content.02

THE PEPIN PRESS | AGILE RABBIT EDITIONS

CHECK FOR *1 CD-ROM in back*

BEFORE AND AFTER EACH CIRCULATION

COMPILED BY GÜNTER BEER

D0608296

Compilation & layout by Günter Beer & Sigurd Buchberger
CD Master by Sigurd Buchberger

Cover and book design by Pepin van Roojen

Cover image by Karoly Kiralyfalvi (www.extraverage.net)

The cover image is an adaptation of an illustration used for
www.drezign.hu (see page 232).

Introduction by Pepin van Roojen
Translations by Justyna Wrzodak (Polish), Vladimir Nazarov (Russian),
Michie Yamakawa (Japanese), LocTeam (German, Spanish, Italian, French and
Portuguese).

With special thanks to Magda Garcia Masana.

ISBN 978 90 5768 103 5
The Pepin Press | Agile Rabbit Editions
Amstedam & Singapore

The Pepin Press BV
P.O. Box 10349
1001 EH Amsterdam
The Netherlands

Tel +31 20 4202021
Fax +31 20 4201152
mail@pepinpress.com
www.pepinpress.com

10 9 8 7 6 5 4 3 2 1
2010 2009 2008 2007 2006

Manufactured in Singapore

Web Design Index By Content.02 contains a selection of 500 websites arranged by subject. Two pages from each site are included: one opening page and one page that is representative of the site. Enclosed is a CD-ROM containing a browser and a one-click facility to view and access the selected sites without having to be online. Together the book and CD offer a comprehensive overview of web design standards in many different fields.

With each site in the book, the URL is indicated. The names of those involved in the design and programming of the sites are stated as follows:

D design
C coding
P production
A agency
M designer's email address

Submissions & recommendations
Each year, brand new editions of all The Pepin Press' web design books are published. Should you wish to submit or recommend designs for consideration, please access the submissions form at www.webdesignindex.org.

The Pepin Press / Agile Rabbit Editions
For more information about The Pepin Press' many publications on design, fashion, popular culture, visual reference and ready-to-use images, please visit www.pepinpress.com.

Web Design Index By Content.02 (Modèles de sites Web par contenu.02) comprend une sélection de 500 sites Web classés par sujet. Deux pages sont consacrées à chaque site : une page d'ouverture et une page représentative du site. Un CD-ROM est inclus : il contient un navigateur et offre la possibilité de voir et d'accéder aux sites sélectionnés par simple clic, sans même avoir besoin d'être connecté à Internet. Livre et CD donnent un aperçu global des designs web standard dans chacun des domaines spécifiques.

L'URL de chaque site est indiquée. Les noms des personnes ayant participé à sa conception et à sa programmation sont indiqués comme suit :

D conception
C codage
P production
A agence
M adresse e-mail du concepteur

Suggestions et recommandations
Chaque année, de nouvelles éditions des ouvrages de design Web de The Pepin Press sont éditées. Si vous avez des designs à nous suggérer ou à nous recommander, vous pouvez accéder au formulaire de suggestions qui se trouve à l'adresse www.webdesignindex.org.

The Pepin Press / Agile Rabbit Editions
Pour en savoir plus sur les nombreuses publications de The Pepin Press consacrées au design, à la mode, à la culture pop, aux références visuelles et aux images prêtes à l'emploi, veuillez visiter le site Web www.pepinpress.com.

Web Design By Content.02收集了按主题分类的500个网址。对每个网址提供两页内容：一个是打开页面，另一个是体现该网址特色的代表性内容。此书还附有CD-ROM，包含一个浏览器和可单击观看并进入所选网址的工具。此套装可帮助你全面了解任何一个领域的网站设计标准。

书中的每个网址都标出其URL。　与网站设计和编程相关的名称如下：

D　　设计
C　　编码
P　　制作
A　　代理
M　　设计师电子信箱

提交和推荐
每年Pepin出版社都都会推出全新的网站设计丛书。如果您想提交或推荐网站设计供我们参考，请登录www.webdesignindex.org填写提交表。

Pepin出版社／Agile Rabbit Editions
如果您想了解更多有关Pepin出版社的设计、时尚、流行文化、视觉参考和现成可用图片出版物方面的信息，请登录www.pepinpress.com。

Web Design Index By Content.02 (Disegno Web per contenuto.02) è una selezione di 500 siti ripartiti per argomento. Per ogni sito sono presentate una home page e una pagina interna per dare un'idea della sua natura. L'accluso CD-ROM contiene il browser e un sistema che consente di visualizzare e accedere alle pagine web desiderate senza la necessità di una connessione a Internet. Il libro e il CD insieme offrono una panoramica dello standard del web design in alcuni settori specifici.

Per ogni sito è indicato l'URL corrispondente. I nomi delle persone che hanno collaborato al design e alla programmazione di ogni sito sono riportati secondo i seguenti criteri:

D design
C codificazione
P produzione
A agenzia
M indirizzo e-mail del designer

Segnalazioni

Ogni anno The Pepin Press pubblica un'edizione aggiornata di tutte le opere che hanno come oggetto il web design. Se desiderate portare alla nostra attenzione un progetto di design, potete scaricare l'apposito modulo sul sito www.webdesignindex.org.

The Pepin Press / Agile Rabbit Editions

Per ulteriori informazioni sulle numerose opere inserite nel nostro catalogo che hanno come oggetto design, moda, cultura popolare, banca immagini e consultazione grafica potete visitare il sito www.pepinpress.com.

Web Design Index By Content.02 には、選りすぐりのウェブサイト500が、カテゴリー別に収録されています。全サイトについて、オープニング・ページと、そのサイトの特徴をよく表しているページを載せています。また、附録のCD-ROMには、ブラウザーがつき、各サイトにワンクリックで簡単にアクセスできます。本とCDを参照すれば、各分野で、現在どんなウェブサイトが人気があるのか、手軽に知ることができます。

本書には、各サイトのURLだけでなく、デザイナーとプログラマーの名前も載せています。表記方法は以下のとおりです。

D	デザイン
C	コーディング
P	プロダクション
A	エージェンシー
M	デザイナーのEメール・アドレス

ウェブサイトの自薦・他薦

Pepin Press は、ウェブデザイン・ブックの改訂版を毎年出版しています。自分のウェブサイトを掲載ご希望の場合、また推薦したいサイトがある場合には、www.webdesignindex.orgにアクセスしてお申し込みください。

The Pepin Press / Agile Rabbit Editions

Pepin Press は、デザインやファッション、ポップ・カルチャーなどについて多様な出版物を出しています。すぐに使える画像などもありますので、当社の出版物や画像について、詳しい情報をお知りになりたい方は、www.pepinpress.comにアクセスしてください。

Web Design Index By Content.02 (Diseño de páginas web por contenidos.02) presenta una selección de 500 sitios web organizados por temas. De cada sitio web se incluyen dos páginas: una página inicial y una página representativa del sitio. Además, se adjunta un CD-ROM con un explorador que permite acceder a las páginas con total funcionalidad sin necesidad de estar conectado a Internet. Juntos, el libro y el CD ofrecen un panorama exhaustivo de los patrones utilizados en el campo del diseño web en numerosos ámbitos.

Se indica la URL de cada sitio que aparece en el libro. Asimismo, el nombre de las personas que han participado en el diseño y la programación de dichos sitios se recoge del modo siguiente:

D diseño
C codificación
P producción
A agencia
M dirección de correo electrónico del diseñador

Propuestas y recomendaciones
Cada año, se publican nuevas ediciones de todos los libros de diseño de páginas web de The Pepin Press. Si desea proponer o recomendar un diseño para que se tenga en cuenta para próximas ediciones, rellene el formulario que figura en www.webdesignindex.org.

The Pepin Press / Agile Rabbit Editions
Para obtener más información acerca de las numerosas publicaciones de The Pepin Press sobre diseño, moda, cultura popular, referencia visual e imágenes listas para utilizar, visite www.pepinpress.com.

Web Design By Content.02(내용별 웹 디자인.02)에는 주제별로 정렬된 500여개의 웹 사이트 디자인이 들어 있습니다. 각 사이트는 첫 페이지와 사이트의 특징을 잘 나타내는 기본 페이지 등 두 페이지로 구성되어 있습니다. 함께 제공된 CD-ROM에는 브라우저와 선택한 사이트를 보고 액세스할 수 있는 원 클릭 기능이 들어 있습니다. 또한 책과 CD에는 특정 분야의 표준 웹 디자인에 대해 알기 쉽게 설명되어 있습니다.

책에는 각 사이트의 URL이 표시되어 있습니다. 각 사이트의 디자인 및 프로그래밍 관련 이름은 다음과 같이 표기되어 있습니다.

D	디자인
C	코딩
P	제작
A	대행사
M	디자이너의 전자 메일 주소

제안 및 추천

일년마다 Pepin Press의 모든 웹 디자인 책이 새로운 버전으로 출판됩니다. 생각하고 있는 디자인을 제안하거나 추천하시려면 www.webdesignindex.org의 제출 양식에 액세스하시기 바랍니다.

Pepin Press / Agile Rabbit Editions

디자인, 패션, 대중문화, 영상 자료 및 기성 이미지와 관련된 수많은 Pepin Press의 출판물에 대한 자세한 내용은 www.pepinpress.com을 방문하시기 바랍니다.

Книга «Веб-дизайн по содержанию.02» содержит выборку из 500 веб-сайтов, сгруппированных по темам. Каждый сайт представлен двумя страницами: заглавной и содержательной. К книге прилагается компакт-диск с браузером и утилитой, позволяющей загрузить и просмотреть выбранный сайт одним щелчком мыши. Книга и компакт-диск вместе содержат полный обзор стандартов веб-дизайна во всех приведенных областях.

Для каждого сайта, приведенного в книге, указывается его адрес (URL). Фамилии людей, принимавших участие в проектировании и создании сайтов, отмечены следующим образом:

D дизайн
C программирование
P производство
A агентство
M адрес электронной почты дизайнера

Подача на рассмотрение заявок и рекомендации
Новые издания книг по веб-дизайну издательства The Pepin Press публикуются каждый год. Если вы желаете подать на рассмотрение заявку или порекомендовать какой-либо дизайн, заполните, пожалуйста, бланк заявки на сайте www.webdesignindex.org.

Издательство The Pepin Press / Agile Rabbit Editions
За дополнительной информацией об основных публикациях издательства The Pepin Press по дизайну, моде, современной культуре, визуальным справочникам и библиотекам высококачественных изображений, готовых к непосредственному использованию, обращайтесь на сайт www.pepinpress.com.

Web Design Index By Content.02 (Webdesign nach Thema.02) enthält eine thematisch gegliederte Auswahl von 500 Websites. Jede dieser Sites ist mit je zwei für die Gestaltung repräsentativen Abbildungen vertreten. Auf der beiliegenden CD-ROM können mit einem Internetbrowser die meisten der ausgewählten Websites offline in voller Funktionalität betrachtet werden. So bieten Buch und CD einen umfassenden Überblick über den aktuellen Stand des Webdesigns der unterschiedlichsten Bereiche.

Für jede im Buch genannte Website ist die URL angegeben. Die Namen der an Design und Programmierung der Websites beteiligten Personen sind wie folgt gekennzeichnet:

D Design
C Codierung
P Produktion
A Agentur
M E-Mail-Adresse des Designers

Einsendungen & Empfehlungen
Jedes Jahr werden brandaktuelle Neuausgaben aller Websdesign-Bücher von The Pepin Press herausgebracht. Sollten Sie Designs einreichen oder empfehlen wollen, füllen Sie bitte das entsprechende Einsendeformular unter www.webdesignindex.org aus.

The Pepin Press / Agile Rabbit Editions
Weitere Informationen über die zahlreichen Publikationen von The Pepin Press zu den Themen Design, Mode, Kultur, visuelle Referenz und Bilder zur direkten Verwendung finden Sie auf unserer Website unter www.pepinpress.com.

Web Design Index By Content.02 (Web Design por Conteúdo.02) contém uma selec-
ção de 500 sítios na Web, organizados por assunto. Foram incluídas duas páginas
de cada sítio na Web: uma de abertura e uma representativa do mesmo. O CD-ROM
anexo contém um programa de navegação e está estruturado de modo a permitir
a visualização e o acesso offline aos sítios na Web seleccionados com um clique.
Em conjunto, o livro e o CD proporcionam uma perspectiva abrangente do nível de
Web design em diversas áreas.

É indicado o URL de cada sítio na Web presente no livro. Os nomes das pessoas
envolvidas na concepção e programação dos sítios na Web são indicados da se-
guinte forma:

D design
C codificação
P produção
A agência
M endereço de correio electrónico do designer

Propostas e recomendações
Todos os anos, The Pepin Press publica edições novas de todos os seus livros
sobre Web design. Para propor ou recomendar designs à nossa avaliação, aceda
ao formulário de propostas em www.webdesignindex.org.

The Pepin Press/Agile Rabbit Editions
Para obter mais informações sobre as diversas publicações de The Pepin Press
sobre design, moda, cultura popular, referências visuais e imagens prontas a
usar, visite www.pepinpress.com.

Web Design Index By Content.02 zawiera wybór 500 ułożonych tematycznie stron internetowych. Każda z tych stron reprezentowana jest stroną startową oraz inną dla niej charakterystyczną stroną. Do książki dołączony jest CD-ROM zawierający przeglądarkę i funkcję pokazywania i wywołania wybranych stron internetowych poprzez jedno kliknięcie. Razem, książka i CD-ROM, oferują wyczerpujące zestawienie standardów projektowania stron internetowych w obrębie wielu dziedzin.

Na każdej stronie książki podawany jest URL danej strony internetowej. Nazwiska osób zaangażowanych w projektowanie i programowanie stron internetowych podawane są następująco:

D	projektowanie
C	kodowanie
P	wykonanie
A	agencja
M	adres email projektanta

Propozycje i rekomendacje

Każdego roku wydawnictwo The Pepin Press publikuje nowe edycje książek Web Design. Jeśli mają Państwo życzenie przedłożyć lub polecić nam projekt, proszę wypełnić odpowiedni formularz na stronie internetowej www.webdesignindex.org.

Wydawnictwo The Pepin Press / Agile Rabbit Editions

Więcej informacji o licznych publikacjach wydawnictwa The Pepin Press na temat projektowania, mody, kultury, referencji wizualnych oraz gotowych do bezpośredniego użycia obrazów znajdą Państwo na stronie internetowej www.pepinpress.com.

○ ○ ○ fluidum contemporary interiors zürich

fluidum

news
the company
sofas and armchairs
beds
chairs
tables
low tables
services
references
where to buy
contact
sale

contact address e-news

 fluidum GmbH join our mailing list
 contemporary interiors
 Bändlistrasse 29
 CH-8064 Zürich
 first name : _ _ _ _ _ _ _ _ _ _ _ _ _ _ _ _
 phone +41 1 440 42 85
 fax +41 1 440 42 86 name : _

 contact@fluidum.ch E-Mail : _ _ _ _ _ _ _ _ _ _ _ _ _ _ _ _ _ _

 >>

○ ○ ○ fluidum contemporary interiors zürich

fluidum

news
the company
sofas and armchairs
beds
chairs
tables
low tables
services
references
where to buy
contact
sale

big spender
bird
club
deep
lizard
lizard de luxe
round

more information

Big Spender | Friedemann Ramacher 2000 < >

'big spender' is an exceptionally comfortable range of cushioned seating whose loose elements can be combined to the
user's personal taste. Apart from linear sofas with or without armrests, 'big spender' elements can also compile into day
beds, round-the-corner combinations and generously sized and varied 'seatscapes'. Its cushionless, somewhat
pronounced voluminous design lends to 'big spender' a lucid and inviting keynote.

www.fluidum.ch
D: friedemann ramacher **C:** pierre morgadès **P:** pierre morgadès
A: wattstyle **M:** www.wattstyle.ch

○ ○ ○ A10

new European architecture

A10 is a new architecture magazine
with a European focus. Six times a
year, it presents the latest architecture
on the ancient continent.

CLICK HERE FOR
THE CONTENTS
OF A10 #8

Sub-
scribe
here

about
inside
contact
get

○ ○ ○ Contents A10 #8

A10
new European
architecture

about
inside A10
contact
get

#1 I #2 I #3 I #4 I #5 I #6 I #7 I #8

#8 (Mar/Apr 2006)

On the spot

News and observations

www.a10magazine.com
D: arjan groot **C:** kim dijkstra
M: mail@a10magazine.com

Gregotti Associati International Site

Gregotti Associati International

| Studio | Projects | News | Culture | Contact |

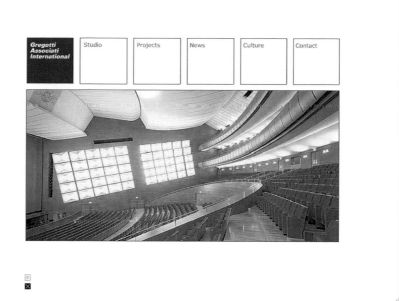

Gregotti Associati Site

Gregotti Associati International

STUDIO > **PRACTICE**

Gregotti Associati International was founded in 1974 by Vittorio Gregotti. Currently there are three partners, Vittorio Gregotti, Augusto Cagnardi and Michele Reginaldi, supported by twelve associates, a large group of young architects and an efficient and organizational structure.

Gregotti Associati International is an architectural design firm that collaborates regularly with engineering firms for the development of projects, and with experts and scholars when forming analysis groups for particularly demanding or complex issues.

Since the 1970s there has been a continuous increase in activities. In the course of these years there have been hundreds of projects developed in over 20 countries in Europe, the US, Africa, the Middle East, and Asia. Numerous projects have been realised, such as master plans for big cities, redevelopment plans for urban areas, theaters, stadia, museums, public buildings, curches, university and research centers, banks, companies headquarters, housing districts, commercial and open spaces.

Gregotti Associati International has its main offices in

 Print

www.gregottiassociati.com
D: dario zannier, fabio zannier **C:** caroline hue
M: gai.milano@gregottiassociati-link.it

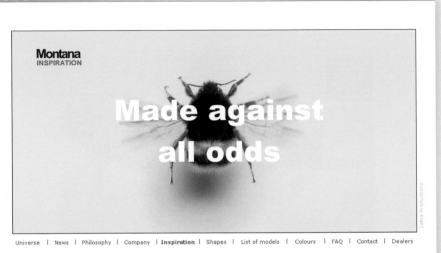

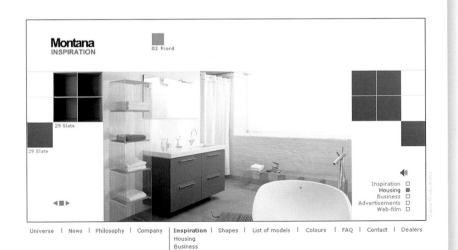

www.montana.dk

D: lars norman, birgit kristiansen **C:** gitte brinck, boris hansen **P:** birgit kristiansen

A: zebra productions **M:** zebra@zebra-pro.dk

www.danuadi.de
D: diego gardón
M: chiclegalaxia@yahoo.com

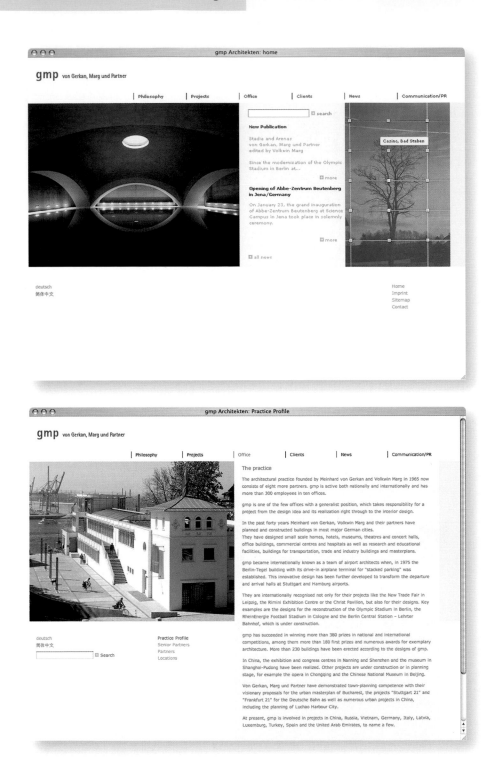

www.gmp-architekten.de

D: pia danner C: wolfgang becker P: gmp architekten
A: macina M: pd@macina.com

www.yesarchi.com
D: trafik **P:** yes architectes
A: trafik **M:** www.lavitrinedetrafik.com

www.wmworkshop.com
D: donato dogali **P:** wmworkshop
A: wmweb **M:** info@wmweb.it

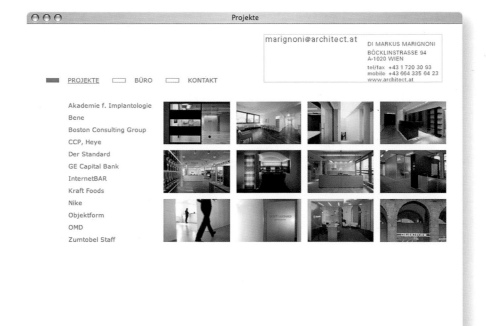

Projekte

marignoni@architect.at

DI MARKUS MARIGNONI
BÖCKLINSTRASSE 94
A-1020 WIEN
tel/fax +43 1 720 30 93
mobile +43 664 335 64 23
www.architect.at

PROJEKTE BÜRO KONTAKT

Akademie f. Implantologie
Bene
Boston Consulting Group
CCP, Heye
Der Standard
GE Capital Bank
InternetBAR
Kraft Foods
Nike
Objektform
OMD
Zumtobel Staff

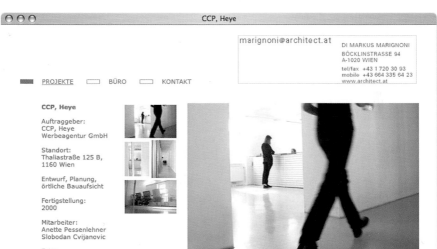

CCP, Heye

marignoni@architect.at

DI MARKUS MARIGNONI
BÖCKLINSTRASSE 94
A-1020 WIEN
tel/fax +43 1 720 30 93
mobile +43 664 335 64 23
www.architect.at

PROJEKTE BÜRO KONTAKT

CCP, Heye

Auftraggeber:
CCP, Heye
Werbeagentur GmbH

Standort:
Thaliastraße 125 B,
1160 Wien

Entwurf, Planung,
örtliche Bauaufsicht

Fertigstellung:
2000

Mitarbeiter:
Anette Pessenlehner
Slobodan Cvijanovic

Foto:
Stefan Badegruber

www.architect.at
D: christina kandlhofer
A: kashi_design M: www.kashi.at

www.dgaarquitectura.com
D: alex soteres, jordi cortada
A: artrivity disseny M: info@artrivity.com

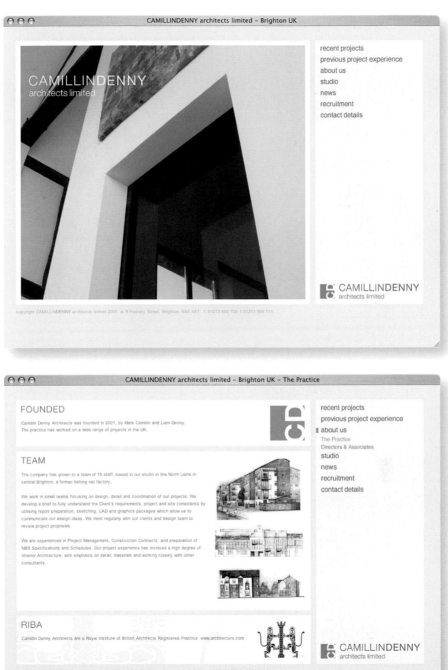

www.camillindenny.com

D: thom bennett

A: thom bennett graphic design M: info@tbgd.co.uk

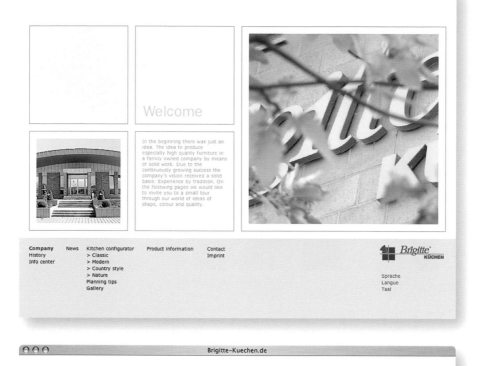

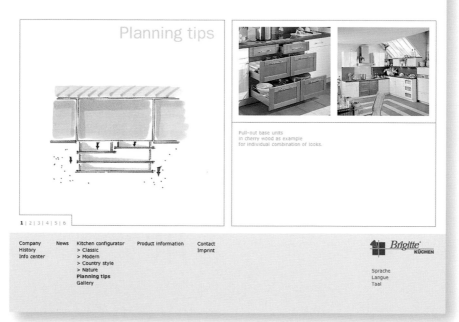

www.brigitte-kuechen.com

D: antje weber, hanno denker

A: quer-denker.com M: mail@quer-denker.com

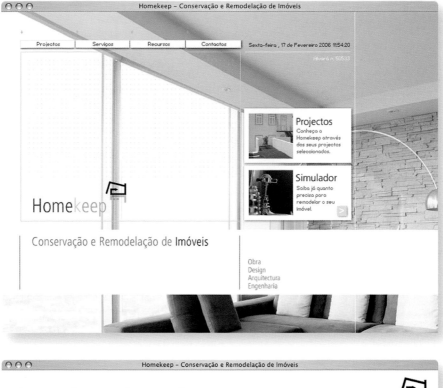

www.homekeep.pt
D: sofia vitor **C:** wolfgang borgsmüller **P:** sofia vitor
A: aftamina **M:** www.aftamina.pt

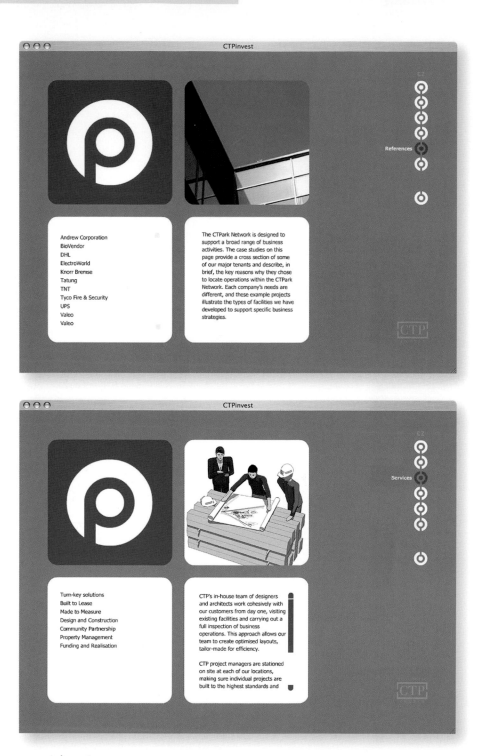

CTPinvest

Andrew Corporation
BioVendor
DHL
ElectroWorld
Knorr Bremse
Tatung
TNT
Tyco Fire & Security
UPS
Valeo
Valeo

The CTPark Network is designed to support a broad range of business activities. The case studies on this page provide a cross section of some of our major tenants and describe, in brief, the key reasons why they chose to locate operations within the CTPark Network. Each company's needs are different, and these example projects illustrate the types of facilities we have developed to support specific business strategies.

References

CTPinvest

Turn-key solutions
Built to Lease
Made to Measure
Design and Construction
Community Partnership
Property Management
Funding and Realisation

CTP's in-house team of designers and architects work cohesively with our customers from day one, visiting existing facilities and carrying out a full inspection of business operations. This approach allows our team to create optimised layouts, tailor-made for efficiency.

CTP project managers are stationed on site at each of our locations, making sure individual projects are built to the highest standards and

Services

www.ctpinvest.com
D: nydrle studio
A: nydrle studio M: helpdesk@nydrle.net

www.sartori-deco.be/xy
D: fx. marciat, j. veronesi P: sartori deco
A: xy area M: xy@xyarea.com

www.andrea-hetzelt.de

D: patricia prem C: patricia prem P: claus roland heinrich

A: heinrichplusprem kommunikationsdesign M: hallo@heinrichplusprem.com

www.vrydaghsconcept.be
D: inés van belle
A: pinker M: ines@pinker.be

www.siematicindewoonmall.nl

D: mattijs janssen **C:** janssen, robert nouwens **P:** mattijs janssen, marcel geerts

A: janssen.nl reclamebureau **M:** info@janssen.nl

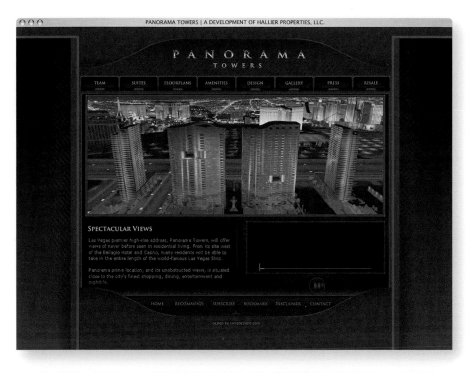

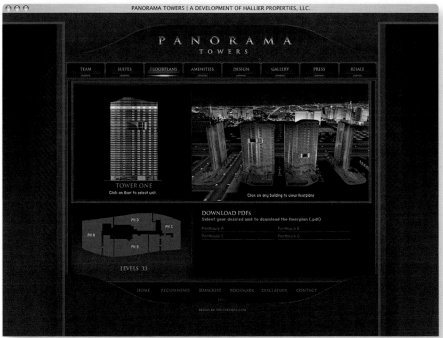

panoramatowers.com
D: tamzdesigns
A: tamzil inc. M: mtamzil@tamzdesigns.com

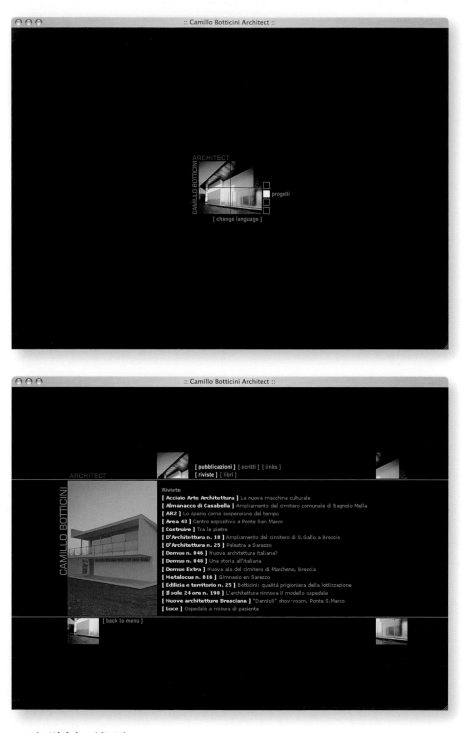

www.botticiniarchitetti.com

D: alessandro raimondo **P:** riccardo borsoni

M: info@design-r.com

[plug.in]

[plug.in]

About
Calendar
 Events
 Exhibitions
 2000
 2001
 2002
 2003
 2004
 2005
 2006
 2007
Network
Projects
Resources
Links
Fotobot
Search

2006

Jan
Feb
Mar
Apr
May
Jun
Jul
Aug
Sep
Oct
Nov
Dec

Thursday
21.9.2006, 14:00-18:00
Public Living Room

2006

14.09.06 Home Made
22.06.06 Einmal Kiew hin und zurück
01.06.06 Jan Torpus – TelcomGallery
27.05.06 Cyber seductions for virtual virgins
04.05.06 Rolf Pfeifer
28.04.06 electric rendez-vous
27.04.06 etoy - Mission Eternity
20.04.06 Bitnik
13.04.06 Rainer Fischbach - Mythos Netz
06.04.06 transmediale 06 - review and video-selection
30.03.06 Zone Interdite
29.03.06 Zone Interdite
25.03.06 Cyber seductions for virtual virgins
16.03.06 VIPER-Festival
25.02.06 Cyber seductions for virtual virgins
23.02.06 Artist talk with SONOgames
27.01.06 Night of the Museums
27.01.06 SONOgames - Leisureland II

Deutsch
⚡ **To Bookmark**
🔊) **Sound**

[plug.in]

[plug.in]

About
Calendar
Network
Projects
Resources
Links
Fotobot
Search

Fotobot

The [plug.in] fotobot's duty is to record what goes on
in [plug.in]'s public living room: the new issues of our
magazines, a new DVD in our collection, the current
exhibition or our visitors. The photos of all these real
life people, objects and events are beamed directly
into the [plug.in] online picture archive, where the
images can be commented on, downloaded, printed or
sent out as digital postcards.

Partners
Belleville

Supporter
Credit Suisse

Links
belleville.ch
Credit Suisse

Deutsch
⚡ **To Bookmark**
🔊) **Sound**

www.iplugin.org

D: brian hoffer, franziska burkhardt **C:** urs beyeler, brian hoffer
A: brianhoffer.com, buka grafik **M:** hoffer@brianhoffer.com

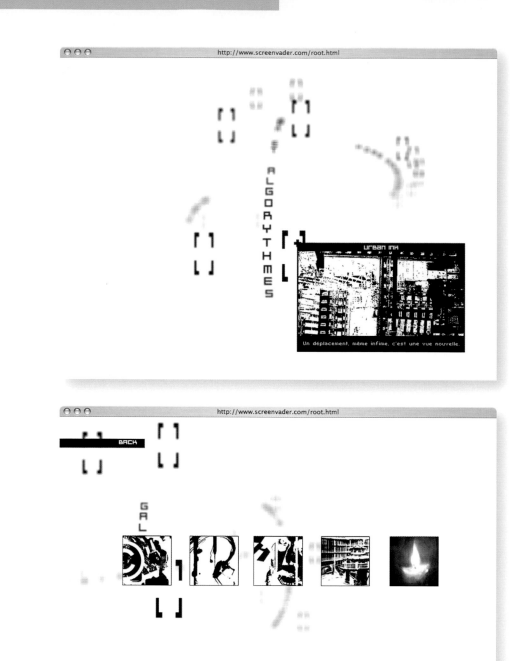

www.screenvader.com
D: stéphane bourez
M: stephane@screenvader.com

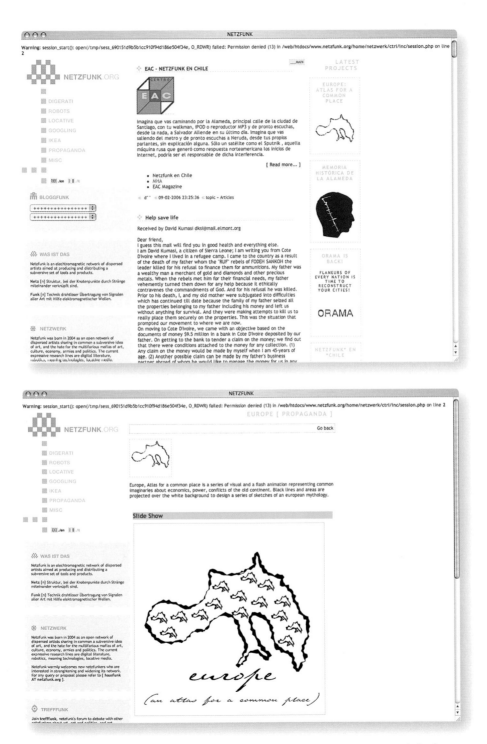

www.netzfunk.org

D: david boardman C: d-@netzfunk.org

M: d-@netzfunk.org

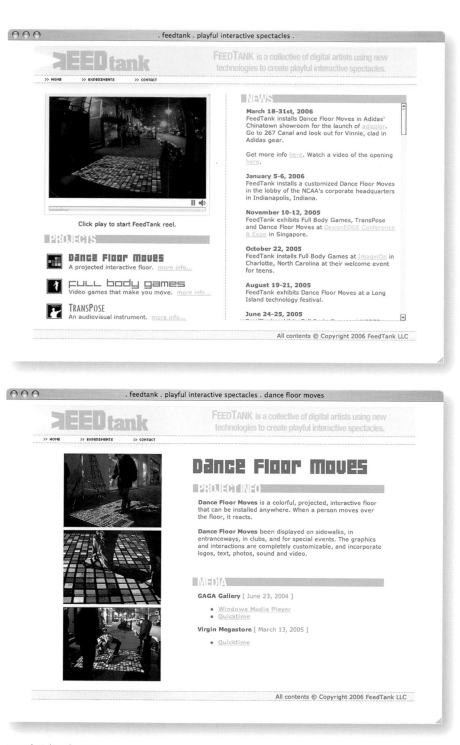

www.feedtank.com

D: jonah warren, steven sanborn

A: feedtank M: info@feedtank.com

www.c-cil.com
D: c_cil
M: c_lacomb@club.fr

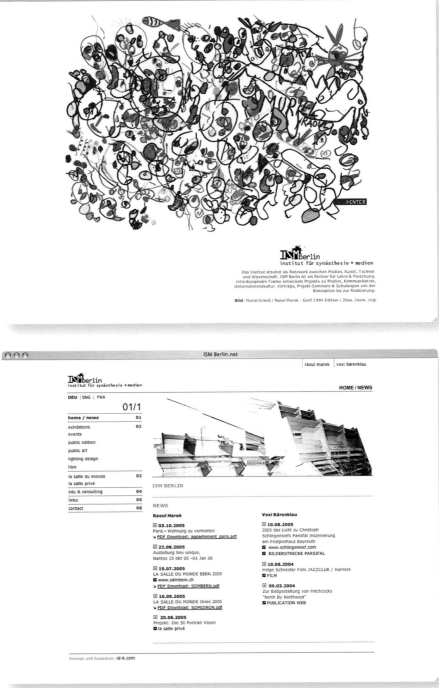

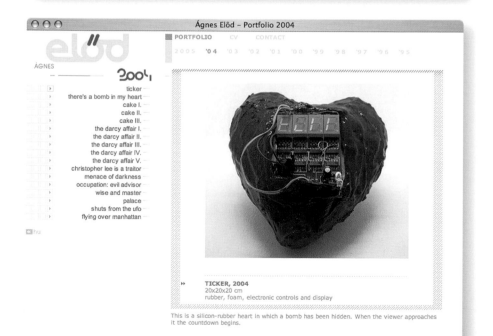

Ágnes Előd – Portfolio 2005

PORTFOLIO CV CONTACT

2005 '04 '03 '02 '01 '00 '99 '98 '97 '96 '95

ÁGNES

2005

- harry potter
- star wars
- matrix
- i was young, and had to make a living from something
- my heart now belongs to someone else
- burda-style flaming heart
- burda-style chinese heavy metal heart
- erich von däniken sculptures I.
- erich von däniken sculptures II.
- erich von däniken sculptures III.

HARRY POTTER, 2005
70x100 cm
print

In this picture I replaced the faces of the three main characters from "Harry Potter" with my own face, and the faces of my long-term studio partners. Ron Weasley's face is replaced by the face of Ádám Szabó, Harry Potter's is replaced by György Szász's face, and the face of Hermione Granger is replaced by my own.

Ágnes Előd – Portfolio 2004

PORTFOLIO CV CONTACT

2005 **'04** '03 '02 '01 '00 '99 '98 '97 '96 '95

ÁGNES

2004

- ticker
- there's a bomb in my heart
- cake I.
- cake II.
- cake III.
- the darcy affair I.
- the darcy affair II.
- the darcy affair III.
- the darcy affair IV.
- the darcy affair V.
- christopher lee is a traitor
- menace of darkness
- occupation: evil advisor
- wise and master
- palace
- shuts from the ufo
- flying over manhattan

TICKER, 2004
20x20x20 cm
rubber, foam, electronic controls and display

This is a silicon-rubber heart in which a bomb has been hidden. When the viewer approaches it the countdown begins.

www.agneselod.hu

D: géza nyíry

A: nyk design M: info@nyk.hu

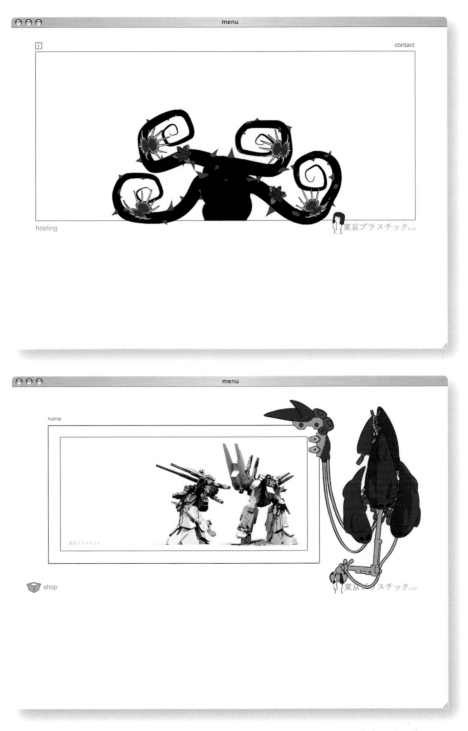

www.tokyoplastic.com
D: sam lanyon jones, andrew cope
A: tokyoplastic M: talk@tokyoplastic.com

menu

portafolio
curriculum
textos
contacto y presentación

Maider López

menu

«««< 1 2 3 4 5

Desde la playa 1

Intervención en la playa de Itzurun. 28
Agosto 2005. Zumaia.
Itzurun hondartzan egindako
eskuhartze. 2005ko Abuztuaren 28a.
Zumaia.
Intervention made in Itzurun beech.
2005/08/28. Zumaia
46 x 26,5 cm. Fotografía

Desde la playa 3

46 x 26,5 cm.
Photograph

Desde la playa 2

46 x 26,5 cm.
Argazkia

www.maiderlopez.com

D: josé maría martínez burgos, hafo **C:** josé maría martínez burgos **P:** maider lopez
A: animatu **M:** hafo@animatu.com

ANTIGIRL; INTERIM (2006)

MEMOIRS · ARCHIVE · **HANDMADE**

mission: turbulence
› march 07, 2005
part of the passion & fury collection.

ANTIGIRL; INTERIM (2006)

MEMOIRS · ARCHIVE · HANDMADE

we made two of these, one for the client and another to keep. this book contains a sample picture of every design that was created for the client lauren hart; this book was then given to her at the opening of the salon. a whole can of orange krylon paint was used to make the 2 books, and you can't tell from the pictures but it is shiny as hell. arik cut out the circle with precision, and derrick west illustrated the root drawing. 8x8x.25 inches.

› chip board, 80# semigloss, paint, wire.

www.antigirl.com
D: tiphanie brooke **C:** mike buzzard **P:** arik 1
A: antigirl **M:** t.tart@antigirl.com

www.araldyte.com
D: tom painter
A: tdpstudio M: info@tdpdesign.com

www.jeanneworks.net
D: maurits de bruijn
M: info@mauritsdebruijn.nl

010101.sfmoma.org

D: keiko hayashi, stephen jaycox P: stephen jaycox, perimetre-flux

A: perimetre-flux design M: webmaster@sfmoma.org

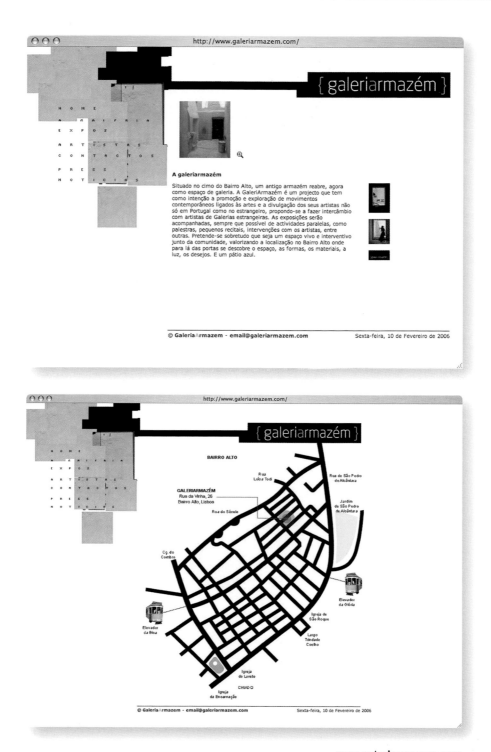

A galeriarmazém

Situado no cimo do Bairro Alto, um antigo armazém reabre, agora como espaço de galeria. A GaleriArmazém é um projecto que tem como intenção a promoção e exploração de movimentos contemporâneos ligados às artes e a divulgação dos seus artistas não só em Portugal como no estrangeiro, propondo-se a fazer intercâmbio com artistas de Galerias estrangeiras. As exposições serão acompanhadas, sempre que possível de actividades paralelas, como palestras, pequenos recitais, intervenções com os artistas, entre outras. Pretende-se sobretudo que seja um espaço vivo e interventivo junto da comunidade, valorizando a localização no Bairro Alto onde para lá das portas se descobre o espaço, as formas, os materiais, a luz, os desejos. É um pátio azul.

© GaleriaArmazem - email@galeriarmazem.com Sexta-feira, 10 de Fevereiro de 2006

www.galeriarmazem.com
D: mário cameira C: hugo castanho
M: mariocameira@gmail.com

www.nsj.ca

D: chris tucker C: tyler hicks P: chris tucker
A: pretty girl designs M: tucker_chrisa@hotmail.com

www.sketch.uk.com
D: katya bonnenfant
M: mail@katya-bonnenfant.com

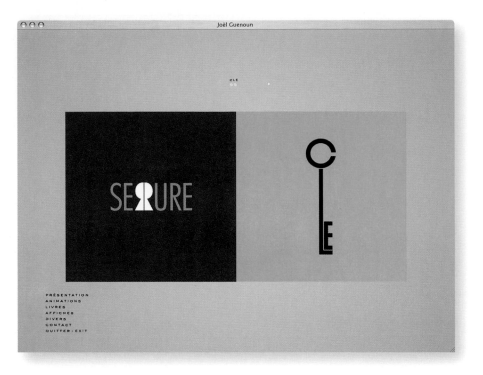

www.joelguenoun.com
D: arno roddier **C:** www.kodeagency.com **P:** joel guenoun
A: www.aruno.net **M:** contact@joelguenoun.com

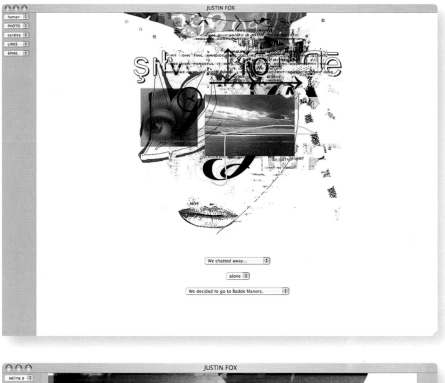

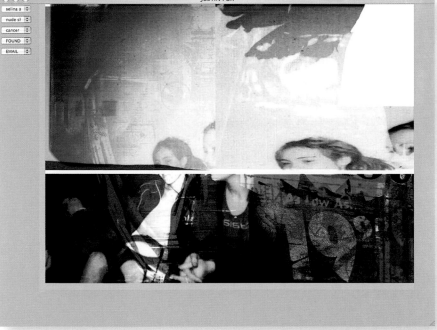

www.justinfox.com.au
D: justin fox
M: justin@australianinfront.com.au

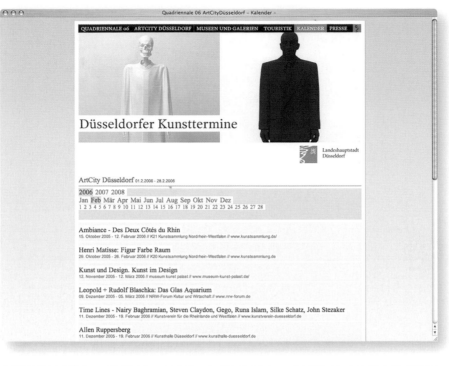

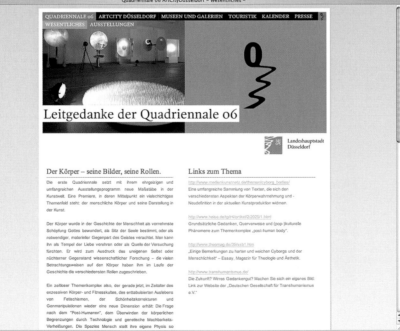

www.quadriennale.de

D: karsten blachke C: lars wöhning, marcel dickhage

A: v2a.net M: md@v2a.net

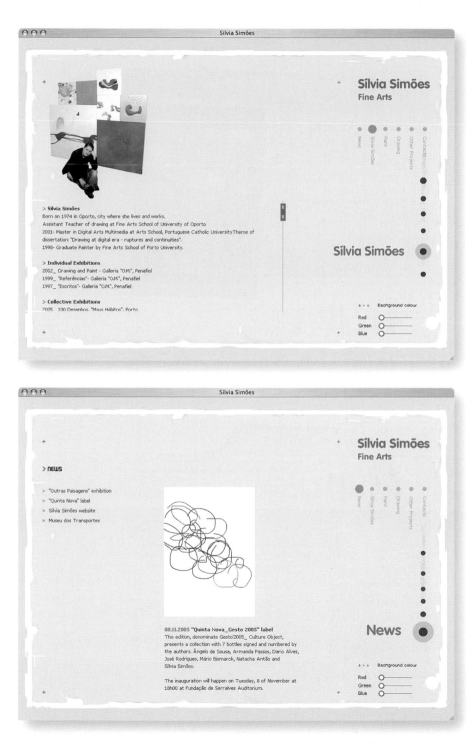

Silvia Simões

Sílvia Simões
Fine Arts

News · Silvia Simões · Paint · Drawing · Other Projects · Contacts

Sílvia Simões

> **Sílvia Simões**
Born on 1974 in Oporto, city where she lives and works.
Assistant Teacher of drawing at Fine Arts School of University of Oporto
2001- Master in Digital Arts Multimedia at Arts School, Portuguese Catholic University Theme of dissertation: "Drawing at digital era - ruptures and continuities".
1998- Graduate Painter by Fine Arts School of Porto University.

> **Individual Exhibitions**
2002_ Drawing and Paint - Galleria "O.M.", Penafiel
1999_ "Referências"- Galleria "O.M.", Penafiel
1997_ "Escritos"- Galleria "O.M.", Penafiel

> **Collective Exhibitions**
2005_ 100 Desenhos, "Maus Hábitos", Porto

Background colour
Red
Green
Blue

Silvia Simões

Sílvia Simões
Fine Arts

News · Silvia Simões · Paint · Drawing · Other Projects · Contacts

> **NEWS**

> "Outras Paisagens" exhibition
> "Quinta Nova" label
> Sílvia Simões website
> Museu dos Transportes

News

08.11.2005 **"Quinta Nova_Gesto 2005" label**
This edition, denominate Gesto'2005_ Culture Object, presents a collection with 7 bottles signed and numbered by the authors. Ângelo de Sousa, Armanda Passos, Dario Alves, José Rodrigues, Mário Bismarck, Natacha Antão and Sílvia Simões.

The inauguration will happen on Tuesday, 8 of November at 18h00 at Fundação de Serralves Auditorium.

Background colour
Red
Green
Blue

www.silviasimoes.com
D: nuno martins
A: nuno martins M: www.nunomartins.com

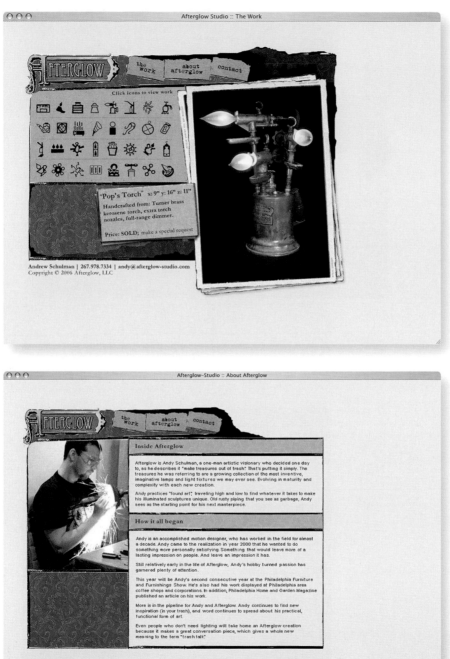

www.afterglow-studio.com

D: april donovan **C:** andrew schulman

A: april donovan **M:** www.grapeape.ws

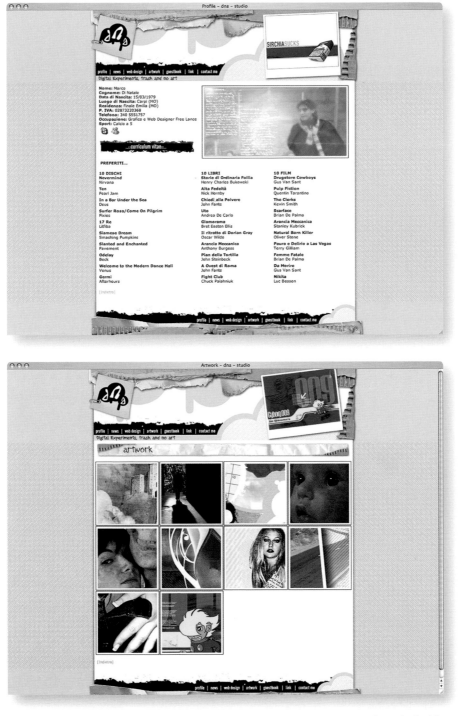

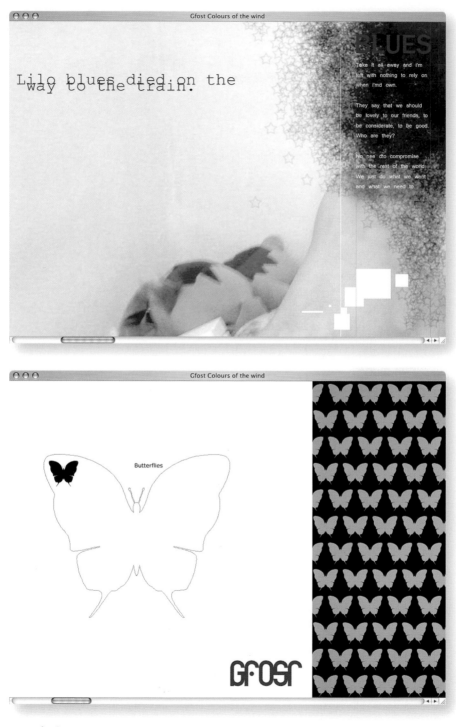

www.gfost.com

D: audi C: john7 P: captain crap

A: gfost M: johnmerques@hotmail.com

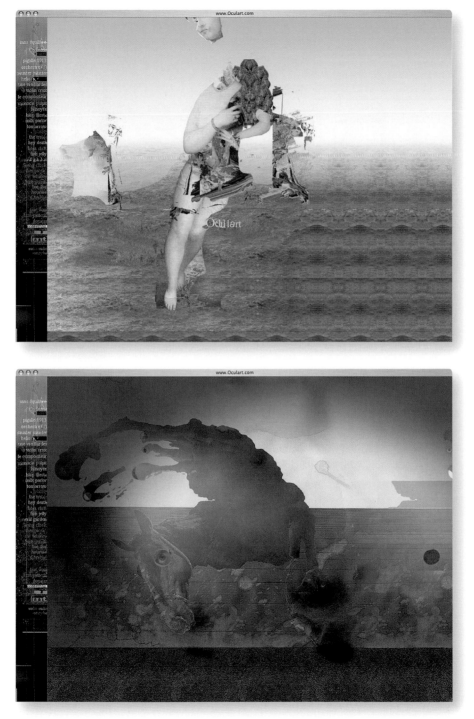

www.OCULART.com

D: geoff lillemon

M: geoff@oculart.com

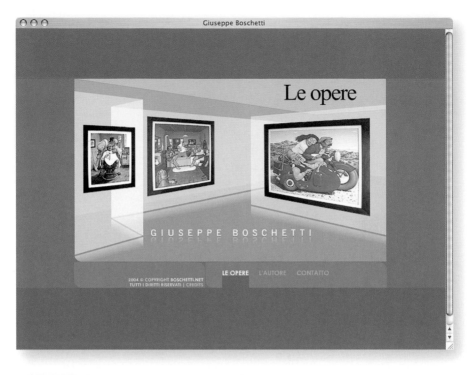

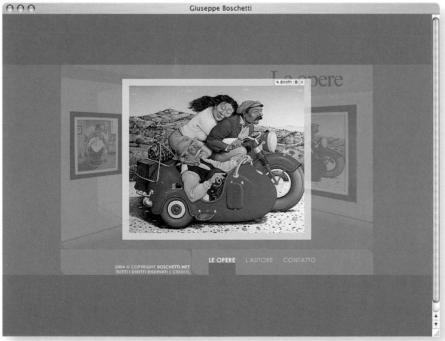

www.boschetti.net
D: marcello boschetti **C:** marcello boschetti **P:** giuseppe boschetti
A: bosqnet **M:** contact@boschetti.net

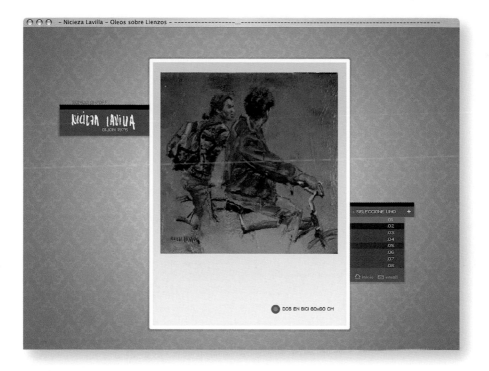

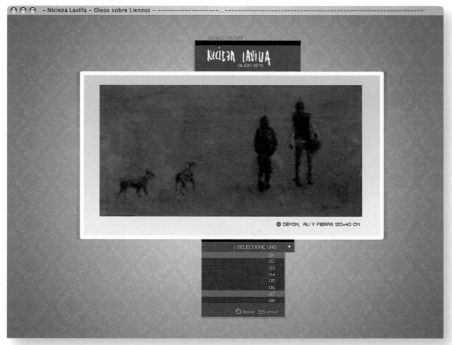

www.niciezalavilla.com
D: pablo reguera C: pablo reguera P: p_rc new media
A: p_rc new media M: www.pabloreguera.com

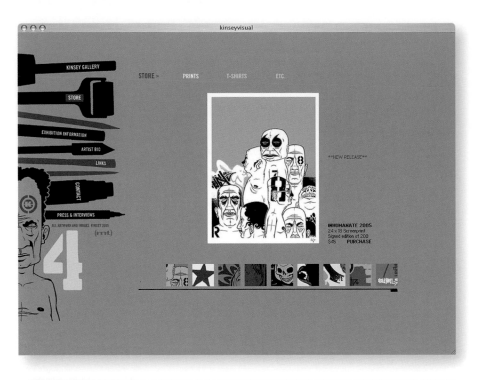

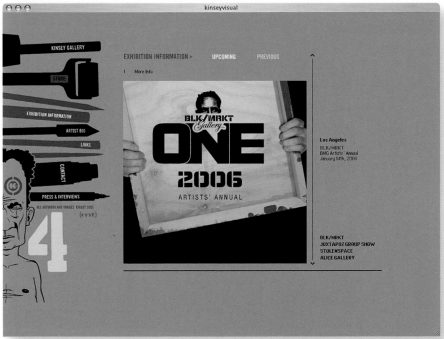

www.kinseyvisual.com
D: dave kinsey, jana desforges **C:** greg huntoon **P:** jana desforges
A: blk/mrkt **M:** contact@kinseyvisual.com

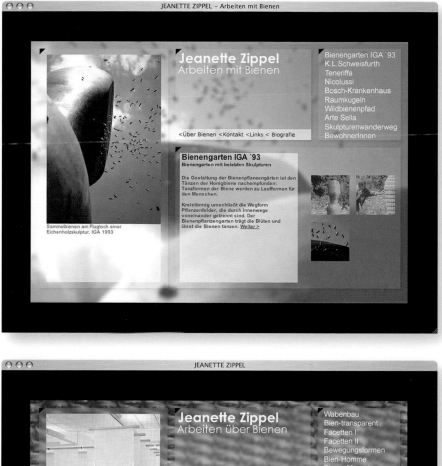

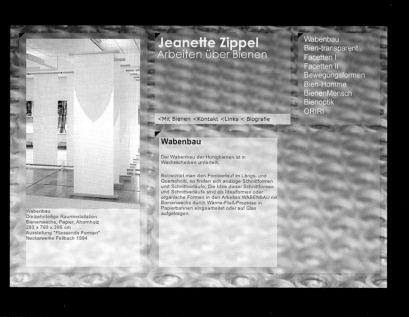

www.jeanettezippel.de

D: tobias wortmann

M: tob99@gmx.de

www.toa.edu.my/unplug
D: chui tuck loong C: ng man meng P: chienni chang
A: the one interactive M: info@theoneinteractive.com

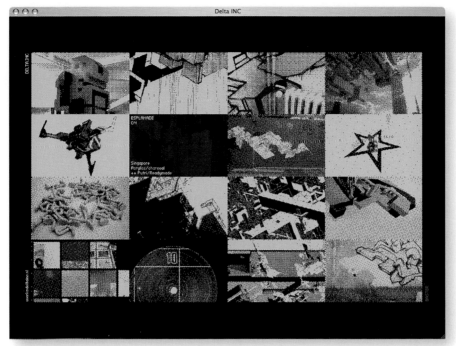

www.deltainc.nl
D: boris tellegen, bas koopmans
M: x@deltainc.nl

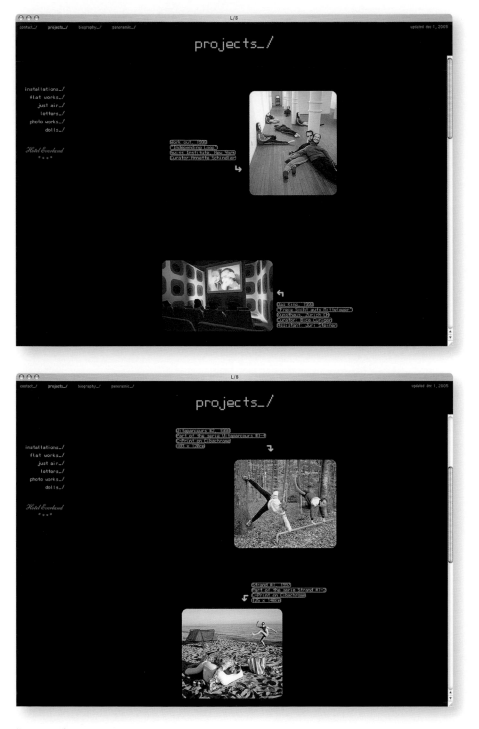

www.langbaumann.com

D: lang/baumann

M: lb@langbaumann.com

alex.gws.pt
D: alexandre ribeiro gomes
A: bürocratik **M:** alex@burocratik.com

www.elitradesign.it
D: marco sironi, roberta sironi
A: elitradesign **M:** elitra@elitradesign.it

folding sheet, frontside, 42.5 x 21cm (opened) / basic design of map by Svenja Plaas

www.grafikpilot.ch
D: marcel schneeberger
A: grafikpilot **M:** kerosin@grafikpilot.ch

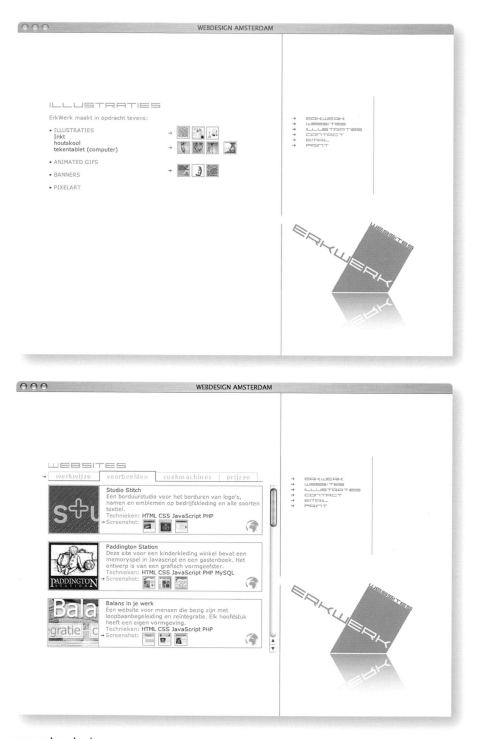

www.erkwerk.nl

D: erik visscher

A: erkwerk M: info@erkwerk.nl

```
<!DOCTYPE html PUBLIC "-//W3C//DTD HTML 4.01 Transitional//EN">
<html>

<head>
<meta http-equiv="content-type" content="text/html;charset=ISO-8859-1">
<meta name="generator" content="bulent bas">
<title>::::::::.. RESUME ...:::::::</title>
```

EDUCATION
1999 - 2001
CITY UNIVERSITY OF NEW YORK
MFA Media Arts Productions.

1992-1996
MARMARA UNIVERSITY
Bachelor's Degree in Fine Arts.

Fluent in Turkish and English. U.S. resident.
Portfolio and references available upon request.

<works / resume / contact / main page >

```
</head>
</body>
</html>
```

```
<!DOCTYPE html PUBLIC "-//W3C//DTD HTML 4.01 Transitional//EN">
<html>

<head>
<meta http-equiv="content-type" content="text/html;charset=ISO-8859-1">
<meta name="generator" content="bulent bas">
<title>::::::::.. PORTFOLIO ...:::::::</title>
```

< video >

ZEKI DEMIRKUBUZ
Concept / Editorial / Animation
1 / 2 / 3 / 4 / 5 / 6 / 7 / 8 / 9

< print >

< web >

< flash >

<works / resume / contact / main page >

```
</head>
</body>
</html>
```

www.bulentbas.com
D: bulent bas
A: bulent bas M: bulent@bulentbas.com

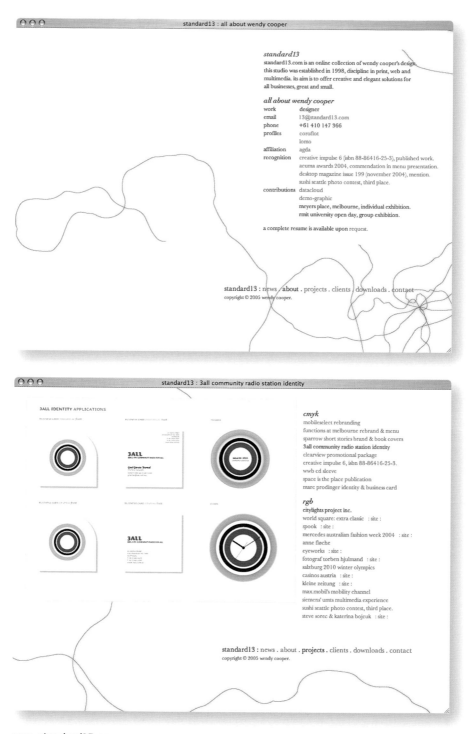

standard13 : all about wendy cooper

standard13
standard13.com is an online collection of wendy cooper's design.
this studio was established in 1998, discipline in print, web and
multimedia. its aim is to offer creative and elegant solutions for
all businesses, great and small.

all about wendy cooper

work	designer
email	13@standard13.com
phone	+61 410 147 366
profiles	coroflot
	lomo
affiliation	agda
recognition	creative impulse 6 (isbn 88-86416-25-3), published work.
	acuma awards 2004, commendation in menu presentation.
	desktop magazine issue 199 (november 2004), mention.
	sushi seattle photo contest, third place.
contributions	datacloud
	demo-graphic
	meyers place, melbourne, individual exhibition.
	rmit university open day, group exhibition.

a complete resume is available upon request.

standard13 : news . about . projects . clients . downloads . contact
copyright © 2005 wendy cooper.

standard13 : 3all community radio station identity

3ALL IDENTITY APPLICATIONS

cmyk
mobileselect rebranding
functions at melbourne rebrand & menu
sparrow short stories brand & book covers
3all community radio station identity
clearview promotional package
creative impulse 6, isbn 88-86416-25-3.
wwb cd sleeve
space is the place publication
marc prodinger identity & business card

rgb
citylights project inc.
world square: extra classic : site :
spook : site :
mercedes australian fashion week 2004 : site :
anne flèche
eyeworks : site :
fotograf torben hjulmand : site :
salzburg 2010 winter olympics
casinos austria : site :
kleine zeitung : site :
max.mobil's mobility channel
siemens umts multimedia experience
sushi seattle photo contest, third place.
steve sorec & katerina bojcuk : site :

standard13 : news . about . **projects** . clients . downloads . contact
copyright © 2005 wendy cooper.

www.standard13.com
D: wendy cooper
A: standard13.com **M:** 13@standard13.com

www.illogika.it

D: daniela cirillo, irene capatti, manuel sgarzi P: illogika s.n.c.

A: illogika s.n.c. M: info@illogika.it

www.susan-chaaban.de

D: susan chaaban

A: susan chaaban M: info@susan-chaaban.de

www.marklucasdesign.co.uk
D: mark lucas
A: mark lucas design M: mail@marklucasdesign.co.uk

www.laboitegraphique.new.fr

D: prigent ewen

A: la boite graphique M: laboitegraphique@free.fr

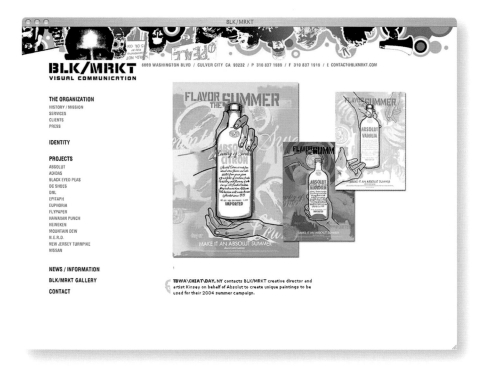

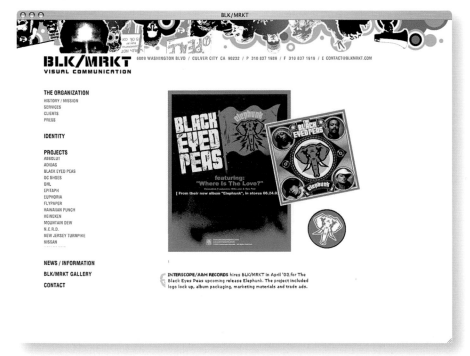

blkmrkt.com
D: ana desforges, dave kinsey C: greg huntoon P: jana desforges
A: blk/mrkt M: contact@blkmrkt.com

PORTFOLIO MULTIMEDIA RAUL HERNANDEZ

ÉSTA ES UNA SELECCIÓN DE MIS TRABAJOS MÁS RECIENTES EN EL ÁMBITO BIDIMENSIONAL Y TRIDIMENSIONAL.MI ESTILO SE CENTRA EN UNA PERCEPCIÓN CLARA Y CONCISA DE FORMAS Y COLORES QUE OTORGAN UN VALOR Y UN SIGNIFICADO MUY ASIMILABLE.MIS CONOCIMIENTOS ABARCAN LENGUAJES DE PROGRAMACIÓN TALES COMO LINGO, ACTIONSCRIPT, HTML, JAVASCRIPT Y PROGRAMAS COMO CORELDRAW, PHOTOSHOP, MM FLASH, MM DIRECTOR, FINALCUTPRO, MM DREAMWEAVER , DVD STUDIO PRO Y MAYA 3D .

IMPRIMIR CURRICULUM ←

GRAN VIA, 536 2º 4ª BARCELONA 08015
TEL. 934547489 info@raulhernandez.es

PONG • Juego interactivo • SOFTWARE UTILIZADO→ CorelDraw 12, MM Flash MX, MM dreamweaver MX • HISTORIA→ Remake del juego arcade de los 70, básicamente es un ejercicio de programación y aplicación de inteligencia al propio interactivo para una mayor jugabilidad [usuario-ordenador]. [2005]

WWW.MERCADONEGRO.ORG • WebSite diseñado para la asociación Galeria • SOFTWARE UTILIZADO → MM Dreamweaver MX, MM Flash MX, CorelDraw12, Photoshop CS • HISTORIA→ Site informativo y promocional de eventos culturales trimenstrales dirigido a creativos, diseñadores y artistas en general para promoción y venta de sus obras.[2005]

www.raulhernandez.es

D: raul hernandez gracia

A: raul hernandez M: info@raulhernandez.es

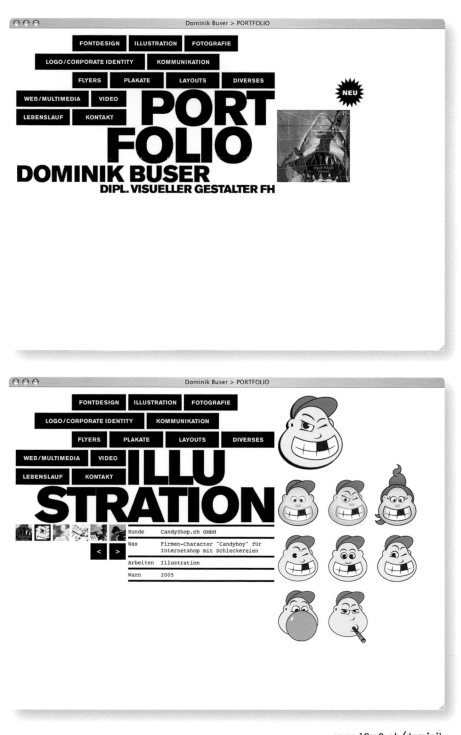

www.19m2.ch/dominik
D: dominik buser
A: 19m2 atelierkollektiv M: dominik@19m2.ch

www.ricupitodesign.it
D: andrea luxich C: francesco m. munafò
A: pangoo design M: www.pangoo.it

www.piperboy.com
D: edvin lee
A: common brand M: hello@piperboy.com

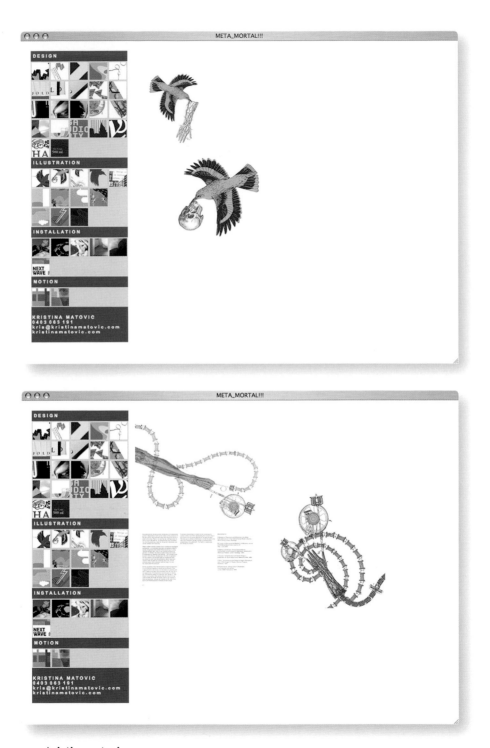

www.kristinamatovic.com
D: kristina matovic
M: kris@kristinamatovic.com

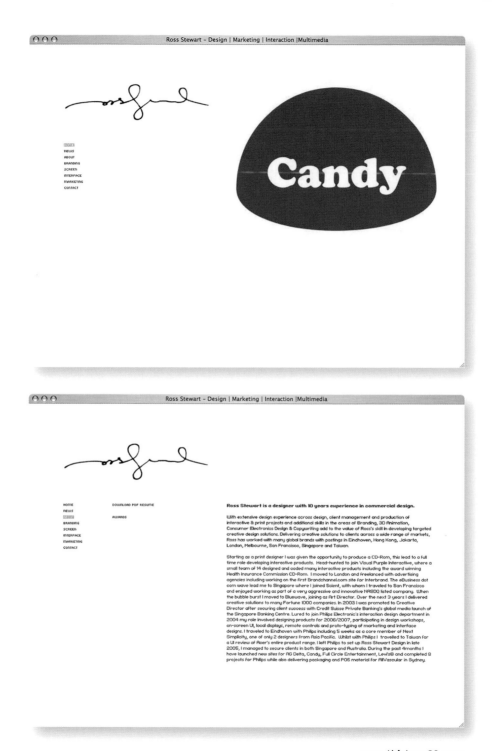

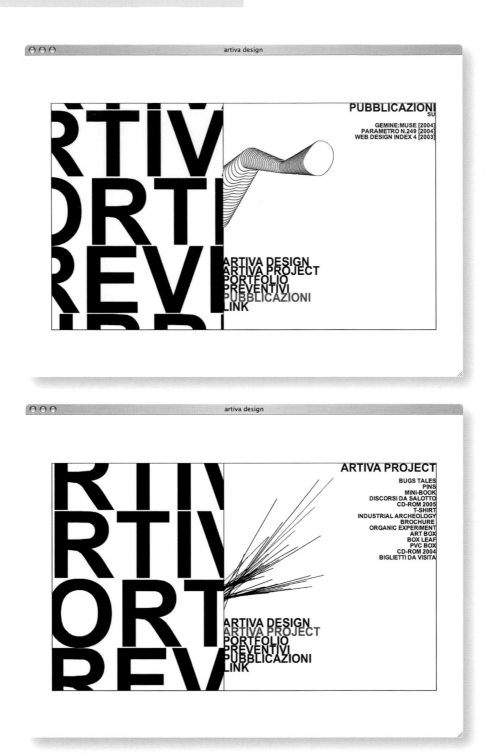

www.artiva.it

D: daniele de batté, davide sossi C: daniele de batté, davide sossi P: artiva

A: artiva design M: info@artiva.it

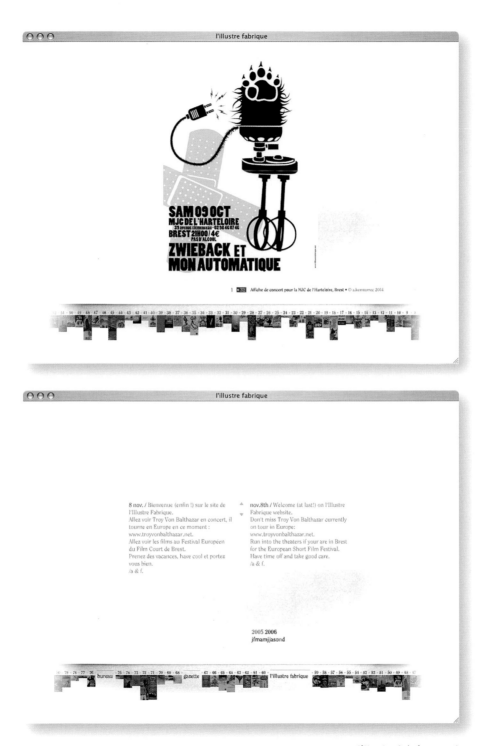

1 ▪▪▪ Affiche de concert pour la MJC de l'Harteloire, Brest • © a.kermarrec 2004

8 nov. / Bienvenue (enfin !) sur le site de l'Illustre Fabrique.
Allez voir Troy Von Balthazar en concert, il tourne en Europe en ce moment : www.troyvonbalthazar.net.
Allez voir les films au Festival Européen du Film Court de Brest.
Prenez des vacances, have cool et portez vous bien.
/a & f.

nov.8th / Welcome (at last!) on l'Illustre Fabrique website.
Don't miss Troy Von Balthazar currently on tour in Europe: www.troyvonbalthazar.net.
Run into the theaters if your are in Brest for the European Short Film Festival.
Have time off and take good care.
/a & f.

2005 2006
jfmamjjasond

www.lillustrefabrique.net
D: prigent ewen
A: la boito graphique M: laboitegraphique.new.fr

The Consult – Creative Design Agency

The Consult
Design & Art Direction

Profile
Selected work

Ascendis
Original Copywriting
Brighter Marketing
Leeds College of Art & Design
Diamond Days
Ready Planted
Jacqueline Callaghan
Designmash
Leeds Met University
The Consult
Terior

Get in touch

Prev. Next. 1 of 3

Following a three way pitch, Leeds College of Art & Design invited
The Consult to design this year's prospectus.

info@theconsult.com

The Consult – Creative Design Agency

The Consult
Design & Art Direction

Profile
Selected work

Ascendis
Original Copywriting
Brighter Marketing
Leeds College of Art & Design
Diamond Days
Ready Planted
Jacqueline Callaghan
Designmash
Leeds Met University
The Consult
Terior

Get in touch

Prev. Next. 1 of 2

The Leeds School of Contemporary Art & Graphic Design at Leeds Met
University commissioned us to design their new website. We focused on
the processes and experiences of being a part of the School rather than
past students work.

info@theconsult.com

www.theconsult.com
D: john-paul warner **P:** alex atkinson, rebecca keast
M: www.theconsult.com

www.patsmedia.nl

D: paul olsman

A: patsmedia M: info@patsmedia.nl

www.zeroconstile.com

D: manuela zinzeri

A: manuela zinzeri (freelance) **M:** askme@zeroconstile.com

www.limbus.fr

D: stefanos athanassopoulos P: emmanuelle ibara
A: limbus studio M: contact@limbus.fr

www.jameskingman.com

D: james kingman

M: james@jameskingman.com

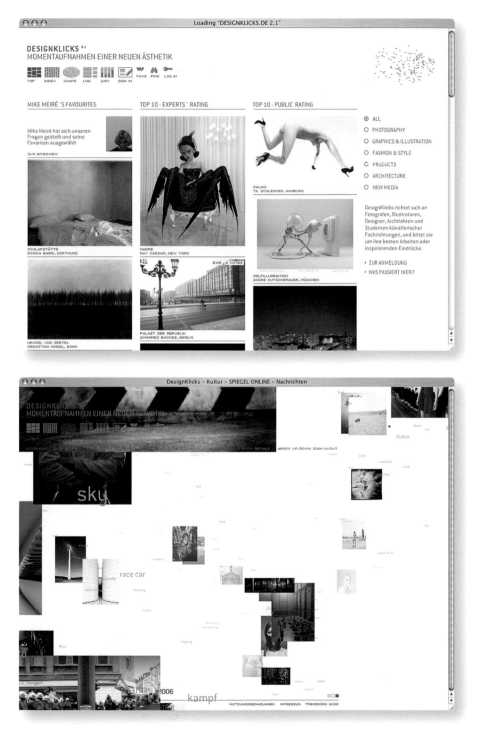

www.designklicks.de

D: stefan landrock **C:** deutschlandrock **P:** trendbüro hamburg

A: www.deutschlandrock.de **M:** designklicks@trendbuero.de

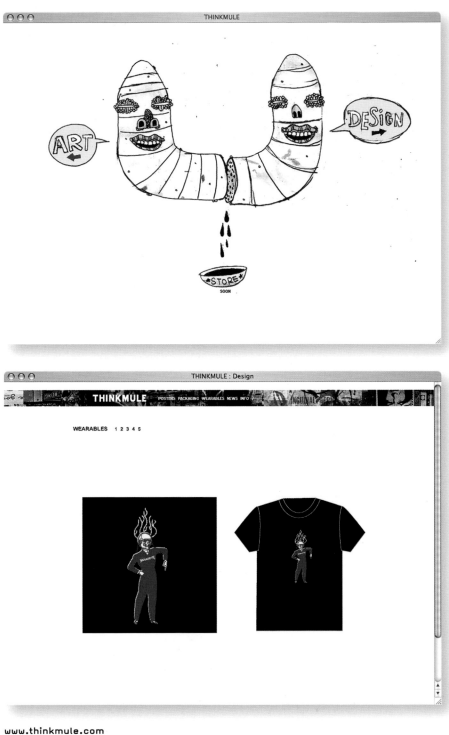

www.thinkmule.com
D: thinkmule C: aaron tanner
A: thinkmule M: www.thinkmule.com

splintered – freelance creativity and design

SPLINTERED
FREELANCE CREATIVITY AND DESIGN +

main sections +
home
news
portfolio
experiments
about
feeds

experimental
externals
del.icio.us

latest news
- ariadne article on the TAW3 accessibility testing and reporting tool
- presenting at the next MDAWG meeting
- speaking at (salford) chapel street business group seminar
- 20min.ch mentions text size toolbar
- see me speak at @media 2006, london, 15-16 june

latest portfolio pieces
- Supreme Education - Supreme Education plc
- xcart based furniture store -
- hands-on identity - hands-on consultants

latest experiments
- flickr RSS feed
- firefox print/print preview button menu
- firefox send link button
- splintered striper
- web essentials 05 - molly holzschlag keynote SMIL

© patrick h. lauke aka redux
re•dux (adj): brought back; returned. used postpositively. [latin : re-, re- + dux, leader; see duke.]

Sonar Yen band photography | portfolio | splintered – freelance creativity and design

SPLINTERED
FREELANCE CREATIVITY AND DESIGN +

main sections +
home
news
portfolio
experiments
about
feeds

experimental
externals
del.icio.us

Sonar Yen band photography

client:	The Sonar Yen
completed:	2004-02-21
category:	photography
description:	Photographs for The Sonar Yen, taken around the seedy back streets of Manchester's northern quarter.

A very successful hour of shooting, putting my newly acquired Lomo LC-A and a trusty Zenitar fish-eye lens to good use.

The results exceeded all expectations. Shown here is only a small selection of the 30+ photographs that came out of the shoot.

⊛ view this project

© patrick h. lauke aka redux
re•dux (adj): brought back; returned. used postpositively. [latin : re-, re- + dux, leader; see duke.]

www.splintered.co.uk
D: patrick h. lauke
M: redux@splintered.co.uk

www.kombinat-ost.com
D: daniel knorn
A: kombinat-ost M: knorn@kombinat-ost.com

www.koadzn.com
D: koa C: enileda
M: koa@koadzn.com

www.danielherzog.de
D: daniel herzog
M: daniel.herzog@gmail.com

www.thomasthiele.com
D: thomas thiele C: dirk thomas, sebastian petters
A: 4wd media M: kontakt@4wdmedia.de

www.saverioevangelista.com

D: saverio evangelista C: saverio evangelista P: saverio evangelista, simone luti
A: luti*design M: www.luti.net

www.reform-design.com

D: christian kellner, andreas kull, christiane schulz C: christiane schulz

A: reform design M: andreas.kull@reform-design.de

www.pokelondon.com
D: nicky gibson C: simon kallgard P: peter beech
A: poke M: info@pokelondon.com

www.mimai.it

D: mimai group

A: mimai di mirko maiorano M: www.mimai.it

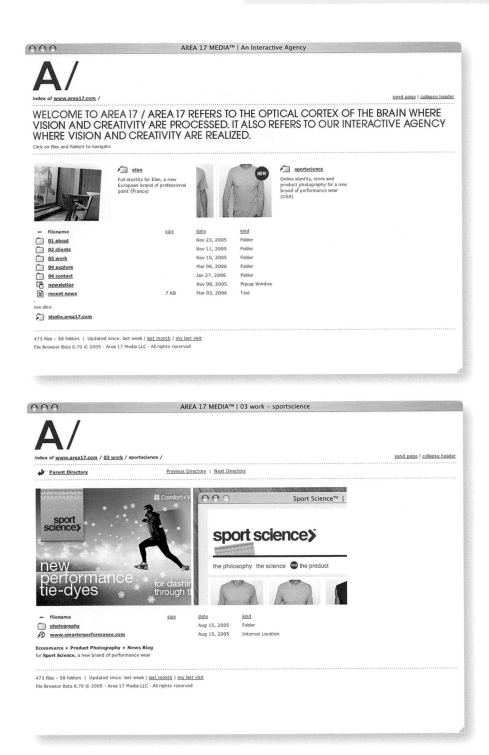

www.area17.com
D: arnaud mercier C: mubashar iqbal P: george eid
A: area 17 M: contact@area17.com

www.herfortundknorn.de

D: daniel knorn

A: herfort+knorn M: dk@herfortundknorn.de

www.gomtch-gomtch.com
D: joana toste **C:** joana toste **P:** gomtch-gomtch
A: gomtch-gomtch **M:** mail@gomtch-gomtch.com

www.replayful.com

D: replayful

A: replayful M: info@replayful.com

www.ilustris.pl

D: andrzej tylkowski, marek charytonowicz **C:** marek charytonowicz

A: mediadream **M:** studio@mediadream.pl

www.ths.nu

D: thomas schostok

A: {ths} thomas schostok design M: www.ths.nu

www.genesidesign.com
D: cristina mulinacci, maurizio ercole
A: genesidesign M: design@genesi.net

TWINPIX web.print.music

TWINPIX ist eine Agentur für Webdesign, Print (Anzeigen, Visitenkarten, Briefpapier, etc), Logo, Corporate Identity, Text und Sound-Design in Welzheim bei Stuttgart. Hinter TWINPIX stehen der Dipl. Designer (FH) und Master of Arts Joe Landen, sowie die Designstudentin Claudia Hahn.

TWINPIX mypage

Die kostengünstige und modulare Homepage mit 6 Kapiteln schon ab 450,- EUR (netto). Mehr Infos: mypage.twinpix.de

News

TWINPIX designt für die Cocolococlub-Veranstaltungen in Schorndorf und Stuttgart Plakate, Flyer, Anzeigen und Web-Banner.

TWINPIX gestaltet für Ludwig Bauer und sein Restaurant Ruccola ein Plakat und Visitenkarten.

TWINPIX entwirft für die Innen-Deko des Cocolococlubs diverse Werbeplanen und Transparente.

TWINPIX designt für den Cocolococlub Plakate, Flyer, Anzeigen und Web-Banner.

TWINPIX realisiert die Website von ak-projectmanagement. www.ak-projectmanagement.com

TWINPIX gestaltet die Website von M1-Bookings um, wegen der Namensänderung zu FAKE Artist Management. www.fakeartists.com

TWINPIX designt eine Zeitungsanzeige und ein Mailing für Auto Weimar.

TWINPIX entwirft zwei Anzeigen für den neuen Kunden Topper Electronics.

TWINPIX hat sein Büro nach Welzheim verlagert. Im Zuge

| NEWS | AGENTUR | REFERENZEN | AUSZEICHNUNGEN | KONTAKT | ONLINE SHOP |

Referenzen

| Websites
| Web-Banner
| Print
| Logo & CI
| Music
| Freelance

Website Projekte

FAKE Artists (Stuttgart)
M1-The Club (Stuttgart)
Großecker & Pyttel (Obersulm)
Tennisrado (Filderstadt)
mdproductions (Aichtal)
Tannhof (Alfdorf)
ak-projectmanagement (Stgt)

Armand van Helden (USA)
Netmen IHS (Hochwang)
DJ Thomsen (Berlin)
Bennett & Bennett (Herrenberg)
die Leute (Freiburg)
Felix da Housecat (USA)

Sunradio Creativo (Spanien)
van der Velden (Aachen)
Light Up! (Stuttgart)
Kirchheim teckt ... (Kirchheim)
Cafe Niethammer (Jettingen)
in the pink (Welzheim)

| NEWS | AGENTUR | REFERENZEN | AUSZEICHNUNGEN | KONTAKT | ONLINE SHOP |

www.twinpix.de

D: joe landen, claudia hahn C: joe landen P: joe landen
A: twinpix web.print.music M: info@twinpix.de

www.caliboor.com
D: jan schlösser
A: caliboor design studio M: jan@caliboor.com

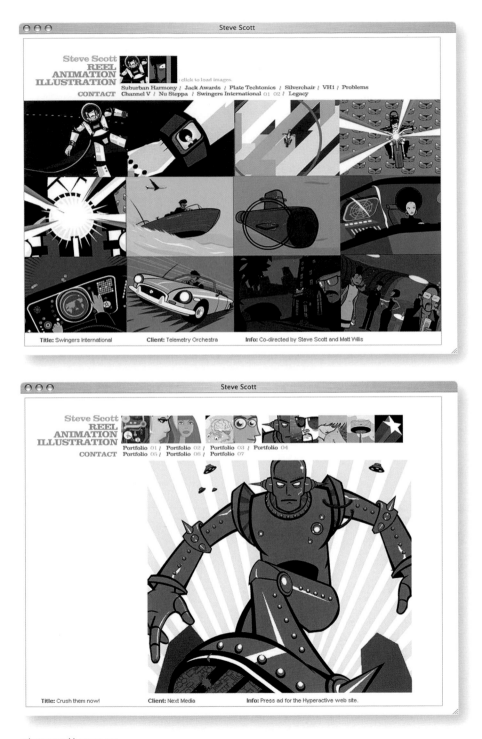

stevescott.com.au

D: steve scott

M: steve@stevescott.com.au

www.vievent.fr

D: florian raffene

M: infos@vievent.fr

www.playgroundsfestival.nl

D: jorg van keulen, emiel van wanrooij C: c. raaijmakers, bas van hout P: loek jurres
A: the cre8ion.lab – schijndel M: www.cre8ion.com

hom-p.net
D: jean-philippe maigret C: alexandre koch P: hom-p
A: hom-p M: contact@hom-p.net

www.z-design.it

D: marco zingoni

A: z-design M: zingoni@z-design.it

www.zerokilowatt.com

D: cristiano andreani **C:** maura battistoni **P:** dagomedia
A: zerokilowatt visual communication design **M:** cristiano@zerokilowatt.com

kazst.com

D: kazuyo miyashita

A: kazuyo*studio M: k_info@kazst.com

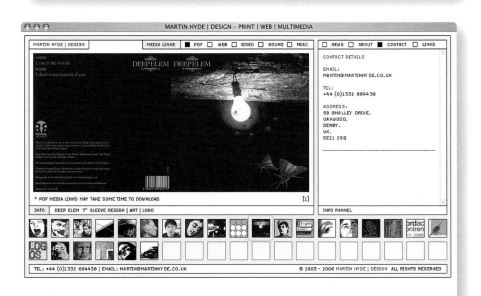

www.martinhyde.co.uk
D: martin hyde
A: martin hyde | design M: www.martinhyde.co.uk

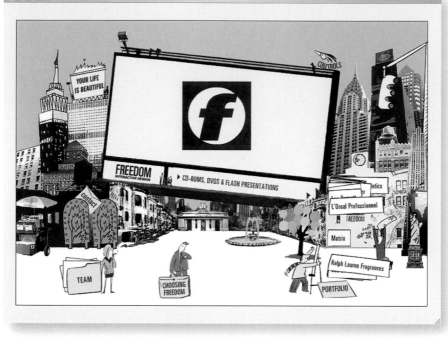

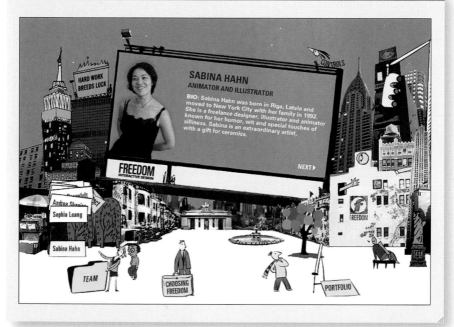

www.freedominteractivedesign.com

D: shea gonyo, sabina hahn, mark ferdman C: josh ott, shea gonyo P: mark ferdman

A: freedom interactive design M: info@freedominteractivedesign.com

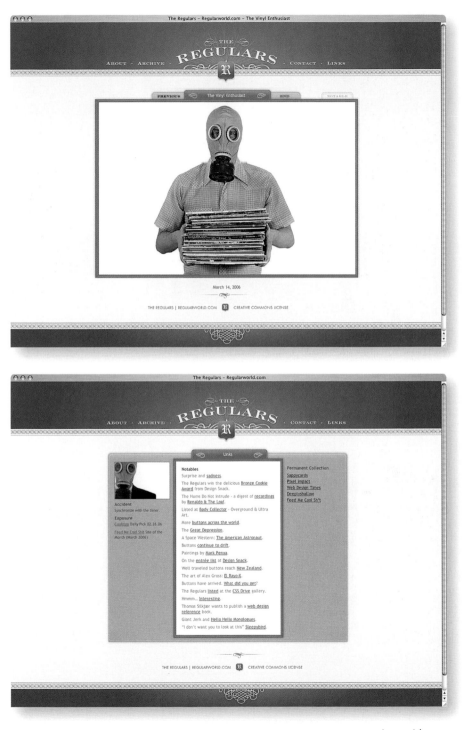

regularworld.com
D: gaston masque
A: the regulars M: regularworld.com

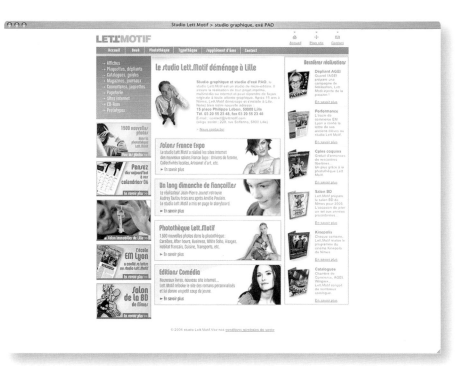

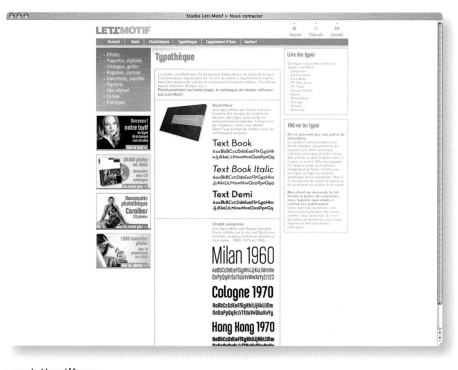

www.lettmotif.com

D: jean francois jeunet

A: lettmotif M: contact@lettmotif.com

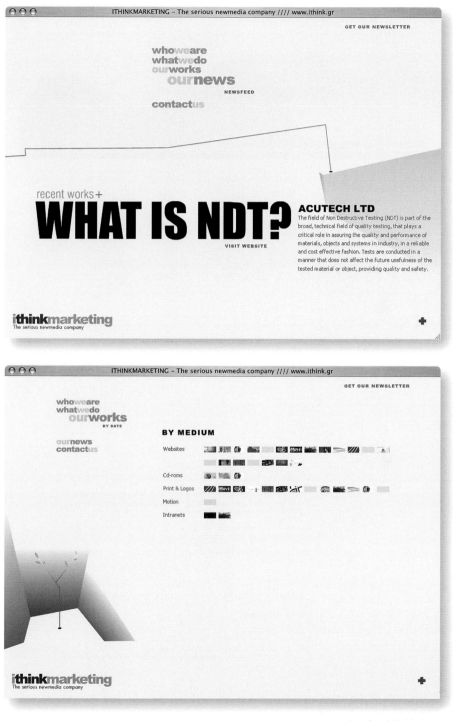

www.ithink.gr
D: ithinkmarketing **P:** stavros tsalikoglou
A: ithinkmarketing **M:** info@ithink.gr

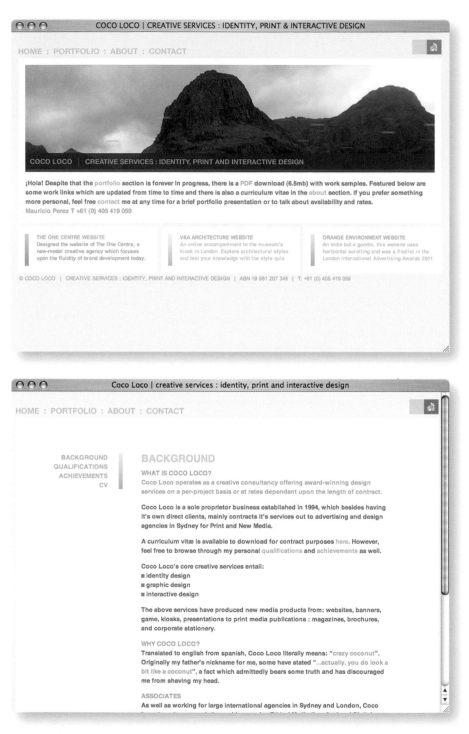

www.teil.ch
D: teil.ch
A: teil.ch M: info@teil.ch

www.darkybuthappy.free.fr
D: élisa bottin
M: elisa.bottin@free.fr

www.nadinefiege.de
D: nadine fiege
M: kontakt@nadinefiege.de

www.dixonbaxi.com
D: dixonbaxi
A: dixonbaxi **M:** info@dixonbaxi.com

www.insanelab.net

D: bibi gloaguen, juan díaz-faes C: alberto alvarez P: alberto alvarez

A: insane M: crash@insanelab.net

www.geturl.it
D: ivan pedri
A: ivan pedri M: info@geturl.it

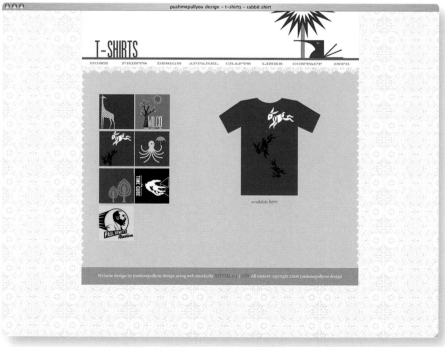

www.pushmepullyoudesign.com

D: eleanor grosch

A: pushmepullyou design M: pushmepullyoudesign@gmail.com

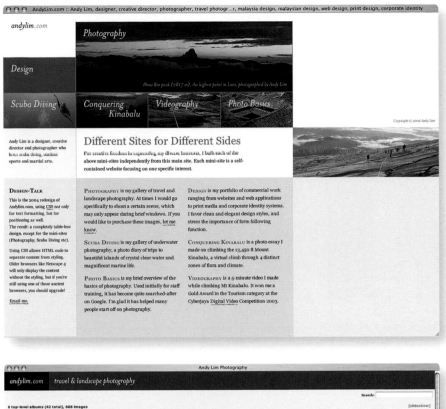

AndyLim.com :: Andy Lim, designer, creative director, photographer, travel photogr...r, malaysia design, malaysian design, web design, print design, corporate identity

andylim.com

Photography

Design

Scuba Diving

Conquering Kinabalu

Videography

Photo Basics

Phou Bia peak (2817 m), the highest point in Laos, photographed by Andy Lim

Copyright © 2006 Andy Lim

Andy Lim is a designer, creative director and photographer who loves scuba diving, outdoor sports and martial arts.

Different Sites for Different Sides

For creative freedom in expressing my diverse interests, I built each of the above mini-sites independently from this main site. Each mini-site is a self-contained website focusing on one specific interest.

DESIGN-TALK

This is the 2004 redesign of Andylim.com, using CSS not only for text formatting, but for positioning as well. The result: a completely table-less design, except for the mini-sites (Photography; Scuba Diving etc).

Using CSS allows HTML code to separate content from styling. Older browsers like Netscape 4 will only display the content without the styling, but if you're still using one of those ancient browsers, you should upgrade!

Email me.

PHOTOGRAPHY is my gallery of travel and landscape photography. At times I would go specifically to shoot a certain scene, which may only appear during brief windows. If you would like to purchase these images, let me know.

SCUBA DIVING is my gallery of underwater photography, a photo diary of trips to beautiful islands of crystal clear water and magnificent marine life.

PHOTO BASICS is my brief overview of the basics of photography. Used initially for staff training, it has become quite searched-after on Google. I'm glad it has helped many people start off on photography.

DESIGN is my portfolio of commercial work ranging from websites and web applications to print media and corporate identity systems. I favor clean and elegant design styles, and stress the importance of form following function.

CONQUERING KINABALU is a photo essay I made on climbing the 13,450 ft Mount Kinabalu, a virtual climb through 4 distinct zones of flora and climate.

VIDEOGRAPHY is a 5-minute video I made while climbing Mt Kinabalu. It won me a Gold Award in the Tourism category at the Cyberjaya Digital Video Competition 2003.

Andy Lim Photography

andylim.com *travel & landscape photography*

Search:

6 top-level albums (42 total), 668 images

[slideshow]

Welcome to a selection of my outdoor landscape and travel photography. All these and more are available from my portfolio at Alamy Images and my stock photography assignments at Immagine Stock Photography. I'm also available for assignments and event photography.

Image Library:
All images in this gallery are protected by copyright and may not be copied, reproduced or republished in any form without my permission. If you would like to use any of these images, they are available for sale via Alamy Images, or you can contact me directly for a quote.

Technical Quality:
I pay painstaking attention to technical quality, both during the picture-taking moment as well as during post-production. All my images print to sizes of 30x45cm (11x17") at 300dpi with excellent sharpness. My panoramic images can be even bigger sizes, optimized for large high-quality printing. If you intend to buy an image but would like to inspect the image quality at 100% magnification, I can email partial crops of the original files for inspection.

Camera Gear:
Nikon D70 digital SLR, 10-20mm, 18-70mm, 70-300mm, 50mm, Manfrotto 055 Pro, Gitzo 1027, Nikon SB-600. For underwater photography I use a Canon 850. In the past, I shot 35mm slide film with Nikon and Pentax SLR cameras, and dabbled with black-and-white darkroom printing.

Selling Your Photos:
If you have some photos that are just sitting in your computer, you might as well first make some money for you. Microstock agencies let almost anyone earn money from their photos:
Shutterstock (my current returns: USD30/mth)
iStockphoto (my current returns: USD70/mth)

- Andy Lim

Laos

8 albums of scenes from Luang Prabang, Vientiane, Xieng Khouang, Mekong River, Annam Highlands, Vang Vieng and rural Hmong village life.

Updated on 01/18/06.
8 items, 860 visits since 01/03/06.

Thailand

3 albums from Phi Phi Island, Pileh Bay, Maya Bay, Lo Sama Bay, Poda Island, Krabi and Bangkok.

Updated on 12/15/05.
3 items, 5258 visits since 11/05/03.

Malaysia

13 albums containing scenes from Mount Kinabalu, Bukit Tabur, Perhentian Island, Redang Island, Paya Indah, Langkawi, Pantai Kerachut, Batu Feringghi, Penang, Sabah, Selangor.

Updated on 10/05/05.
13 items, 10544 visits since 11/05/03.

www.andylim.com
D: andy lim
A: andy lim M: www.andylim.com

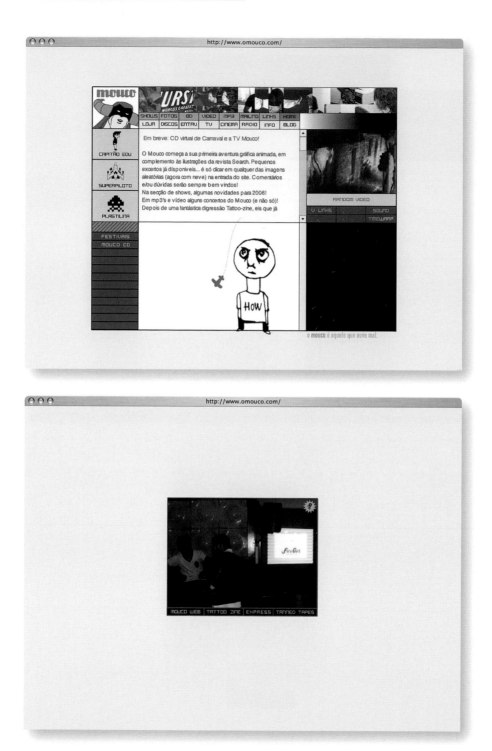

www.omouco.com
D: augusto lima
A: plastilina design M: plasti75@hotmail.com

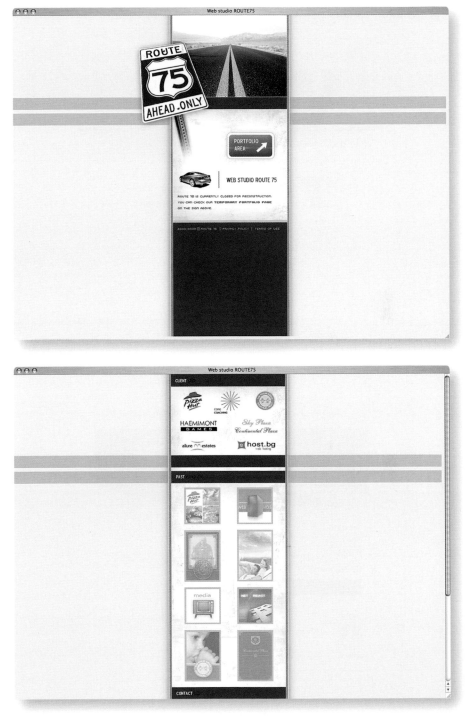

www.route75.com
D: hristo spasunin
A: route 75 M: info@route75.com

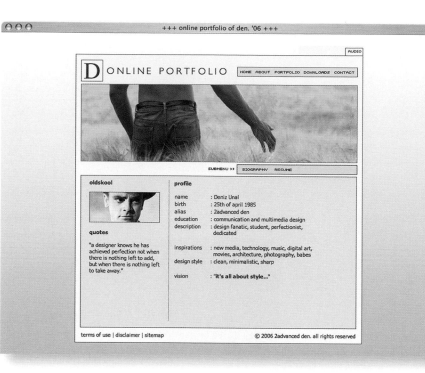

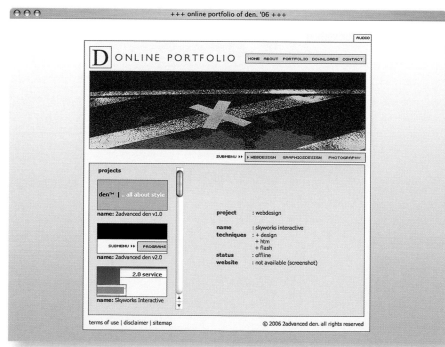

www.den-online.nl/home.htm

D: d. unal

M: mail@den-online.nl

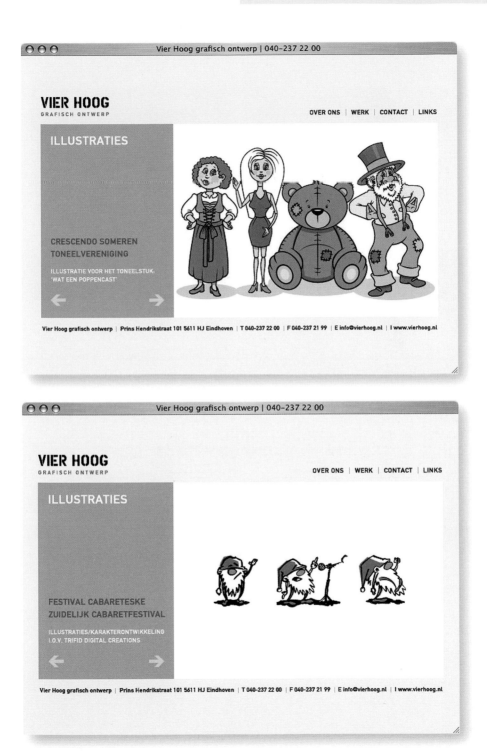

www.vierhoog.nl
D: chris van seggelen
A: vier hoog grafisch ontwerp M: www.vierhoog.nl

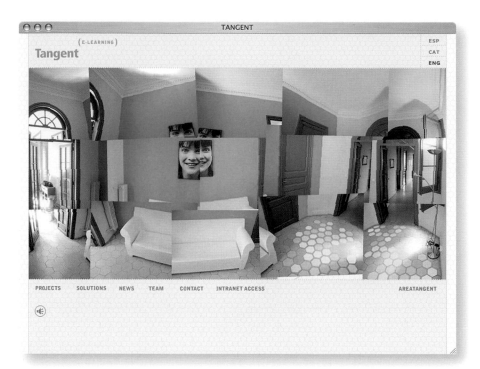

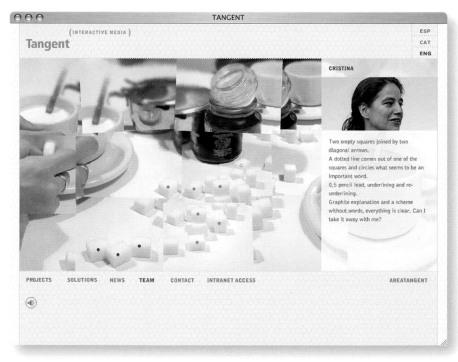

www.tangent.es

D: jorge ferrera C: raúl fernandez P: cristian cisa, josep mª marimon

A: tangent audiovisual M: info@tangent.es

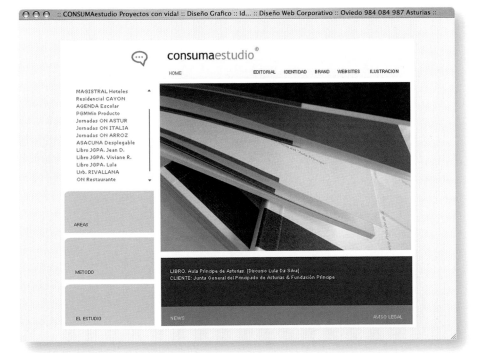

www.consumaestudio.com

D: frank pérez C: pablo rodríguez, angel garcía

A: consumaestudio® M: hola@consumaestudio.com

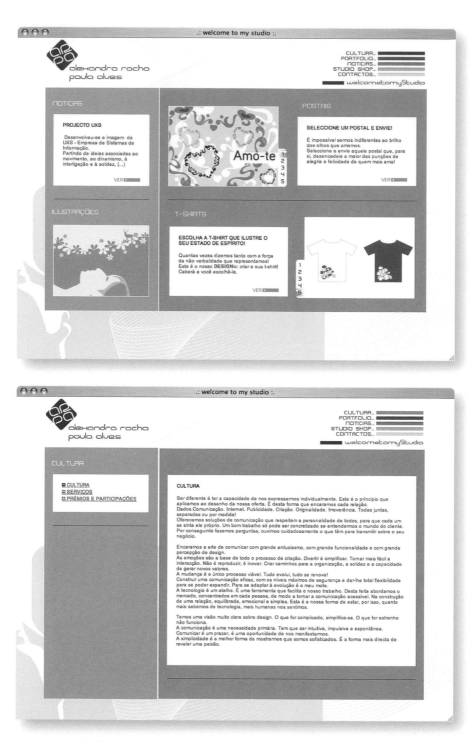

www.gotomystudio.com

D: alexandra rocha, paula alves **C:** alexandra rocha, susana teixeira, hélder ribeiro

M: geral@gotomystudio.com

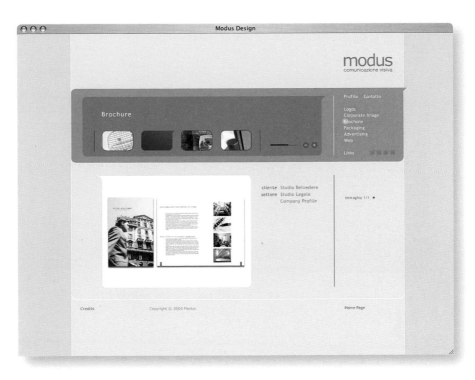

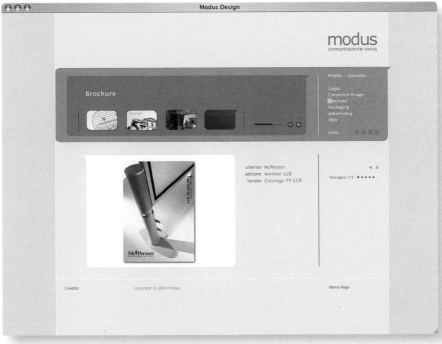

www.modus.it
D: cristina silva, luca basili C: alessandra tagliabue
A: modus comunicazione visiva, luca basili M: cristina@modus.it

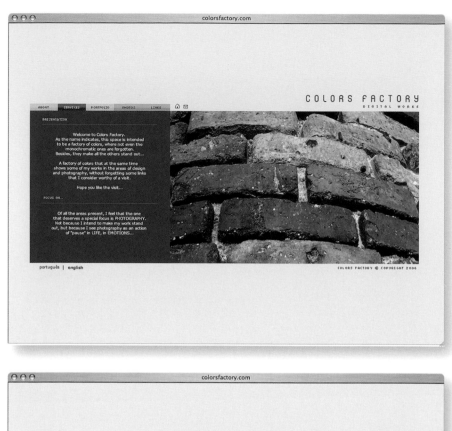

www.colorsfactory.com

D: ricardo ferreira

A: colors factory M: info@colorsfactory.com

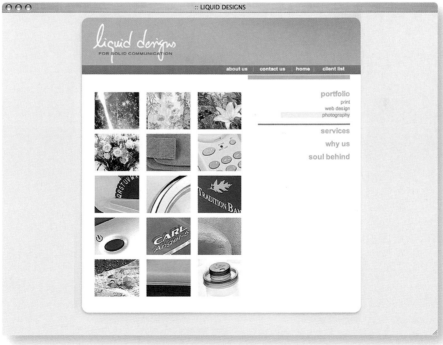

www.liquiddesignsindia.com
D: kushal grover
A: liquid designs india **M:** kushalgrover@gmail.com

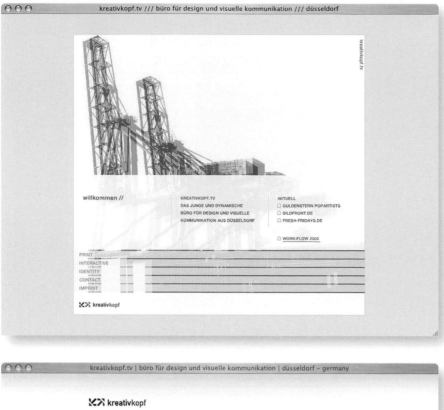

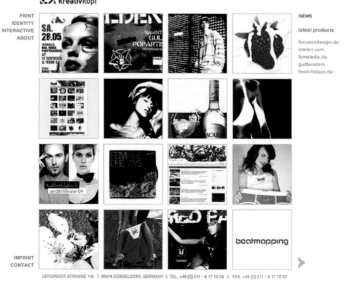

www.kreativkopf.tv

D: jan weiss

A: www.kreativkopf.tv **M:** j.weiss@kreativkopf.tv

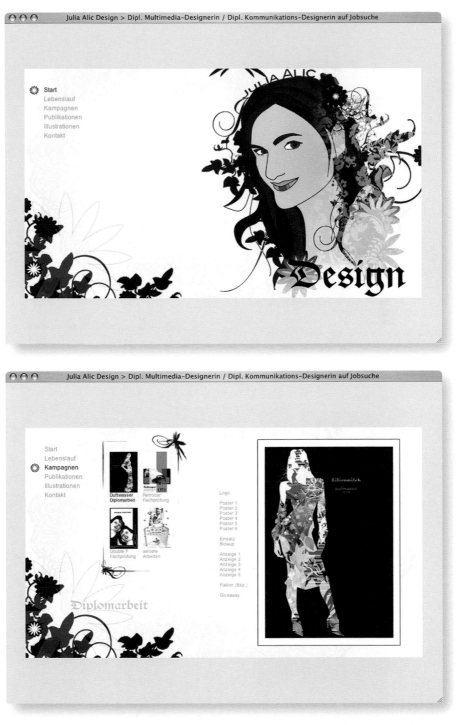

www.julia-alic-design.de

D: julia alic C: mark siepen P: julia alic

M: info@julia-alic-design.de

www.ar2design.com

D: arturo esparza

A: ar2design M: ar2@ar2design.com

www.djbfacilitair.nl

D: koos dekker

A: djbfacilitair M: koos@djbfacilitair.nl

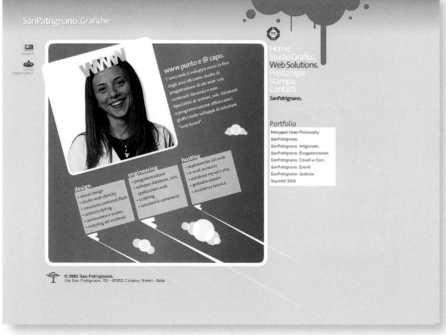

grafiche.sanpatrignano.org

D: andrea bianchi P: sanpatrignano. grafiche

A: sanpatrignano. grafiche M: andbia@gmail.com

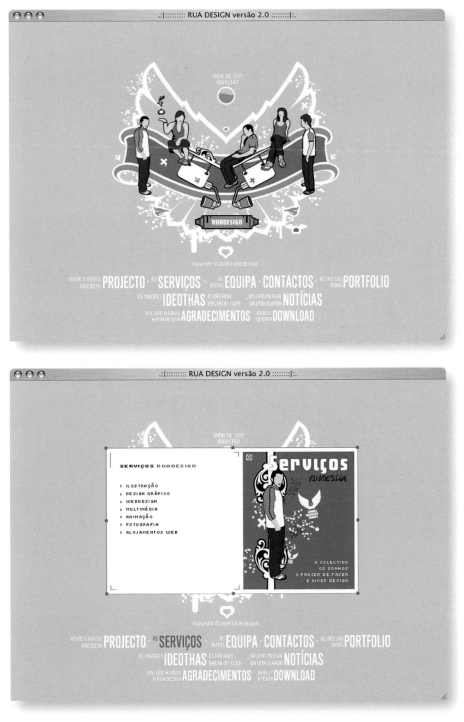

www.ruadesign.net

D: ruadesign

A: ruadesign　M: geral@ruadesign.net

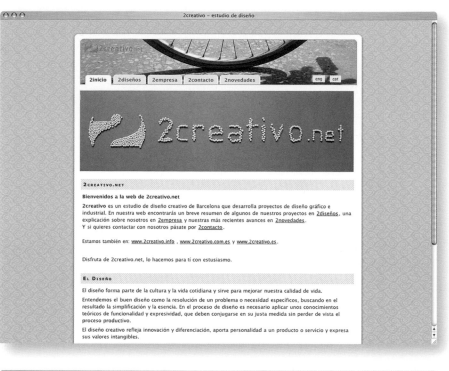

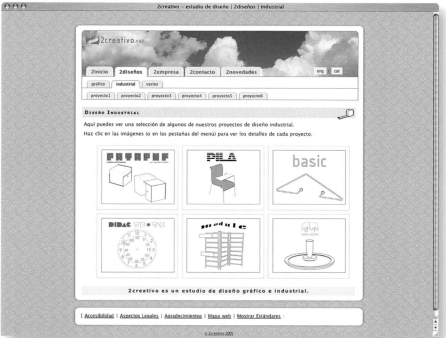

www.2creativo.net

D: 2creativo

A: 2creativo M: 2creativo@2creativo.net

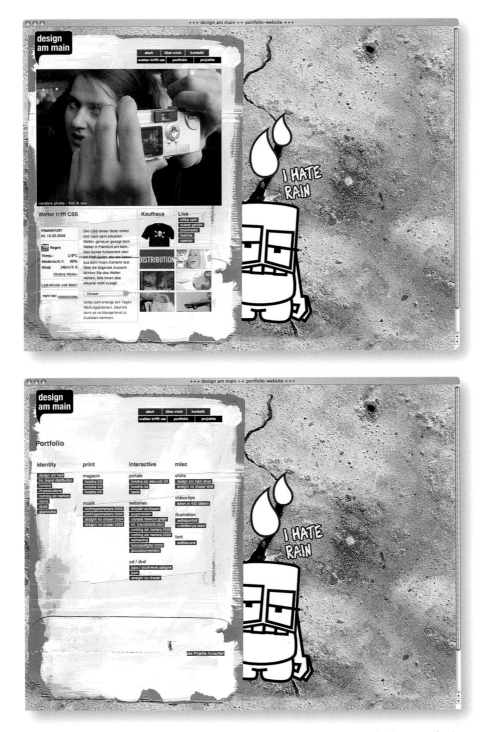

www.designammain.de
D: christian kunz
A: kolossaldigital.de M: ck@kolossaldigital.de

THIS WAY DESIGN

03

Cover photo: Kim Ramberhaug

This website features a selection of my work.

Some of the clients I've had the pleasure of working with include Telenor, Telia, Siemens, Tine, Hexans, St.Olaus Hospital, De Norske Bokdubbene, Egmont Serieforlaget, Filmtilsynet, Arthaus and Natt8Dag.

This Way Design
c/o Håvard Gjelseth
Stensgata 40b
0451 Oslo
Org: 981 885 236
Phone: +47 41 45 46 42

Thanx to: Almir Busevac for help with flash programming, Chris Pelsor for proofreading, and Ken Olling for inspiration.

Respect to my mentor
Tore Ulvik

RECENT WORK
SUPERMERCADO
ILLUSTRATION ETC.
PAGE 82

Supermercado started as an online project for artists from South Europe in April 2004. From 28th October to 6th November an exhibition was held in Oslo, Norway, and I did the promotion of the event, involving profile, poster, invitation and catalogue. Supermercado, meaning supermarket, I chose the shopping bag as the metaphor and object for the design. Also, I designed a logo for each of the artists, becoming a store within this supermarket.

CLICK, OR CLICK-DRAG CORNERS TO GO TO NEXT OR PREVIOUS PAGE
(you can also use your arrow keys)

THIS WAY DESIGN

One of Norway's best known schools of art and music, and the birthplace for bands such as Motorpsycho and production facility Stargate Studios. I did the profile and illustrations for both website and various print materials: a logo with a classic typeface and an energetic twist meets the photocopy-dada-style-illustrations in a happy marriage.

TRØNDERTUN
FOLKEHØGSKOLE

www.thiswaydesign.com
D: håvard gjelseth C: almir busevac P: håvard gjelseth
A: this way design M: hgjelseth@thiswaydesign.com

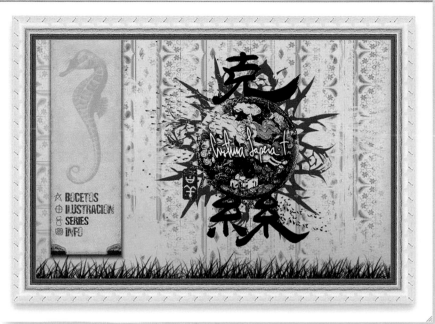

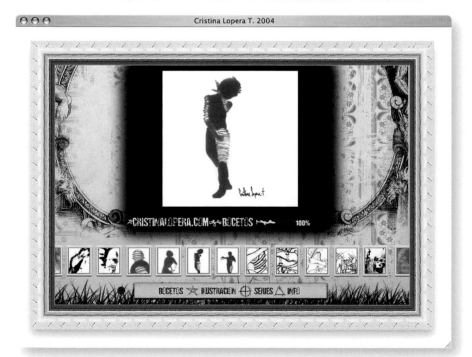

www.cristinalopera.com
D: ragde **C:** ragde **P:** cristina lopera
A: ragde.com **M:** info@ragde.com

www.dna-studio.biz

D: marco di natale

A: dna studio M: marco@dna-studio.biz

www.sirang.com

D: mo. arian

A: sirang rasaneh M: arian@sirang.net

www.visualbk.com.ar
D: blanca san miguel
A: visual_bk M: blancasm@visualbk.com.ar

www.wtf7.com
D: nemanja nenadic
A: graphicstyle M: www.graphicstyle.net

www.aoaovision.com

D: lin ao C: feng chen, lin ao P: nine-up studio

M: aoao@aoaovision.com

ARCHIVE.

Vanidad

EGOISTE PUBLICACIONES · FROM 2000 TO 2003

Illustration

DESCRIPTION
Press ad for LeBook, promotional tee-shirt design and illustrations for Vanidad, the trend magazine from Spain.

PROCESS
From the year 2000 to 2003, Sergio del Puerto was the magazine's art director. The original magazine layout was designed by Fernando Gutiérrez (Pentagram). Here is a selection of some interesting pieces that Sergio did for Vanidad. The photos for the LeBook ad were taken from an Erez Sabag's fashion editorial with stylist José Silva. The same concept was used for the promotional tee-shirt. For the magazine's 10th anniversary, a book was published with the best articles and images from the first ten years.

RELATED LINKS
www.vanidad.es

Press ad, tee-shirt details and the 10th anniversary book

Back to Top

Accelerated Music Culture

XLR8R MAGAZINE · 2004

Illustration

DESCRIPTION
Illustrations for the cover, index, and a Special Feature logo for the "Best of 2004" issue of San Francisco's electronic music magazine.

PROCESS
Every issue, XLR8R invites a different creative to contribute, filling the some sections of the magazine with his own style. This issue was the most important one of the year, so the illustrations should be so too. The magazine's readers voted for the best artist of the year, and chose Mathew Dear, so he was on the cover, in a very simple portrait. For the index, Serial Cut™ mixed several techniques: pencil drawings with pixels, Play-Doh® strings and stickers bought in a chinese shop in the centre of Madrid. The boom box, the walkman and the DAT were the main elements, with a nostalgic retro style.

RELATED LINKS
www.xlr8r.com
www.spectralsound.com

Pencil strokes for the index section

www.serialcut.com
D: sergio del puerto
A: serial cut™ M: info@serialcut.com

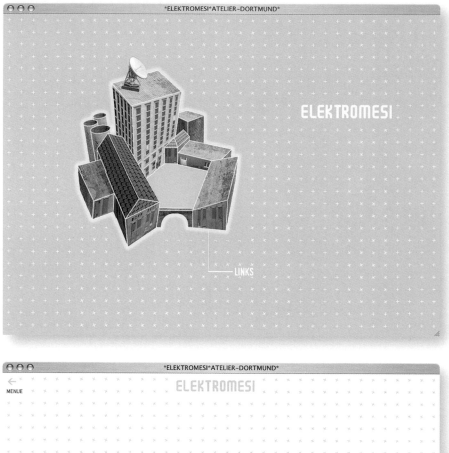

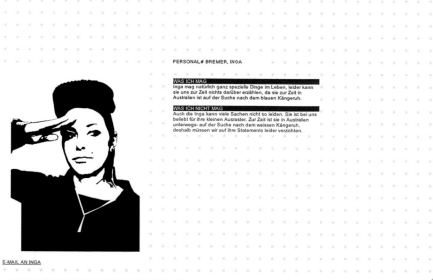

www.elektromesi.com
D: bruno bauch
M: post@elektromesi.com

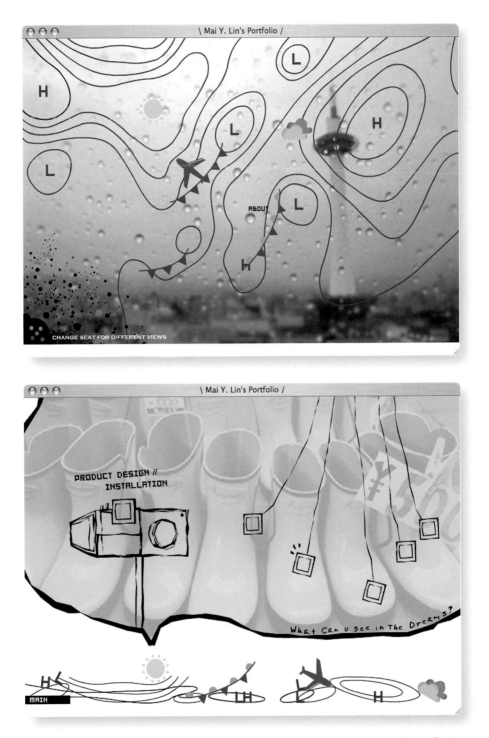

www.nevermai.com
D: mai yi-chun lin
M: maiylin@gmail.com

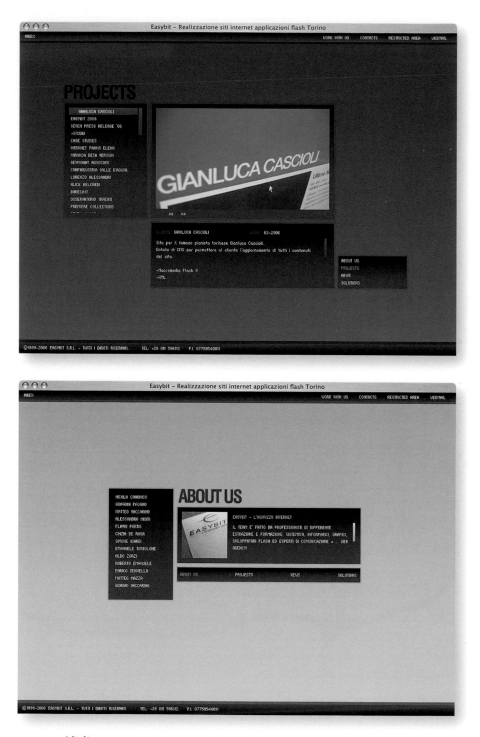

www.easybit.it

D: emanuele tortolone C: matteo vaccarino, aldo zorzi P: nicola canonico

A: easybit s.r.l M: marketing@easybit.it

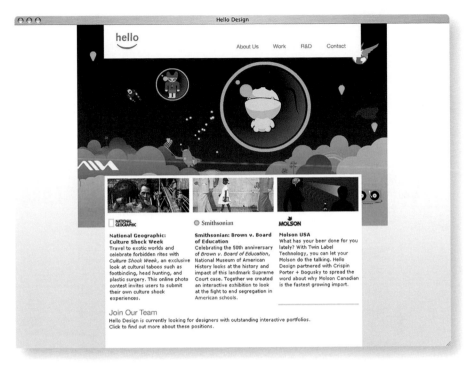

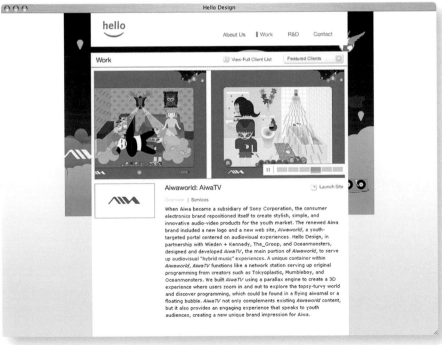

www.hellodesign.com

D: david lai, hiro niwa C: dan phiffer P: szu ann chen
A: hello design M: hello@hellodesign.com

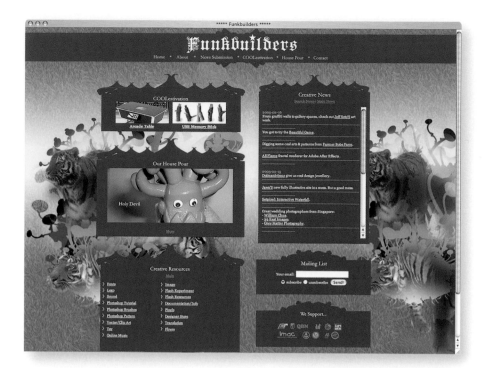

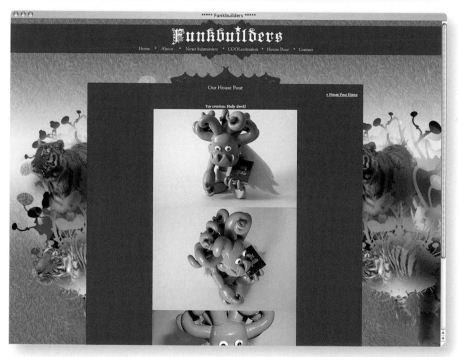

www.funkbuilders.com

D: alan

A: funkbuilders M: www.funkbuilders.com

www.romy-vizzini.be
D: romy vizzini
M: infn@romy-vizzini.be

www.hellohikimori.com

D: nathalie melato, david rondel cambou C: vincent legrand P: hki

A: hellohikimori M: incoming@hellohikimori.com

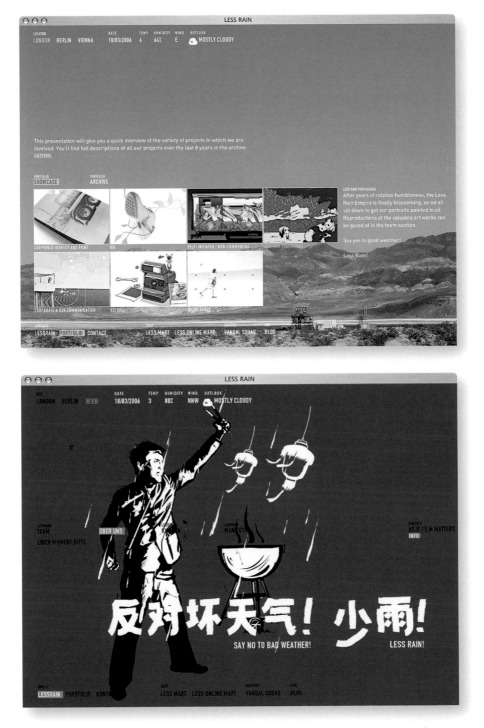

www.lessrain.com

D: less rain

A: less rain M: reception@lessrain.com

www.lalozambrano.com

D: lalo zambrano

M: www.lalozambrano.com

www.septime.net

D: nicolas combes, david polonia C: romain moussac P: ulysse lacombe
A: septime creation M: info@septime.net

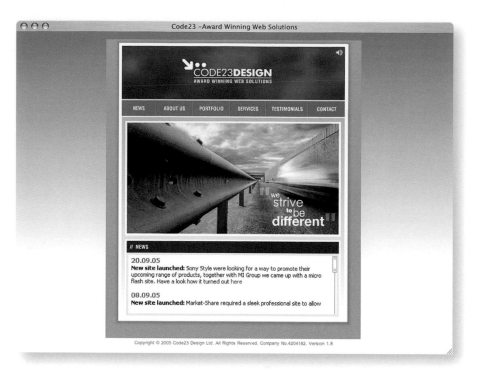

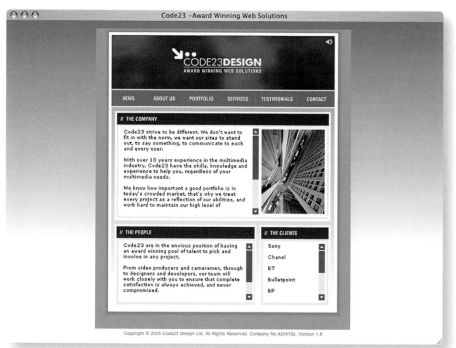

www.code23.com
D: james ansell
M: info@code23.com

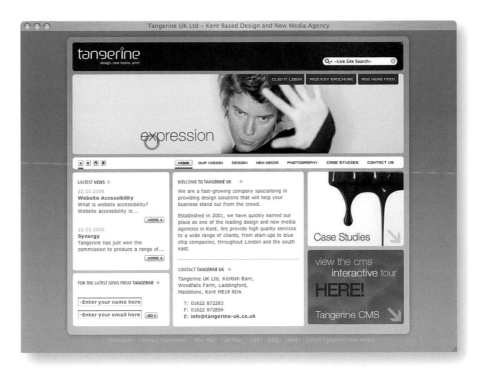

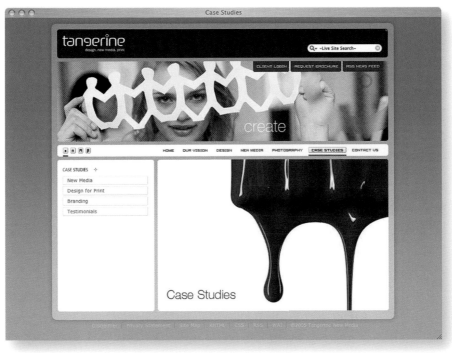

www.tangerine-uk.co.uk
D: andy vinnicombe C: andy vinnicombe P: tangerine uk ltd
A: tangerine uk ltd M: andy@tangerine-uk.co.uk

www.mohlberg.de

D: markus mohlberg

A: mohlberg.de **M:** markus@mohlberg.de

www.firegirl.co.pt
D: renato seixas C: nuno baldaia
A: firegirl M: info@firegirl.co.pt

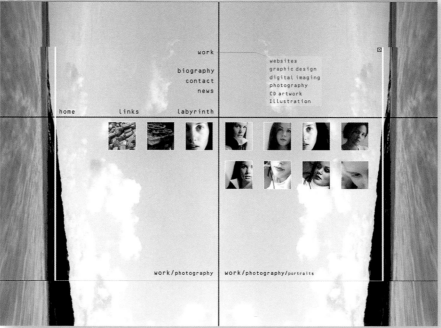

www.reddogproducts.com

D: simon van weelden

A: simon van weelden **M:** simon@projekt67.com

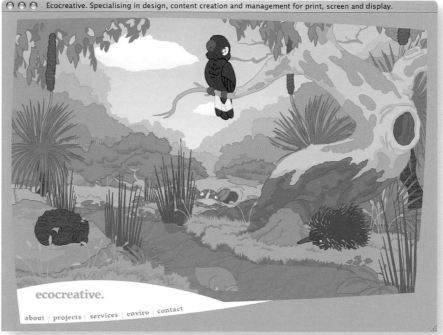

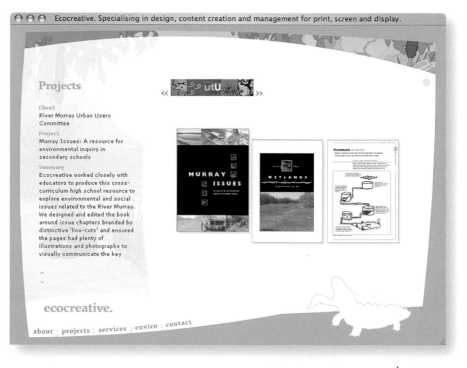

www.ecocreative.com.au/main.htm
D: robin green P: matthew wright-simon
A: ecocreative M: info@ecocreative.com.au

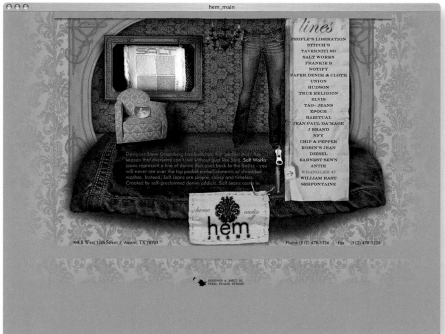

www.hemjeans.com

D: gary a. dorsey P: gary dorsey, kaysie dorsey

A: pixel peach studio M: info@pixelpeach.com

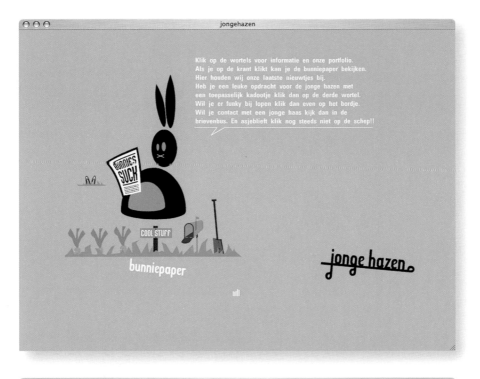

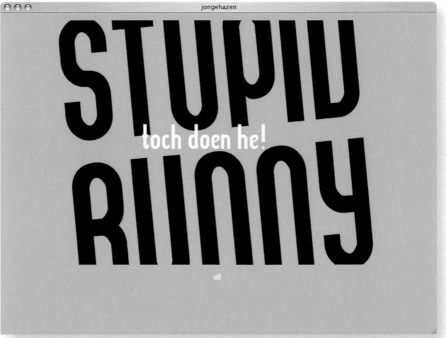

www.jongehazen.nl

D: de jongehazen C: quibuzz P: behappy

A: de jongehazen M: info@jongehazen.nl

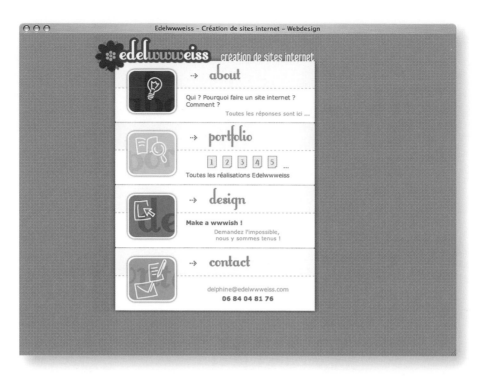

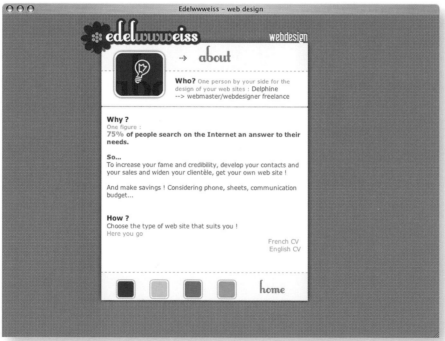

www.edelwwweiss.com

D: delphine pagès

A: edelwwweiss M: delphine@edelwwweiss.com

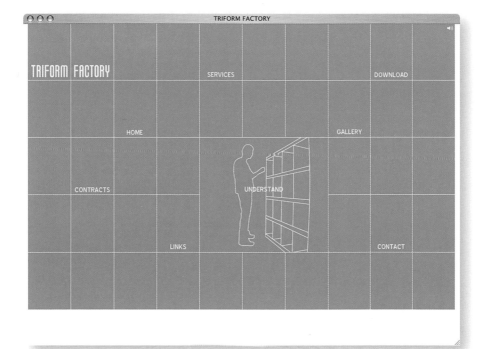

www.triform.sk
D: brano pepel C: brano pepel, rasto janko
A: kamikadze M: www.kamikadze.sk

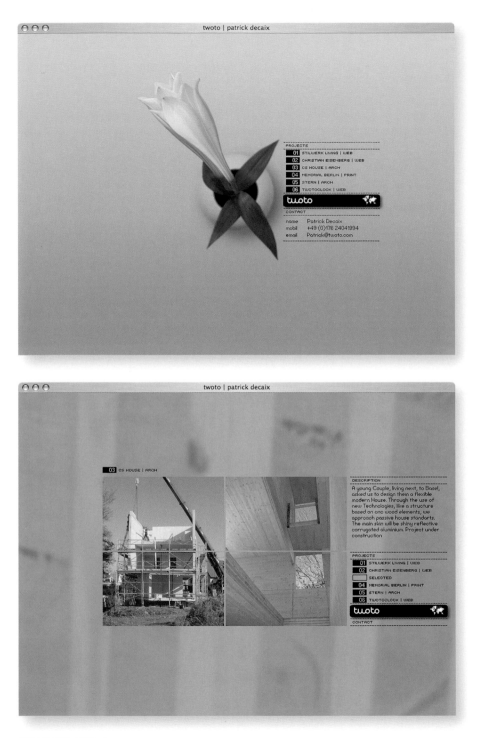

www.twoto.com
D: patrick decaix
A: www.twoto.com **M:** patrick@twoto.com

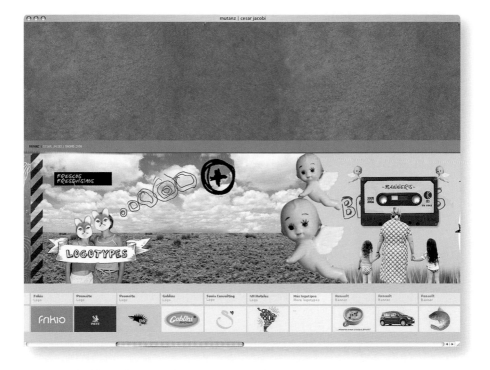

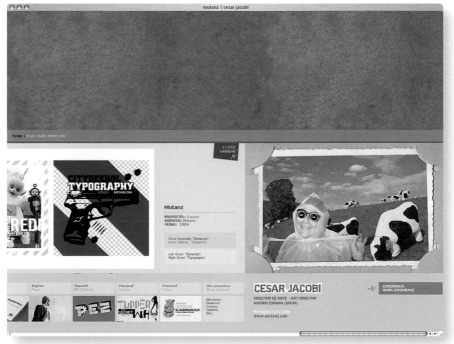

www.mutanz.com
D: cesar jacobi
M: jacobi@mutanz.com

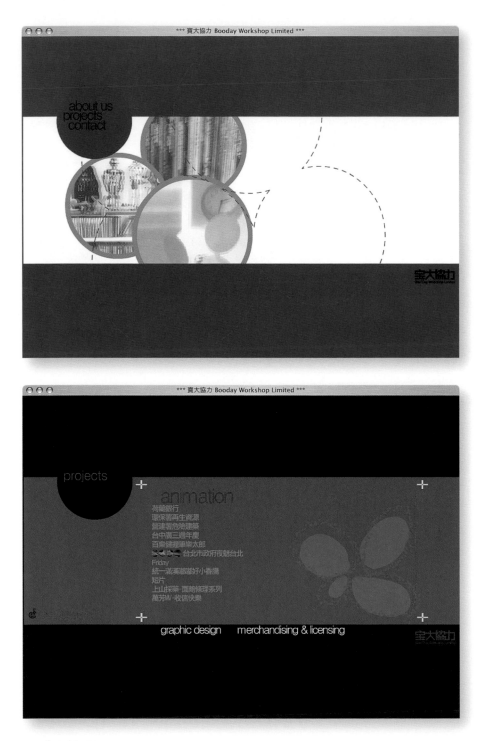

www.booday.com

D: mei-yu lee P: johnny chang

A: booday workshop limited M: johnny@mogu.com.tw

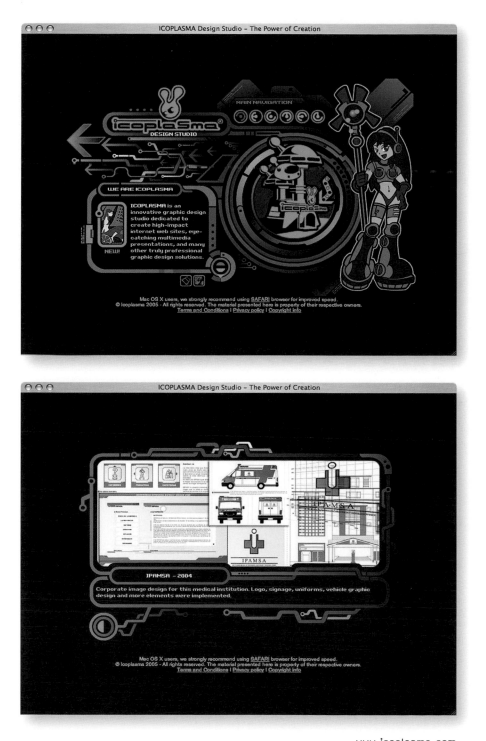

www.icoplasma.com

D: gerardo tato, jill lópez, alejandro tato C: gerardo tato P: gerardo tato
A: icoplasma design studio M: Info@icoplasma.com

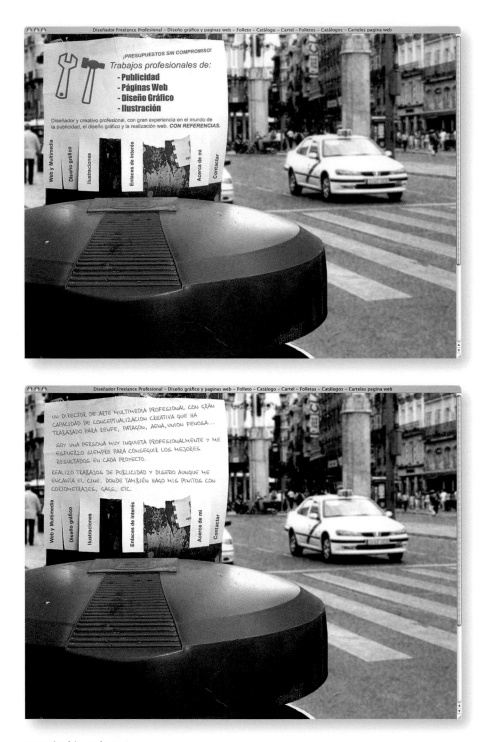

www.davidpareja.net
D: david pareja ruiz C: david pareja ruiz, miguel benitez, raul ledo
A: david pareja ruiz M: info@davidpareja.net

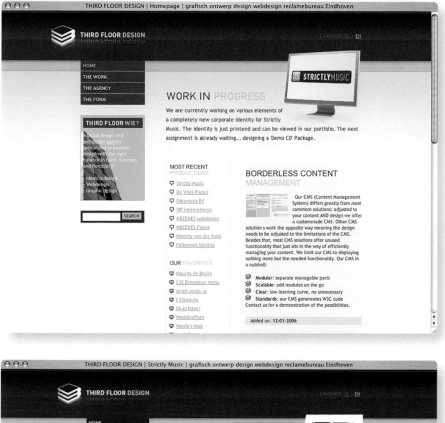

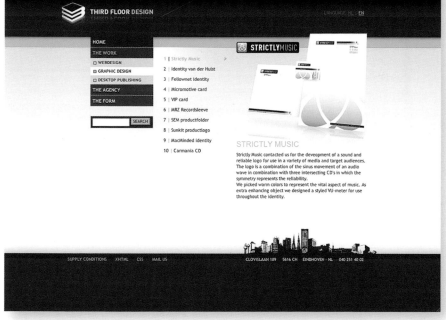

www.thirdfloordesign.nl

D: mark copal **C:** bob kersten

A: third floor design **M:** info@thirdfloordesign.nl

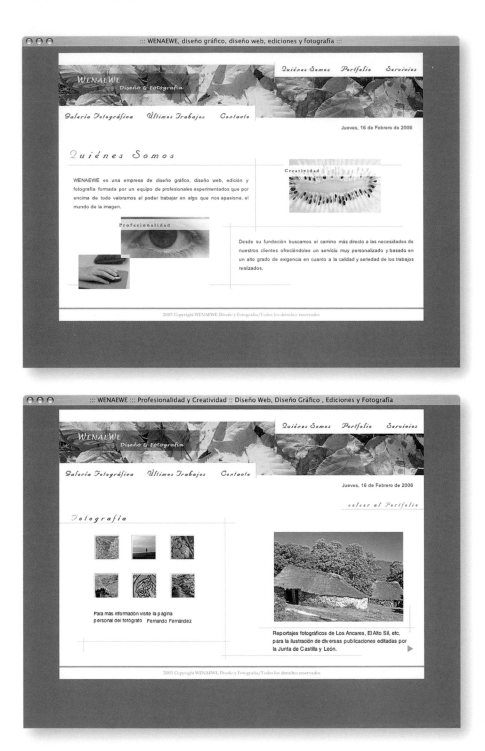

www.wenaewe.com

D: ef **C:** ef **P:** equipo wenaewe

A: wenaewe, diseño y fotografía **M:** dioxina2004@yahoo.es

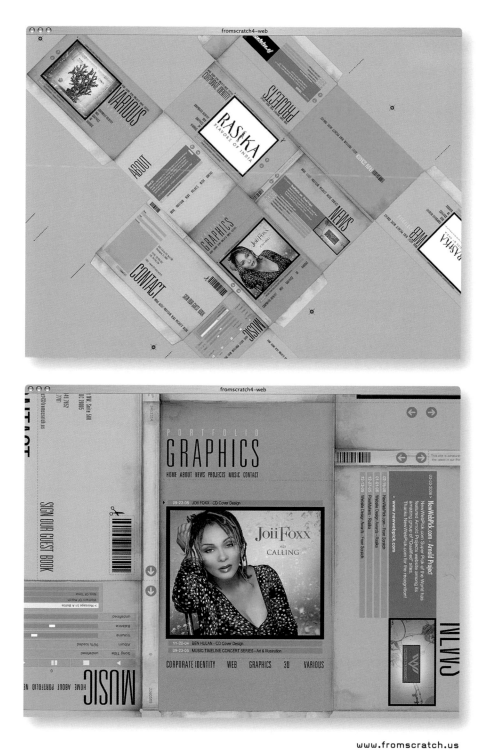

www.fromscratch.us

D: cristian strittmatter **C:** gabriel toledano **P:** sandra strittmatter

A: from scratch design studio **M:** contact@fromscratch.us

www.mediaboom.com
D: sean cooke **C:** sean cooke, frank depino **P:** frank depino
A: mediaboom **M:** www.mediaboom.com

www.bobscube.com
D: 15 letters
A: 15 letters M: www.15letters.com

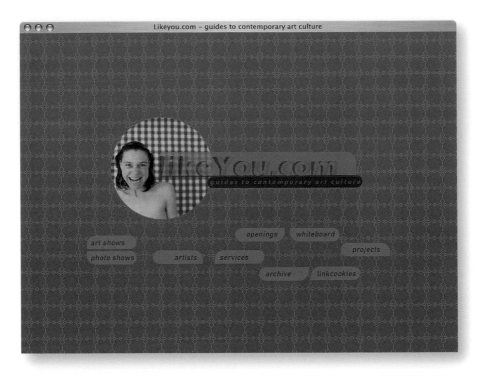

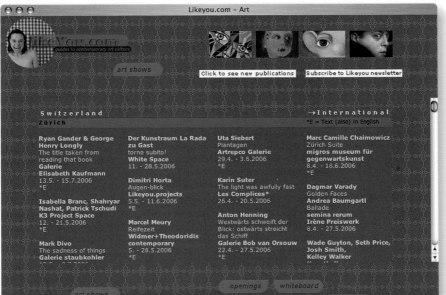

www.likeyou.com

D: centrik isler C: centrik isler, luc gross, hanna züllig P: centrik isler

A: the webfactory, cbc zurich M: www.likeyou.com

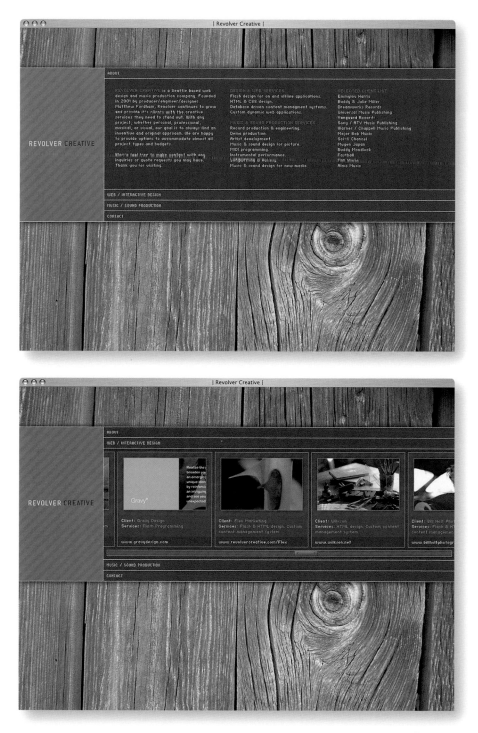

www.revolvercreative.com
D: matthew fordham
A: revolver creative M: www.revolvercreative.com

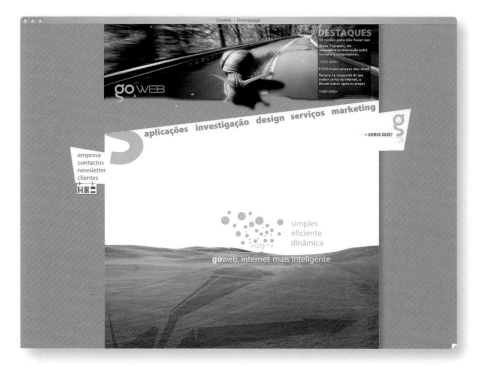

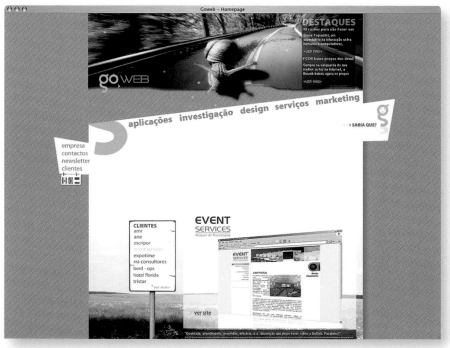

www.goweb.pt

D: peter steven C: helder vasconcelos P: josé fonseca, pedro ferreira

A: go web M: info@goweb.pt

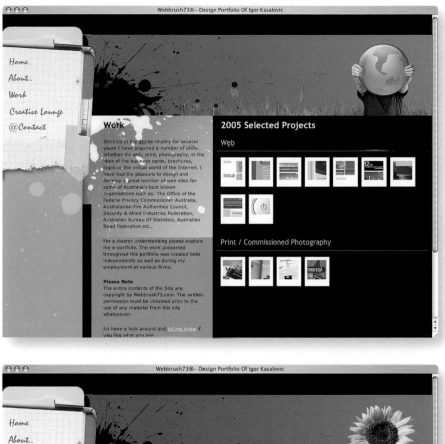

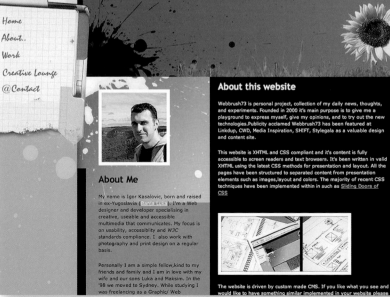

www.webbrush73.com
D: igor kasalovic
M: info@webbrush73.com

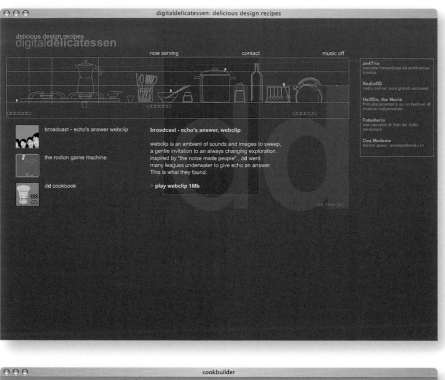

www.digitaldelicatessen.com

D: digitaldelicatessen

M: contact@digitaldelicatessen.com

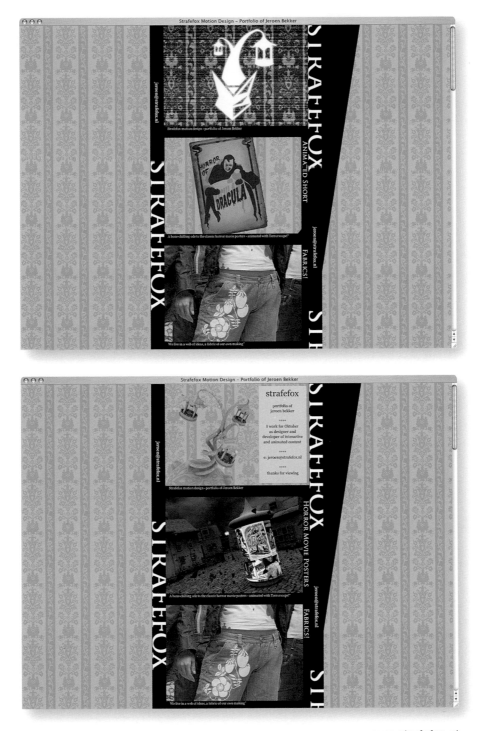

www.strafefox.nl
D: jeroen bekker
A: strafefox M: jeroen@strafefox.nl

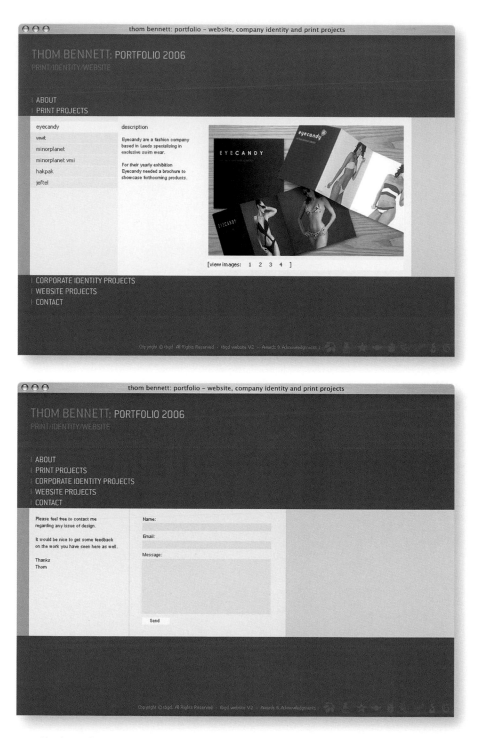

www.tbgd.co.uk

D: thom bennett

A: thom bennett graphic design **M:** info@tbgd.co.uk

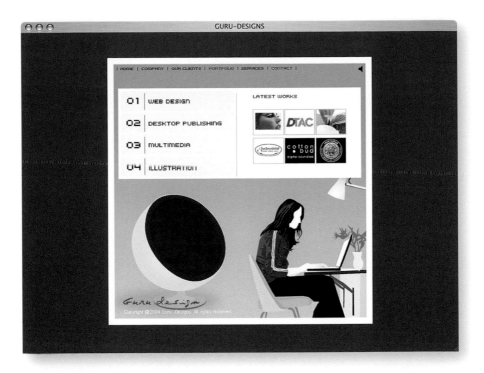

www.guru-designs.com
D: guru design
A: guru design **M:** info@guru-designs.com

www.digital-nature.com

D: juan francisco berbejal rovira C: carlos berbejal rovira P: data click sl

A: digital nature M: info@digital-nature.com

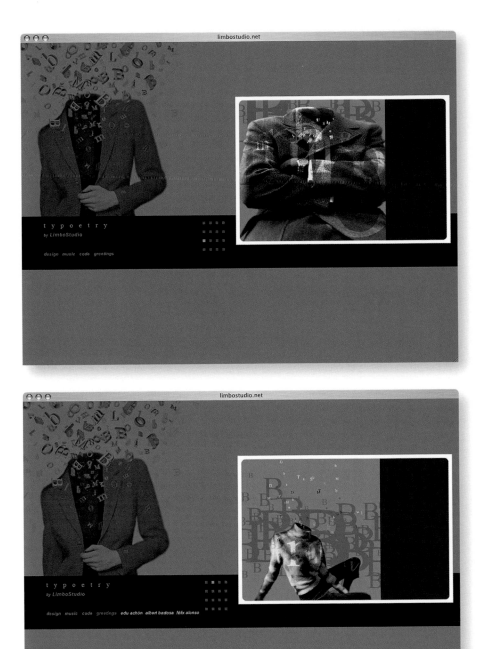

www.limbostudio.net
D: jordi carlos C: tecnoprog.com P: jordi carlos
A: limbostudio M: limbostudio@gmail.com

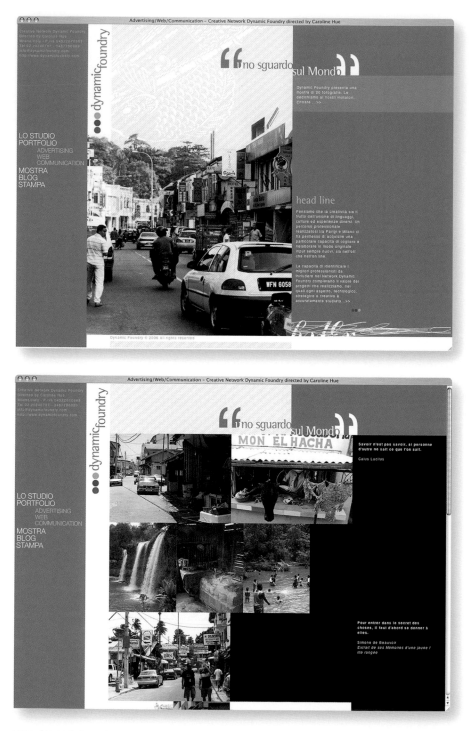

www.dynamicfoundry.com

D: caroline hue C: dynamic foundry staff P: dynamic foundry staff

A: dynamic foundry M: info@dynamicfoundry.com

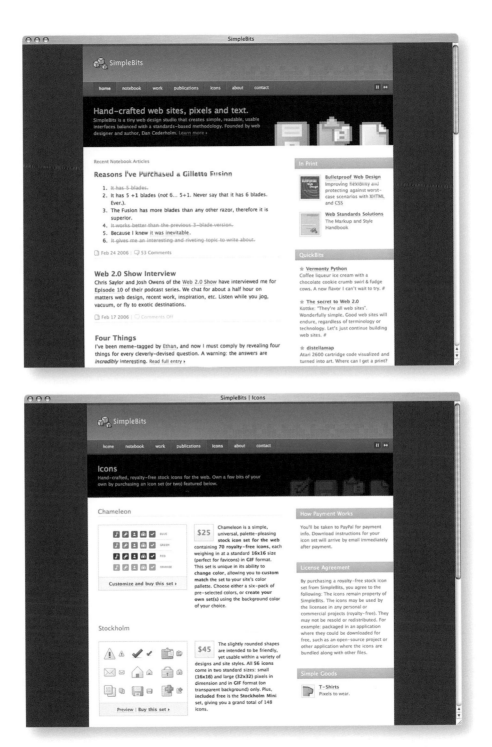

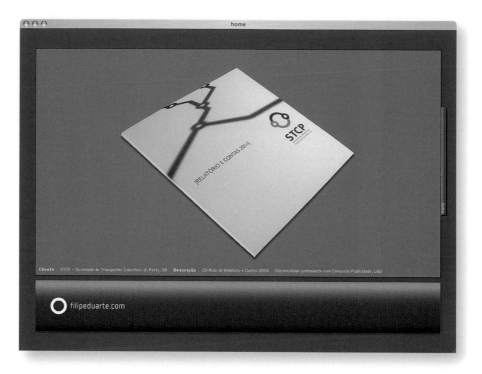

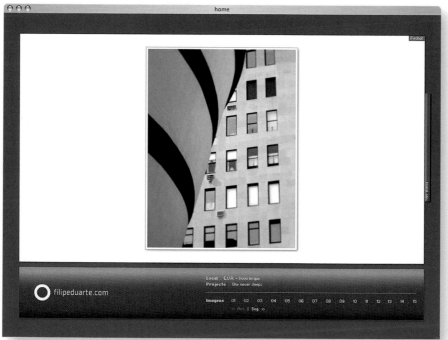

www.filipeduarte.com
D: filipe duarte
A: filipeduarte.com M: info@filipeduarte.com

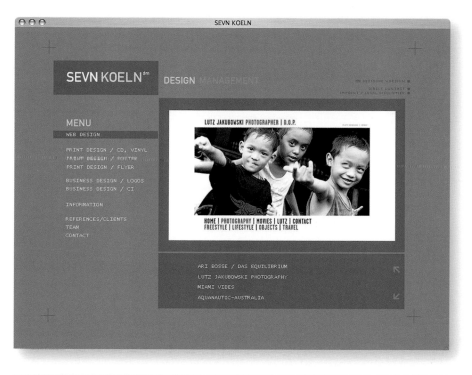

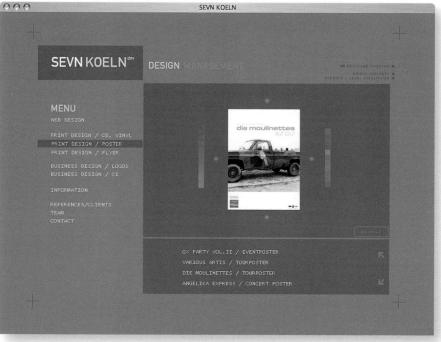

www.sevn.de
D: matthias klegraf C: christian spatz P: matthias klegraf
A: sevn koeln M: info@sevn.de

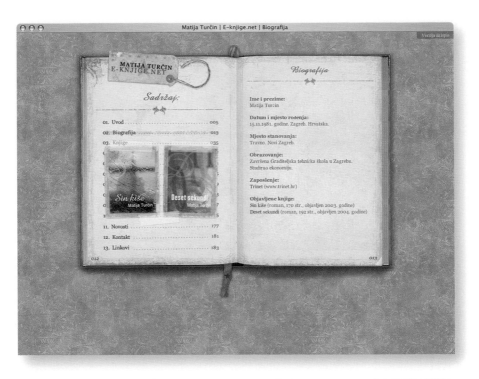

www.e-knjige.net
D: matija turcin
A: trinet M: info@trinet.hr

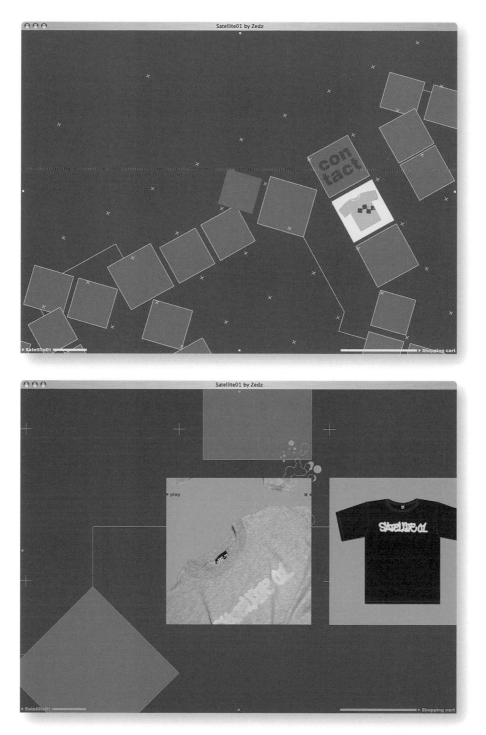

www.satellite01.com
D: ronald wisse
A: visualdata M: www.visualdata.org

www.agdesign.com
D: barry grimes **C:** patrick dennis **P:** barry grimes
A: agdesign company **M:** barryg@agdesign.com

www.manoiki.com
D: domenico manno
M: domenico@manoiki.com

www.k70vision.com

D: sven quandt

M: info@k70vision.com

www.thibaud.be
D: thibaud van vreckem
A: apricus M: thibaud@apricus.be

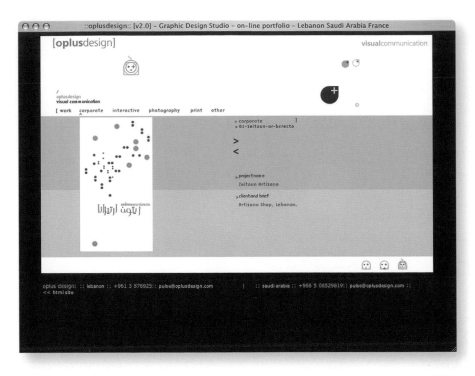

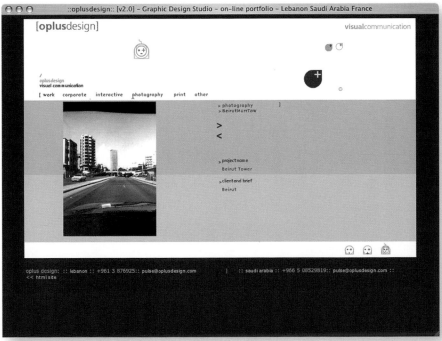

www.oplusdesign.com

D: samer lahoud, toufic tawil C: samer lahoud P: o plus design

A: oplus design M: pulse@oplusdesign.com

www.cedricvinet.com/site2/index.htm
D: cédric vinet
A: cédric vinet **M:** contact@cedricvinet.com

www.iso50.com
D: scott hansen C: dusty brown
A: iso50 M: scott@iso50.com

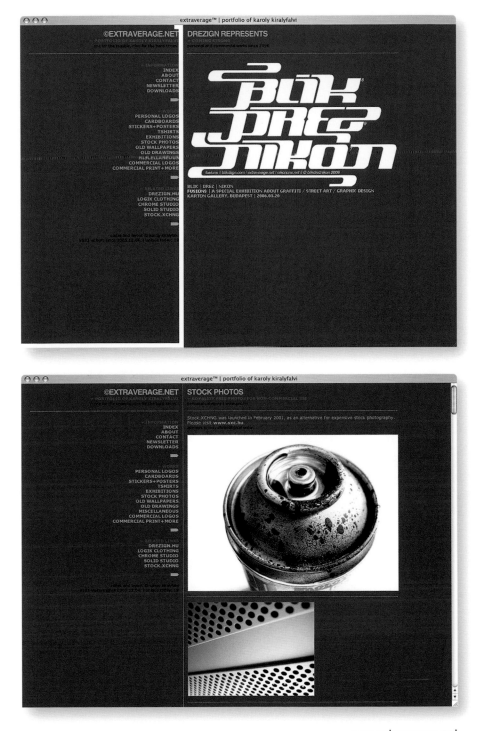

www.extraverage.net

D: karoly kiralyfalvi **C:** karoly kiralyfalvi **P:** drez

M: info@extraverage.net

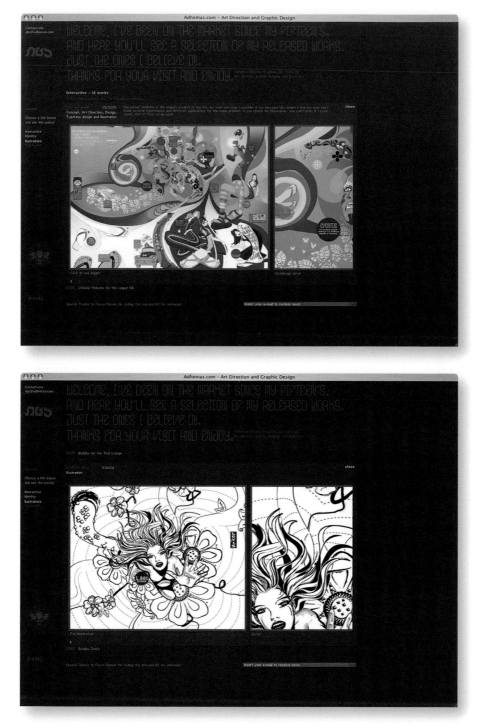

www.adhemas.com

D: adhemas batista **C:** flávio ramos **P:** adhemas batista

M: abs@adhemas.com

www.cubamoon.com

D: jimmy caravotas

A: cubamoon creative M: info@cubamoon.com

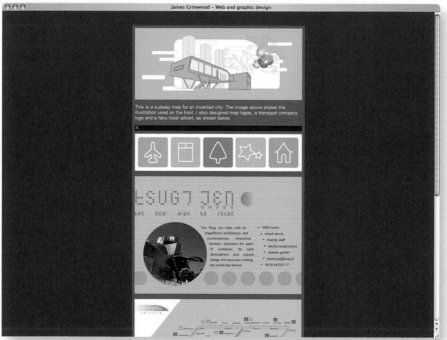

www.jamesgrimwood.co.uk

D: james grimwood

A: james grimwood M: james@jamesgrimwood.co.uk

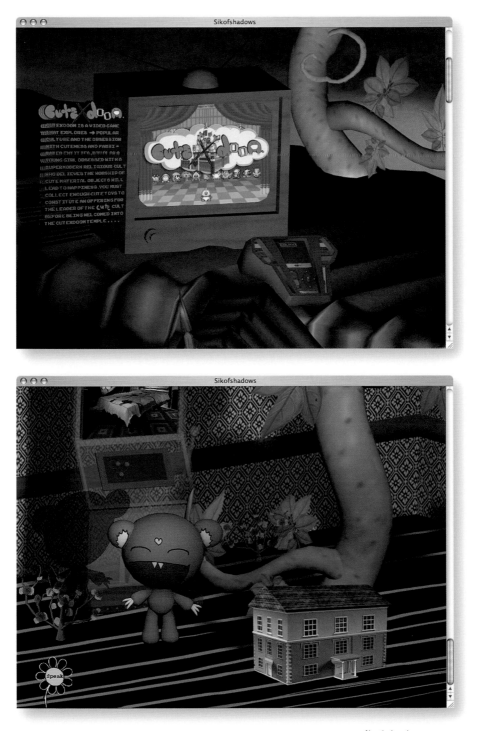

www.sikofshadows.com
D: anita fontaine
A: yumi-co M: ladybuggin@gmail.com

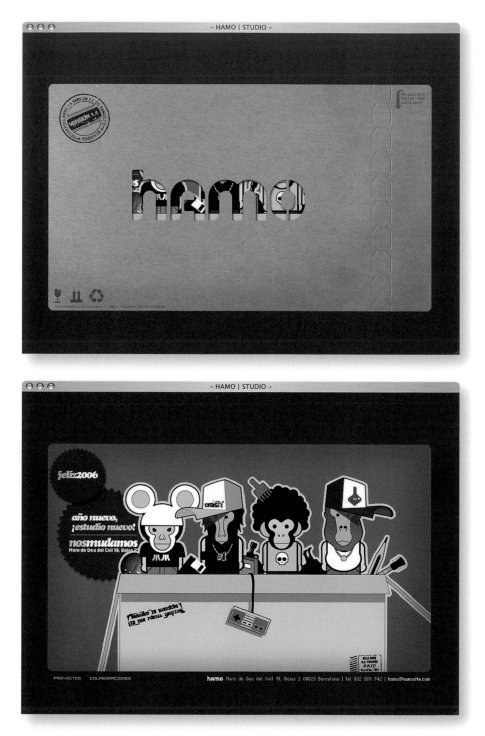

www.hamosite.com
D: pablo sánchez, lui villanueva C: ivan caño P: borja fusté
A: hamo studio M: hamo@hamosite.com

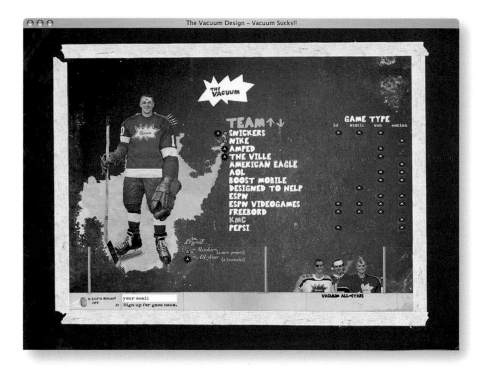

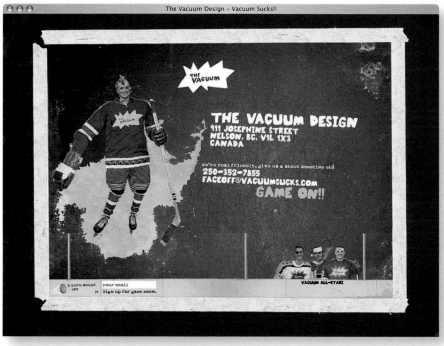

www.vacuumsucks.com
D: nate smith, tyler kealey C: kris mclaughlin P: team vacuum
A: the vacuum design M: faceoff@vacuumsucks.com

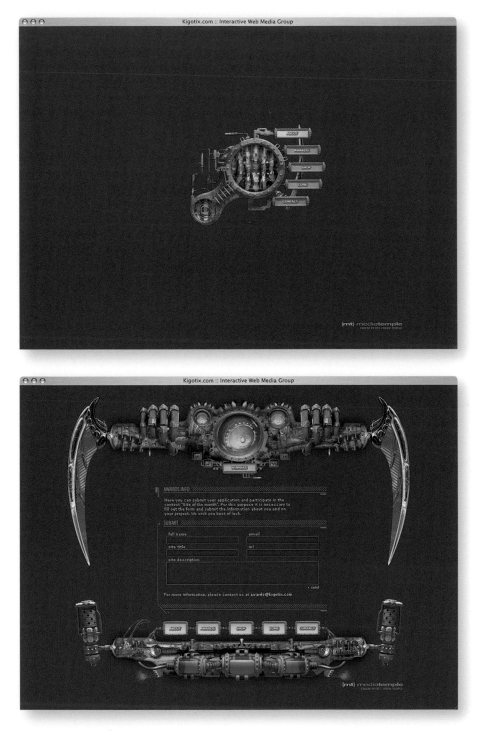

www.kigotix.com/kigotix
D: kuovoy roman C: jiganov artom P: kuovoy roman
A: kigotix M: info@kigotix.com

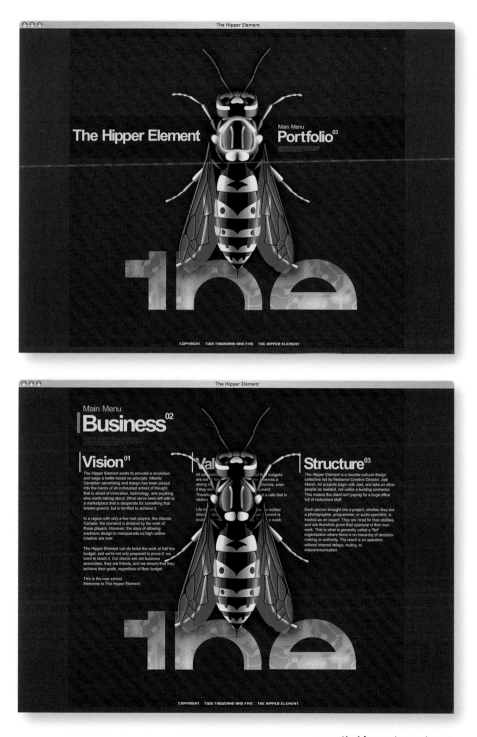

www.thehipperelement.com

D: joel marsh

A: the hipper element M: joel@thehipperelement.com

www.ilkilkilk.com
D: ilk
M: ilkone@gmail.com

www.nowaxx.com

D: fabrice corneux

A: fabrice corneux M: fabrice@nowaxx.com

miniwesterns.free.fr
D: élisa bottin
M: elisa.bottin@free.fr

www.drezign.hu
D: karoly kiralyfalvi **C:** karoly kiralyfalvi **P:** drez
M: hello@drezign.hu

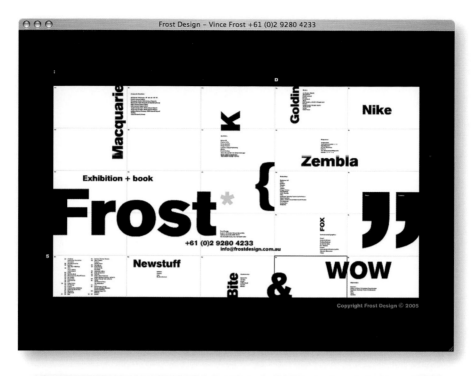

www.frostdesign.com.au
D: fred flade, vince frost
A: de-construct M: info@frostdesign.com.au

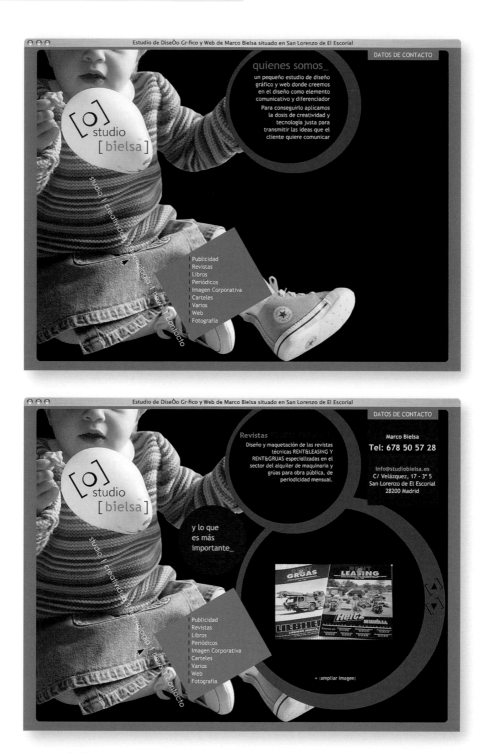

www.studiobielsa.es

D: marco bielsa

A: studiobielsa M: www.studiobielsa.es

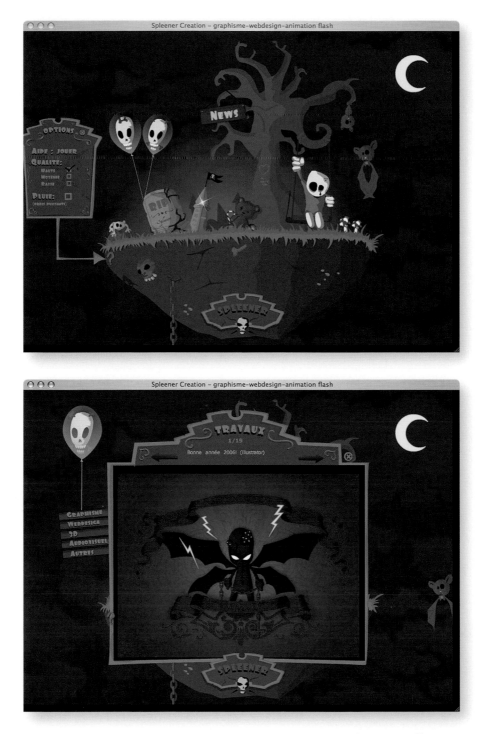

spleener-creation.com
D: richard tran
M: spleener-creation.com

www.chemicalbox.com

D: mario buholzer

A: chemicalbox M: bureau@chemicalbox.com

www.oringe.com

D: benjamin wong

A: oringe M: www.oringe.com

www.fubon.co.uk
D: constantine yarosh, anna yarosh
A: fubon M: info@fubon.co.uk

workrocks.com
D: workrocks
A: workrocks M: team@workrocks.com

www.lyo.com.br

D: leonardo rafael schneider

A: lyo design digital M: lyo@lyo.com.br

www.amberfly.com
D: peter barr C: douglas noble P: amberfly ltd
A: amberfly ltd M: enquiries@amberfly.com

www.pillows.ru
D: sergey golnikov
A: pillows M: psychopillow@mail.ru

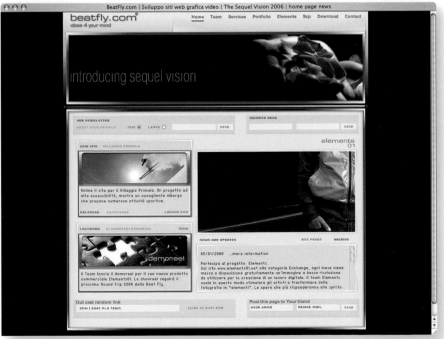

www.beatfly.com
D: patrizio C: macromedia studio P: macromedia
A: beat fly multimedia lab M: comunicazione@beatfly.com

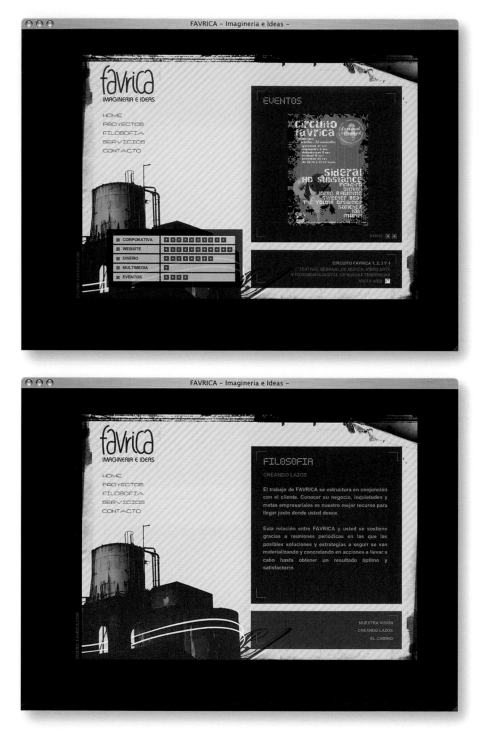

www.favrica.com

D: lydia gardón C: alex zuñiga P: fran martín

A: favrica imagineria e ideas M: info@favrica.com

www.septentrion-design.com

D: philippe delanghe C: guillaume garnier, arno roddier P: septentrion

A: macluhan's M: contact@macluhans.com

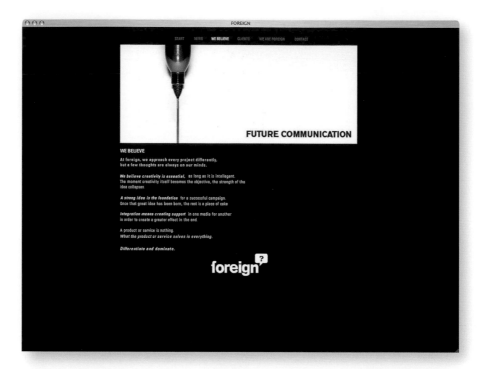

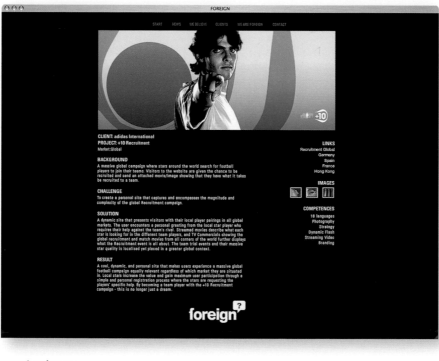

www.foreign.se
D: foreign
M: info@foreign.se

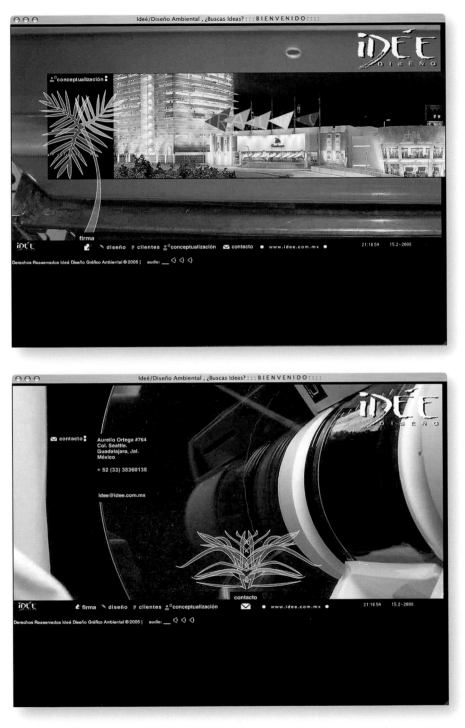

www.idee.com.mx

D: susana masso

A: susana masso M: smasso@idee.com.mx

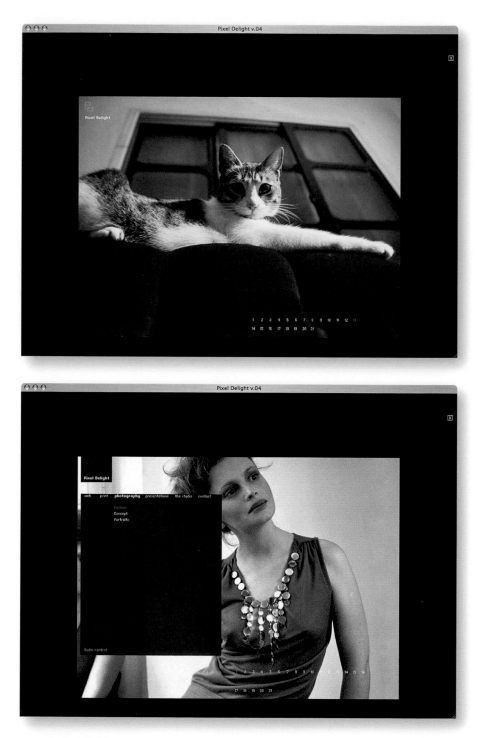

www.pixel-delight.com
D: sharon erlich, sabo diab C: sharon erlich P: sabo diab
A: pixel delight M: info@pixel-delight.com

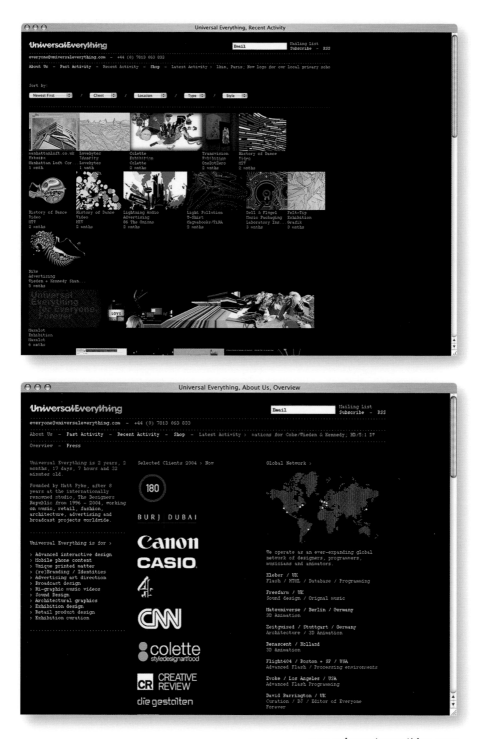

www.universaleverything.com
D: matt pyke C: kleber
A: universal everything M: www.universaleverything.com

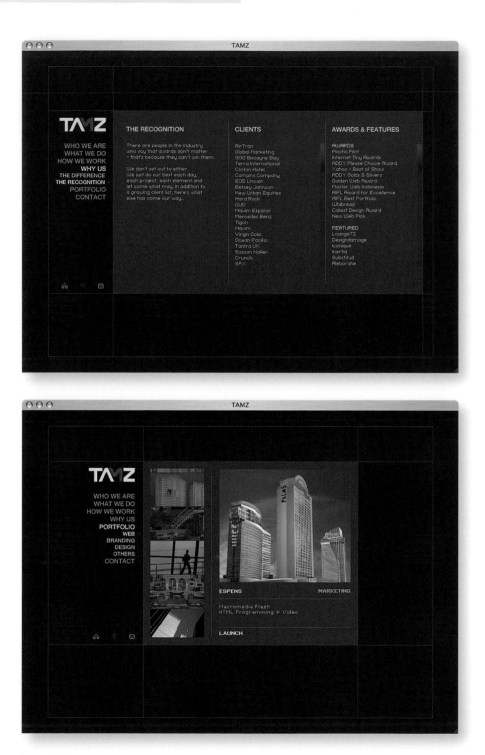

tamzdesigns.com

D: tamzdesigns

A: tamzil inc. M: mtamzil@tamzdesigns.com

www.crew11.net
D: crew11.net
A: hyper island M: rasmus.wangelin@hyperisland.se

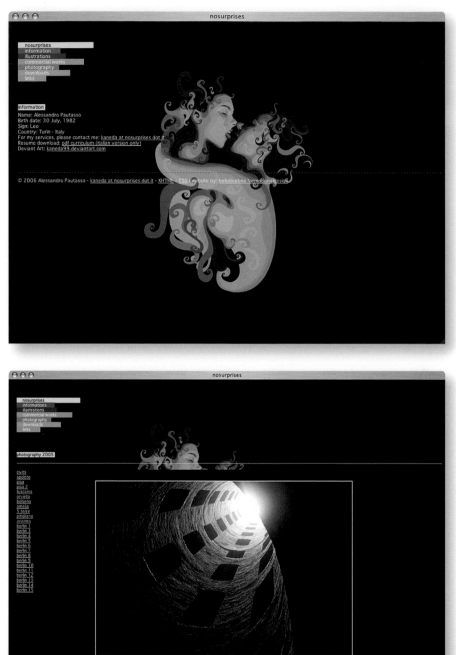

www.nosurprises.it

D: kaneda

A: nosurprises M: kaneda@nosurprises.it

www.32round.com
D: andy gugel
A: thirtytworound M: info@32round.com

www.merrylife.org

D: sarah buyó jolibert

A: sarah buyó jolibert M: sbj@tinet.org

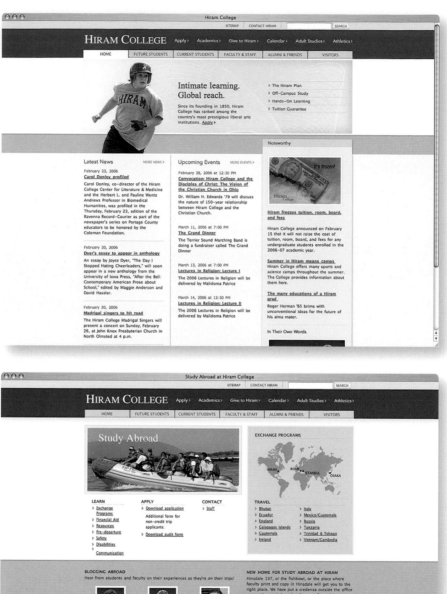

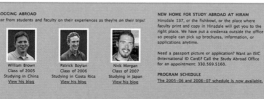

www.hiram.edu

D: cameron moll C: jonathan linczak

A: cameronmoll.com M: www.cameronmoll.com

ESPAÇO EVOE – o corpo das artes

ESPAÇOEVOÉ
O CORPO DAS ARTES

CURSO DE FORMAÇÃO DE ACTORES
[curso profissionalizante]

CURSOS
teatro
dança
consc. corporal

WORKSHOPS
programa sementes

WORKSHOPS
programaterra

ACTIVIDADES
aulas abertas
núcleo de investigação
dionisíacas
cabarés
evoé vai
conversas com Dionísio

EQUIPA

horários quero registar-me na maillinglist

EVOÉ é um grito de saudação a Dionísio, a Baco, a Évios, a Brómio, deus de muitos nomes, deus da dança, do teatro, do vinho, da fertilidade e das festividades corpóreas. É um grito de renascimento do deus nascido duas vezes. (...)

00 DESTAQUES
NOTÍCIAS

16-02-2006
21:36

Interpretação
Interdisciplinar
2ª, 4ª e 6ª
20h00 às 23h00

AGENDA EVOÉ

Workshop Pesquisa de Movimento/Aproximação à paisagem, com Ana Mira

Workshop de Clown, a comicidade do corpo, Ricardo Puccetti, de 1 a 5 de Abril

2º semestre - inscrições abertas para o curso

CONTACTOS/MAPA HORÁRIOS
R. das Canastras, nº 40 | 1100-112 Lisboa | T. 218880838 evoe@evoe.pt

Webdesign: César Augusto [caugusto@portugalmail.pt]

ESPAÇO EVOE – o corpo das artes

ESPAÇOEVOÉ
O CORPO DAS ARTES

CURSO DE FORMAÇÃO DE ACTORES
[curso profissionalizante]

CURSOS
teatro
dança
consc. corporal

WORKSHOPS
programa sementes

WORKSHOPS
programaterra

ACTIVIDADES
aulas abertas
núcleo de investigação
dionisíacas
cabarés
evoé vai
conversas com Dionísio

EQUIPA

horários quero registar-me na maillinglist

EVOÉ é um grito de saudação a Dionísio, a Baco, a Évios, a Brómio, deus de muitos nomes, deus da dança, do teatro, do vinho, da fertilidade e das festividades corpóreas. É um grito de renascimento do deus nascido duas vezes. (...)

02 CURSOS PROGRAMA RAÍZES
TEATRO

16-02-2006
21:36

Iniciação Teatral (turma 1) • Iniciação Teatral (turma 2) • Iniciação Teatral (turma 3) • Interpretação Int. I • Interpretação Int. II • Voz e Canto • Formação de Actores

Preparar, semear, plantar, criar raízes, bases sólidas para construção de projectos artísticos conscientes e consistente.O Programa Raízes é constituído por um conjunto de cursos nas áreas das artes performativas, que visam proporcionar aos jovens estudantes de teatro e dança uma formação abrangente e especializada, bem como oferece cursos de formação livre destinados a pessoas que procuram nas aulas de teatro, dança e consciência corporal um conhecimento

CONTACTOS/MAPA HORÁRIOS
R. das Canastras, nº 40 | 1100-112 Lisboa | T. 218880838 evoe@evoe.pt

Webdesign: César Augusto [caugusto@portugalmail.pt]

www.evoe.pt
D: césar augusto
M: caugusto@portugalmail.pt

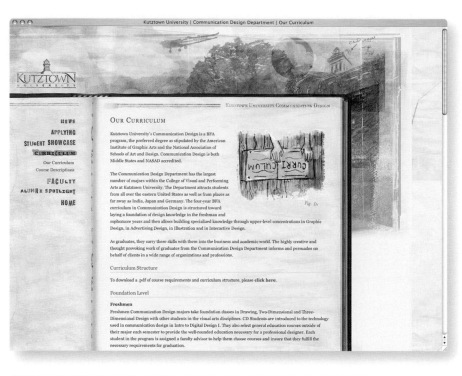

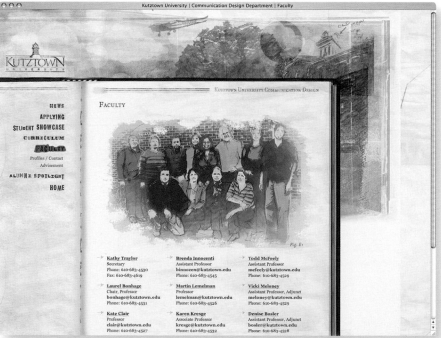

www.kutztown.edu/acad/commdes

D: scott reifsnyder C: michael mcaghon P: todd mcfeely

A: skybased, kutztown university communication design M: mcfeely@kutztown.edu

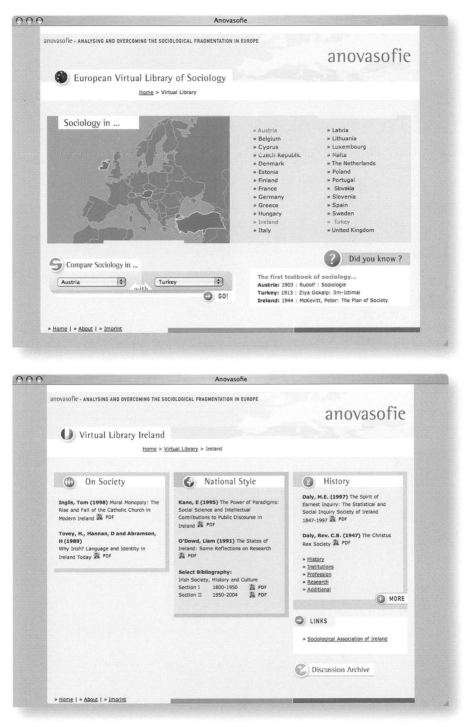

www.anovasofie.net/vl

D: chris poltensteiner C: philip wagner
A: wukonig.com M: joerg@wukonig.com

Architectural Association School of Architecture
Student Work

AA STUDENT BURSARIES & SCHOLARSHIPS

| About the AA | Programmes | Events | Resources | Members | Email |

Unit Websites

Projects Review

CODE ENGINES
CODE / INTERFACES

SUMMER SCHOOL

Intermediate Unit 3

Intermediate Unit 5

inter 7

Intermediate Unit 10

Diploma Unit 6

AA Dip9

contingencies: dip9+

EE ENVIRONMENT & ENERGY

AA D[R]L.net

EmTech

**Inter 10 Installation
Back Members' Room**
Images above and below.

Apply now for the AA Eden Scholarship
Members of the Eden Project Construction team have founded a new scholarship at the AA Graduate School, which will be worth £7,500 each year for five years. The scholarship will be awarded to one MA student from the UK specialising in research into sustainable environmental design (within the Environment & Energy Programme which lasts one year).

For more details on this and many other scholarships and bursaries for AA students click here or contact admissions@aaschool.ac.uk

The application deadline is 30 April

2006 Nicholas Boas Scholarship
This travel scholarship, established in memory of former AA student Nicholas Boas (1975-1998), allows AA students to spend three weeks in Rome from July 2006. The students are based at the British School at Rome, where generations of artists and scholars have researched the history, art and architecture of Italy. All expense for the trip are generously taken care of by the Nicholas Boas Trust and any currently registered student may apply by submitting a short written paragraph, stating why they wish to travel to Rome and what interest they intend to pursue whilst they are there.

The successful candidate is expected to produce a small body of work as a result of their visit – sketches, photographs, or the basis of a project.

The deadline for applications is 5.00 on Tuesday 2 May.

Stephen George Foundation
The Stephen George Foundation is awarded annually to a student in their final year of RIBA Part 1 and offers a £2,000 scholarship for study towards RIBA Part 2. In addition the Scholarship includes a placement at Stephen George and Partners in Leicester of up to eight weeks in the 'year out' and a further year of experience following the Diploma. Launched in memory of the founding partner of the practice, the Scholarship is open to all students of architecture studying in the UK.

To apply, contact
The Practice Manager,
Stephen George
Foundation,
170 London Road,
Leicester
LE2 1ND

or email m.strand@
stephengeorge.co.uk

Closing date for applications is Friday 28 April.

**MY CHAIR –
design competition**
'Even though the function

Architectural Association School of Architecture
News

| About the AA | Programmes | Events | Resources | Members | Email |

**Call for
Conference Papers
The Complexity of the
Ordinary – Context as
Key to Architectural
Strategies**
Thursday/Friday
5/6 October
Royal Academy
of Fine Arts
School of Architecture
Copenhagen
The conference theme is contemporary developments of strategies in contextual architecture, especially in the northern European and Scandinavian architecture. The keynote speakers of the conference and the session-chairs will be practising architect and theoreticians, including Tony Fretton (Tony Fretton Architects), Adam Caruso (Caruso St John), Quintus Miller (Miller & Maranta), Anne Lacaton (Lacaton & Vassal), Andreas Hild (Hild & K), Hohan Ciesing (Johan Celsing Arkitektkontor) and Wilfried Wang (Hoidn/Wang Architects). Please note that the deadline for abstracts in 7 April.

Go to karch.dk for further details.

**Open Competition: AA/ Environments,
Ecology and Sustainability Research
Cluster**
The Architectural Association and the Environments, Ecology and Sustainability Research Cluster together with supporting organisations are sponsoring an open one-stage international competition in search of innovative architectural methodologies and design-related research working towards an ever-evolving understanding of environments, ecology and sustainability. The aim of the competition is to locate new projects that consider the larger contextual issues of environmental change while formulating critical and informed responses. The competition welcomes submissions that absorb new design methods, tectonics, materials, spatial organisations, social structures, formal within their conceptual and proposed frameworks, and/or political parameters that engage with complex environmental and sustainable parameters.

See aaschool.ac.uk/clusters/ees.shtm

**Laser\net opens at
Dundee Contemporary Arts**
John Bell and Adam Covell from Diploma 9 working with Lorens Holm and Paul Guzzardo have installed Laser\net at DCA

Rapid advances in digital technology have been instrumental in changing our perception of subjectivity, and how we think about, and inhabit urban space. It has had an impact on sense of place and sense of self. Our content thus brings together several themes: the threat posed to digital technology and new media by recent rulings on intellectual

**BODYLINE
[E]ND OF OUR
[ME]CHANICAL
[S]TUDIES OF
[M]A UNIT 5
BRIEF AND
[COMM]ENTARY BY
[LEGEN]DRE**

**Bodyline
The End of our Meta-
Mechanical Body**
Edited by
George L-Legendre
Available at £10.00 from the Triangle Bookshop.

Also available to purchase online at AA Publications.

See also
aaschool.ac.uk/exhibitions
for details of
Teacher/Student exhibition.

**If you can't find it,
give us a ring**
public works' new publication from ixia & Article Press, If you can't find it, give us a ring is one of a new series titled New Thinking in Public Art:

www.aaschool.ac.uk

D: chris fenn **C:** chris fenn **P:** rosa ainley

A: architectural association publications **M:** webmaster@aaschool.ac.uk

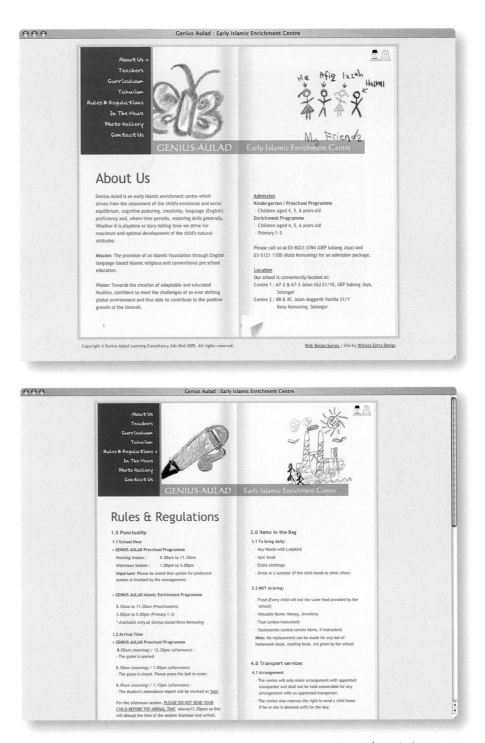

Genius Aulad : Early Islamic Enrichment Centre

About Us

Genius-Aulad is an early Islamic enrichment centre which strives from the attainment of the child's emotional and social equilibrium, cognitive posturing, creativity, language (English) proficiency and, where time permits, motoring skills generally. Whether it is playtime or story-telling time we strive for maximum and optimal development of the child's natural attitudes.

Mission: The provision of an Islamic foundation through English language-based Islamic religious and conventional pre school education.

Vision: Towards the creation of adaptable and educated Muslims, confident to meet the challenges of an ever shifting global environment and thus able to contribute to the positive growth of the Ummah.

Admission
Kindergarten / Preschool Programme
- Children aged 4, 5, 6 years old
Enrichment Programme
- Children aged 4, 5, 6 years old
- Primary 1-3

Please call us at 03-8023 3784 (UEP Subang Jaya) and 03-5121 1100 (Kota Kemuning) for an admission package.

Location
Our school is conveniently located at:
Centre 1 : 67-2 & 67-3 Jalan USJ 21/10, UEP Subang Jaya, Selangor
Centre 2 : 8B & 8C Jalan Anggerik Vanilla 31/Y Kota Kemuning, Selangor

Web Design Survey | Site by Wahaza Extra Design

Genius Aulad : Early Islamic Enrichment Centre

Rules & Regulations

1.0 Punctuality

1.1 School Hour
- **GENIUS AULAD Preschool Programme**
 Morning Session : 8.30am to 11.30am
 Afternoon Session : 1.00pm to 4.00pm
 Important: Please be noted that option for preferred session is finalised by the management.

- **GENIUS AULAD Islamic Enrichment Programme**
 8.30am to 11.30am (Preschoolers)
 3.00pm to 5.00pm (Primary 1-3)
 * Available only at Genius Aulad Kota Kemuning

1.2 Arrival Time
- **GENIUS AULAD Preschool Programme**
 8.00am (morning) / 12.30pm (afternoon) :
 - The gates is opened

 8.30am (morning) / 1.00pm (afternoon):
 - The gates is closed. Please press the bell to enter.

 8.45am (morning) / 1.15pm (afternoon) :
 - The student's attendance report will be marked as 'late'.

 For the afternoon session, PLEASE DO NOT SEND YOUR CHILD BEFORE THE ARRIVAL TIME above(12.30pm) as this will disrupt the flow of the session dismissal and arrival.

3.0 Items in the Bag

3.1 To bring daily:
- Key Words with Ladybird
- Iqra' book
- Extra clothings
- Drink in a tumbler (if the child needs to drink often)

3.2 NOT to bring:
- Food (Every child will eat the same food provided by the school)
- Valuable items: Money, Jewellery
- Toys (unless instructed)
- Stationeries (unless certain items, if instructed)
Note: No replacement can be made for any lost of homework book, reading book, ect given by the school.

4.0 Transport services

4.1 Arrangement
- The centre will only make arrangement with appointed transporter and shall not be held answerable for any arrangement with un appointed transporter.
- The centre also reserves the right to send a child home if he or she is deemed unfit for the day.

www.geniusaulad.com.my
D: mohd hisham saleh C: roby P: ian h. chris
A: wahaza extra design studio M: hisham@wahazaextra.com

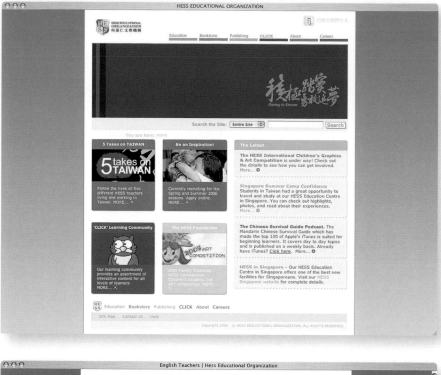

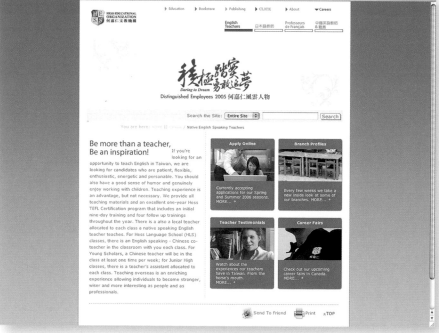

www.hess.com.tw

D: jason lee C: tony liu P: james li

A: hess educational organization M: jamesli@hess.com.tw

About
Classes
Questions
Testimonials
Contact
Enroll Now!

The
Acting
Room

PROFESSIONAL ACTOR TRAINING PROGRAM
Join us in our Fall PROFESSIONAL ACTOR TRAINING CLASS! This is an ongoing, weekly three hour class on Monday nights at the Hollywood UMC, from 7 pm to 10:00 pm. These classes are for working actors only, age mature 16 to adult. We focus on each actor's individual levels and talents so feel free to join us if you're already a trained actor working in the industry or in the early stages of your career. Most of our students are full-time working actors, but we do permit a few beginners if talented.

We DO allow and recommend ONE FREE AUDIT. Students will be admitted by the instructor only after the initial audit. We want you to feel happy with your choice before you join us, and we'd like to get to know you better too.

These ongoing classes are small, and usually range from between 5 -15 students.

Page 1 of 3

Last Page Next Page

© Copyright 2004 Options

About
Classes
Questions
Testimonials
Contact
Enroll Now!

The
Acting
Room

Thank you for your interest in joining The Acting Room. Please let us know who you are and which class you would like to take. Feel free to email us or call us and we will contact you shortly. We look forward to talking with you!

Your Last Name
Your Email Address
Your Address
Your City
Your State Your Zip
Your Phone Number
Your Age

■ Weekly Professional Ongoing
 Acting Class (Monday Nights)
 - $200/month

☐ Spring Acting Program - TBA
☐ Summer Acting Program - TBA

Any Comments?

Submit

© Copyright 2004 Options

theactingroom.com
D: ozzy benn
A: toxic design M: ozzy@toxicdesign.com

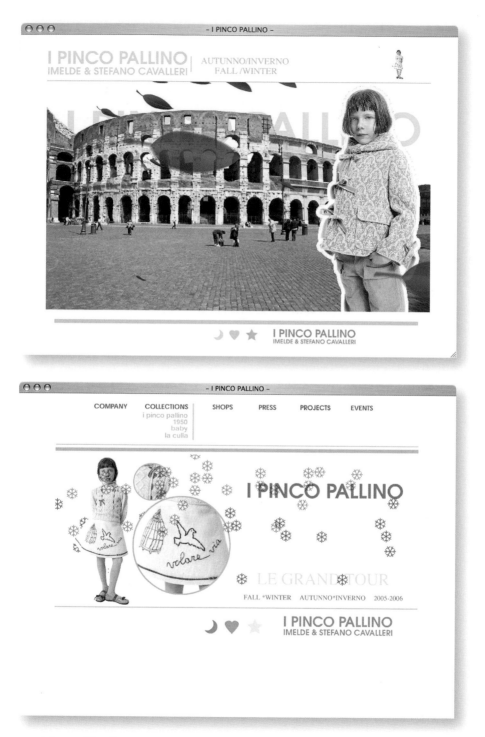

www.ipincopallino.it

D: giacomo cavalleri **C:** micro-studio **P:** giacomo cavalleri
A: micro-studio **M:** g.cavalleri@micro-studio.it

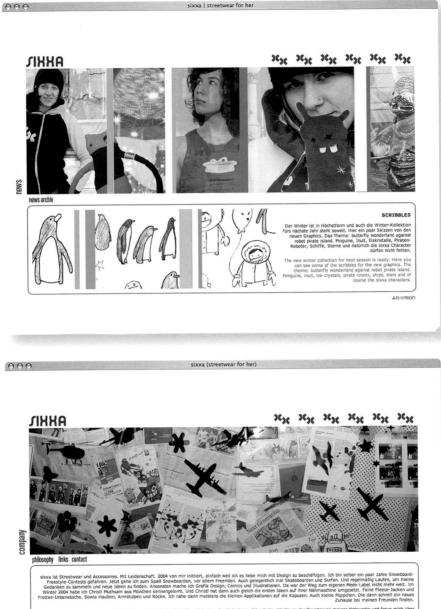

SIXXA

sixxa | streetwear for her

news

news archiv

SCRIBBLES

Der Winter ist in Höchstform und auch die Winter-Kollektion fürs nächste Jahr steht soweit. Hier ein paar Skizzen von den neuen Graphics. Das Thema: butterfly wonderland against robot pirate island. Pinguine, Inuit, Eiskristalle, Piraten-Roboter, Schiffe, Sterne und natürlich die sixxa Character dürfen nicht fehlen.

The new winter collection for next season is ready. Here you can see some of the scribbles for the new graphics. The theme: butterfly wonderland against robot pirate island. Penguins, inuit, ice-crystals, pirate robots, ships, stars and of course the sixxa characters.

Δ.D:VISION

sixxa (streetwear for her)

SIXXA

company

philosophy links contact

sixxa ist Streetwear und Accessoires. Mit Leidenschaft. 2004 von mir initiiert, einfach weil ich es liebe mich mit Design zu beschäftigen. Ich bin selber ein paar Jahre Snowboard-Freestyle-Contests gefahren. Jetzt gehe ich zum Spaß Snowboarden, vor allem Freeriden. Auch gelegentlich mal Skateboarden und Surfen. Und regelmäßig Laufen, um meine Gedanken zu sammeln und neue Ideen zu finden. Ansonsten mache ich Grafik Design, Comics und Illustrationen. Da war der Weg zum eigenen Mode-Label nicht mehr weit. Im Winter 2004 habe ich Christl Muthsam aus München kennengelernt. Und Christl hat dann auch gleich die ersten Ideen auf ihrer Nähmaschine umgesetzt. Feine Fleece-Jacken und im Frottee-Unterwäsche. Sowie Hauben, Armstulpen und Röcke. Ich nähe dann meistens die kleinen Applikationen auf die Kapuzen. Auch kleine Püppchen. Die dann schnell ein neues Zuhause bei meinen Freunden finden.

Für mich ist sixxa mehr als nur ein Label. Mir taugt der direkte Kontakt und Austausch mit Anderen. Ich arbeite ständig an der Erweiterung meines Netzwerks und freue mich über Kooperationen mit anderen Brands. So werdet ihr in der Linksammlung auch andere Streetwear-Labels finden, die ich selber gut finde bzw. kaufe, oder mit denen ich sogar zusammenarbeite.

love your passion, Kathi

Δ.D:VISION

sixxa.at

D: kathi macheiner C: mac krebernik P: lilo krebernik
A: d:vision visual communication gmbh M: studio@dvsn.at

meg.pl
D: michal juszczyk
A: laflaf.net **M:** www.cwalineczka.prv.pl

www.sudways.com

D: susanna ciacci

A: usolab design M: info@uso-lab.it

www.salsajeans.com

D: mourylise heymer C: simão vidinha P: joão ramos

A: redicom M: www.redicom.pt

www.comentrigo.com
D: dani martí
A: palmerita M: www.palmerita.com

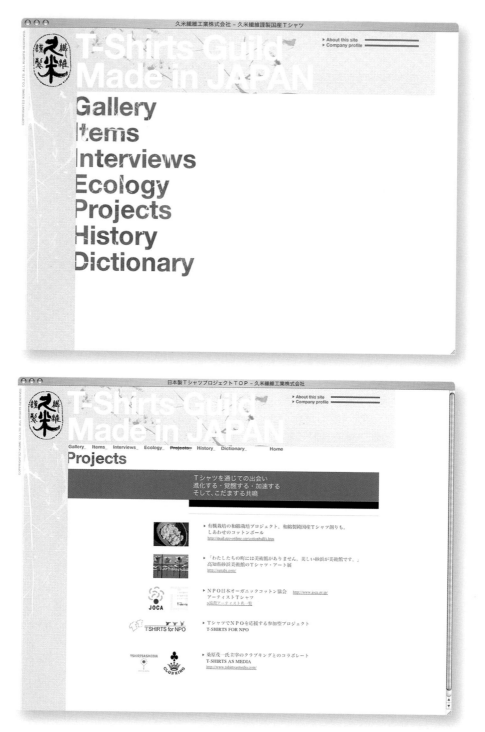

kume.jp

D: takayuki sugihara P: hiroyasu kume

A: roughark interaktiv M: www.roughark.com

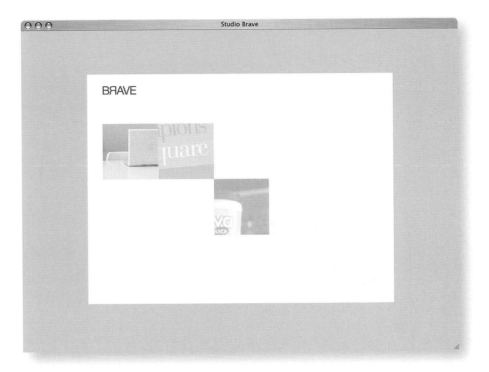

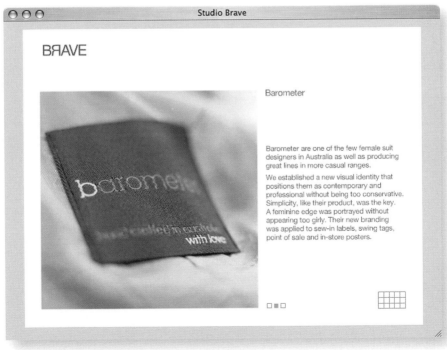

Barometer

Barometer are one of the few female suit
designers in Australia as well as producing
great lines in more casual ranges.

We established a new visual identity that
positions them as contemporary and
professional without being too conservative.
Simplicity, like their product, was the key.
A feminine edge was portrayed without
appearing too girly. Their new branding
was applied to sew-in labels, swing tags,
point of sale and in-store posters.

www.studiobrave.com.au
D: tim sutherland **C:** daniel fisher **P:** propagate
A: studio brave **M:** info@studiobrave.com.au

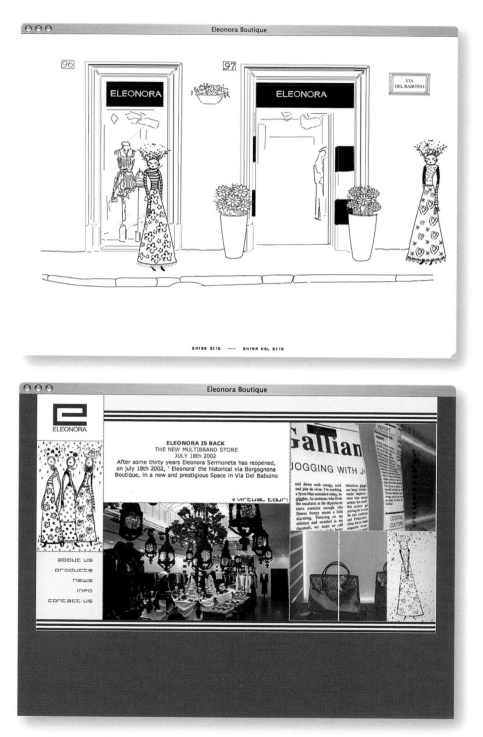

www.eleonoraboutique.com
D: claudio baldino
M: claudio.baldino@gmail.com

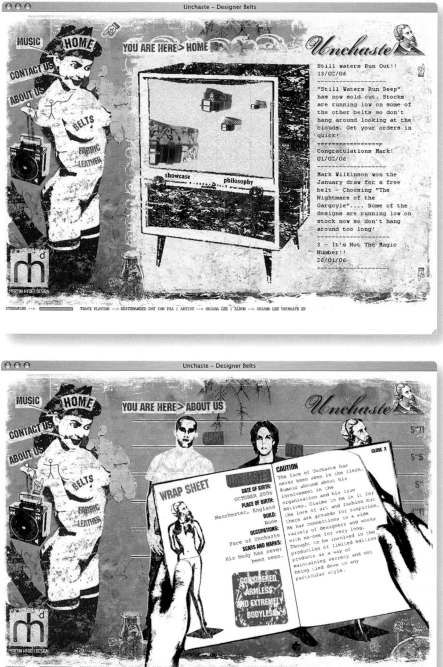

www.unchaste.co.uk
D: martin hyde
A: martin hyde | design M: www.martinhyde.co.uk

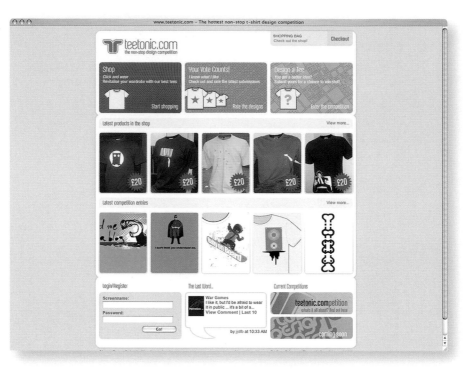

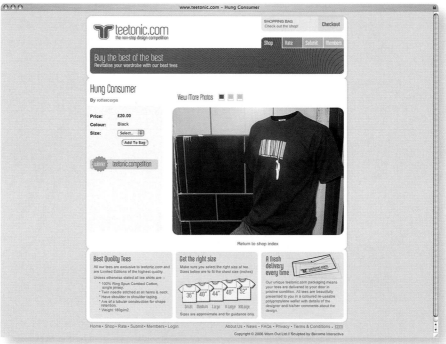

www.teetonic.com

D: paul derwin, tom beddard C: tom beddard, cameron yule P: paul derwin

A: become interactive M: paul@teetonic.com

www.tutto-frankfurt.de

D: dino pannozzo

A: schema f - new media solutions M: info@schema-f.de

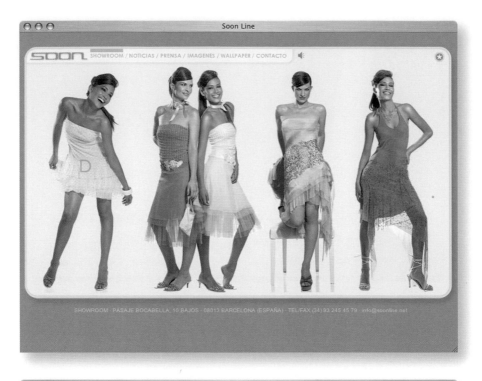

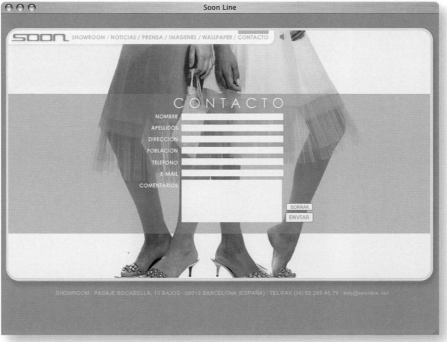

www.soonline.net

D: ragde

A: ragde.com M: info@ragde.com

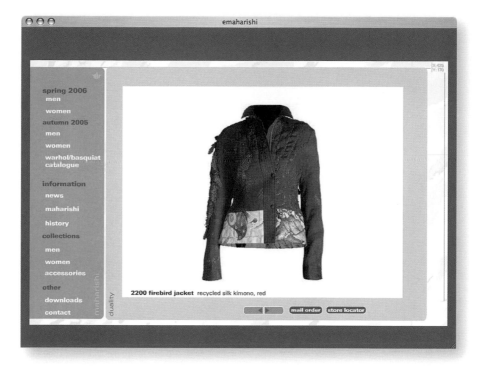

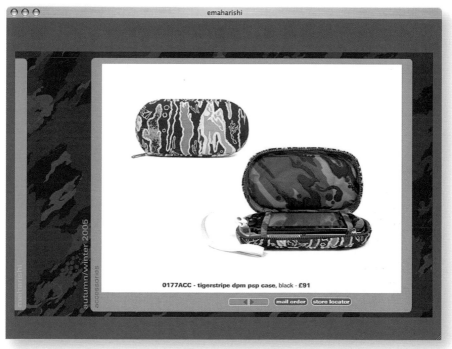

www.emaharishi.com

D: julia shapp C: julia shapp P: maharishi

A: maharishi M: info@emaharishi.com

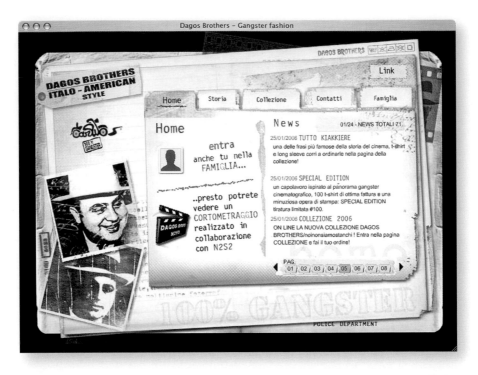

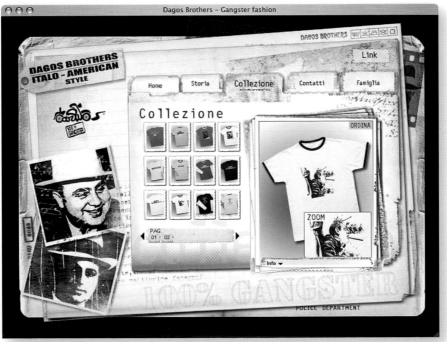

www.dagosbros.it
D: luca fadigati
A: effective studio M: www.effectivestudio.com

www.agustinsala.com

D: cristina guillén malluguiza, a. garcía saúco iglesias P: a. garcía saúco iglesias

A: crisipels M: antonio@enblanco.ws

www.cachetmodels.nl

D: sander van der putten, rob hoekman **C:** jos van de laar **P:** carla van de vorst

A: parque creative **M:** info@parque.nl

www.jato.it

D: antonello coghe

A: fashion communication M: antonello@fashionfm.it

www.keller-company.de

D: stefan behringer C: jürgen wunderle

A: d\sign creativeconcepts M: www.dsign.de

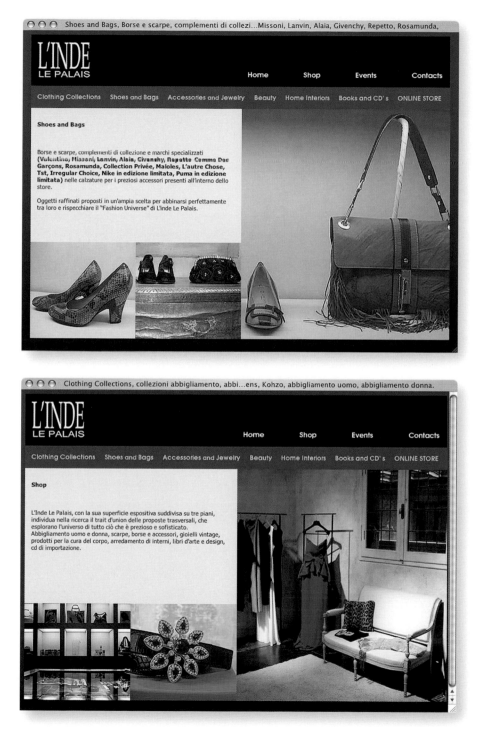

www.lindelepalais.com

D: antonello coghe

A: fashion communication M: antonello@fashionfm.it

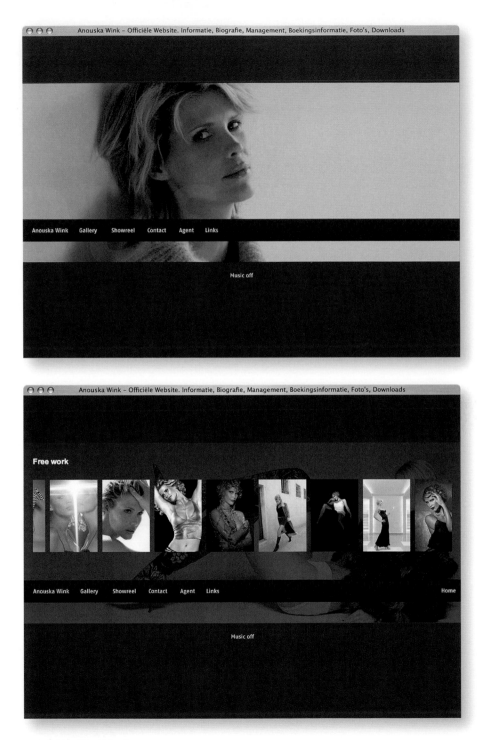

www.anouskawink.nl
D: arnout schutte
A: id interactive M: arnoutschutte@gmail.com

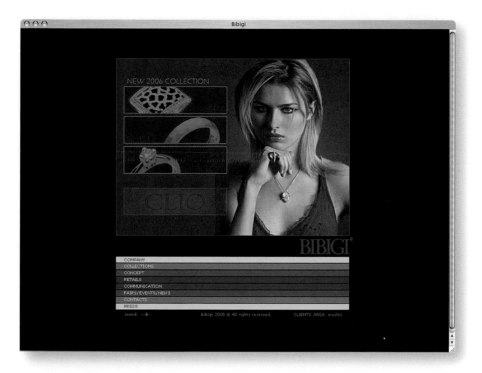

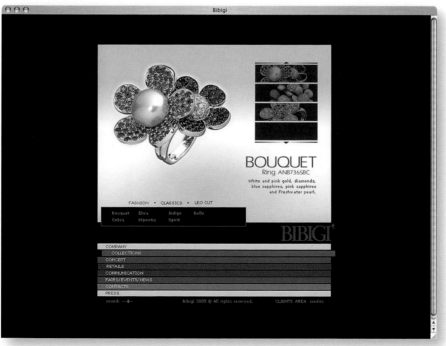

www.bibigi.com
D: federico guidi, luca guidi **C:** fabrizio fusi
A: equent **M:** info@equent.it

www.bianca-porcelli.com

D: fettolini design

A: fettolini design M: www.fettolini-design.net

www.enlaza.us
D: leonardo rafael schneider
A: lyo design digital M: www.lyo.com.br

www.piltonvideo.org

D: minttu mantynen

A: my favourite tiger M: minttu@myfavouritetiger.co.uk

www.cedece-online.com

D: velcro

A: velcro M: www.velorodesign.com

www.areatangent.com

D: jorge ferrera C: raúl fernandez P: cristian cisa, josep mª marimon
A: tangent audiovisual M: info@tangent.es

Scott Ward
DIRECTOR OF PHOTOGRAPHY

01. Credits

- ■ Drama
- ■ Documentary
- ■ Commercial/Corporate

02. Contact
mail@scottaward.co.uk

Drama Credits

The Way We Played
Brazen Hussies.

Scottish-Bosnian co-production
filmed on location in Tuzla, Bosnia.
Dir: Samir Mehanovic.

Night People
STV / Mead Kerr Ltd.

Feature length drama premiering
at the Edinburgh International Film
Festival 2005. Dir: Adrian Mead.

Intergalactic Kitchen
CBBC.

13x30 min Science Fiction drama.
Dir: Shiona McCubbin, Martin Burt
and David Cairns.

Hushtown
BBC / Sprocketeers.

Tartan Smalls. Short Drama.
Dir: Adrian Mead.

**Perpetual Twilight of Gregor
Black**
Cliffhanger / Scottish Arts Council.

Part of series on architectural follies.
Obliqua award for Best Short in
Barcelona International Short Film
Festival 2004. Dir: Huw Davies and
Nigel Atkinson.

Scott Ward
DIRECTOR OF PHOTOGRAPHY

01. Credits

- ■ Drama
- ■ Documentary
- ■ Commercial/Corporate

02. Contact
mail@scottaward.co.uk

Commercials

ESPN Classic
ESPN

Commercial shot in Rome for ESPN
sports channel European launch.

Avante Channel Idents
UPC TV. NL.

Virgin Mobile
Spectre

Extreme Sports Channel Idents
UPC TV. NL.

**Edinburgh International Film
Festival**
Cinema Commercial EIFF

ITV Digital
Homes Ondigital

As Director/Camera. Corporate
video on analogue tv signal switch
off.

Keep Edinburgh Clean
Skyline Productions

Two commercials for Keep
Edinburgh Clean - campaign.

www.scottaward.co.uk
D: minttu mäntynen
A: my favourite tiger **M:** minttu@myfavouritetiger.co.uk

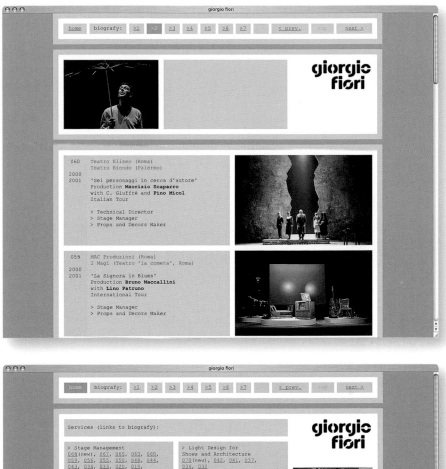

home | biografy: | >1 | >2 | >3 | >4 | >5 | >6 | >7 | < prev. | top | next >

giorgio fiori

```
060   Teatro Eliseo (Roma)
      Teatro Biondo (Palermo)
2000
2001  'Sei personaggi in cerca d'autore'
      Production Maurizio Scaparro
      with C. Giuffré and Pino Micol
      Italian Tour

      > Technical Director
      > Stage Manager
      > Props and Decors Maker
```

```
059   MAC Produzioni (Roma)
      I Magi (Teatro 'la cometa', Roma)
2000
2001  'La Signora in Blues'
      Production Bruno Maccallini
      with Lino Patruno
      International Tour

      > Stage Manager
      > Props and Decors Maker
```

giorgio fiori

home | biografy: | >1 | >2 | >3 | >4 | >5 | >6 | >7 | < prev. | top | next >

Services (links to biografy):

> Stage Management
068(new), 067, 065, 063, 060,
059, 056, 055, 050, 048, 044,
043, 034, 033, 020, 019,
001-004

> Technical Direction
067, 066, 065, 064, 063, 060,
054, 053, 051, 049, 048, 047,
046, 045, 040, 039, 038, 033,
029, 028, 023

> Consulting and
Project Management
065, 052, 046, 030, 025, 021,
017

> Courses for Theater
069(new)

> Light Design for
Shows and Architecture
070(new), 042, 041, 037,
036, 032

> Sound Projects for
Theater and Installations
068(new), 064, 063, 031

> Idealization and Realization
of Props and Decors
061, 060, 059, 058, 056, 051,
050, 044, 026, 025, 024, 020,
015, 014, 012

> Others
065, 062, 058, 057, 031, 027,
022, 016, 014, 012, 011, 010,
009, 008, 007, 006, 005

```
Tel:
0041 (0)44 951 10 16

Mobile:
0041 (0)78 882 09 53

Adress:
Giorgio Fiori
Grüningerstr. 18
8624 Grüt
Switzerland

mail@stagemanagement.info
```

www.stagemanagement.info
D: marcel schneeberger
A: grafikpilot M: kerosin@grafikpilot.ch

www.daringplanet.com

D: paul corrigan

A: oddity studios, daring planet M: paul@daringplanet.com

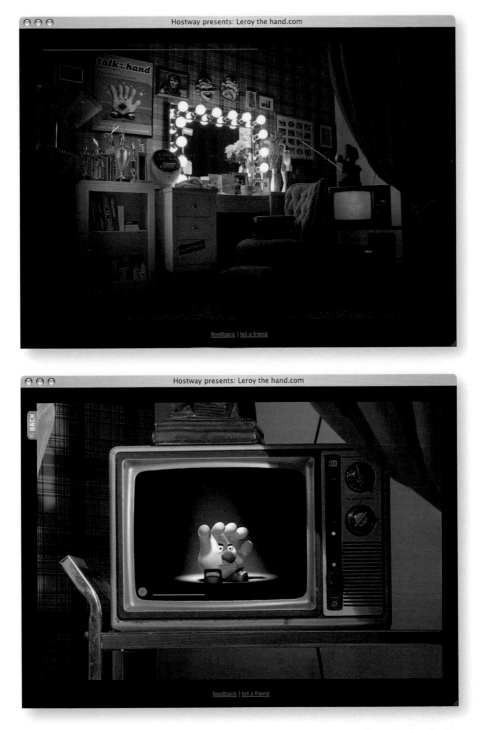

www.leroythehand.com

D: 15 letters

M: www.15letters.com

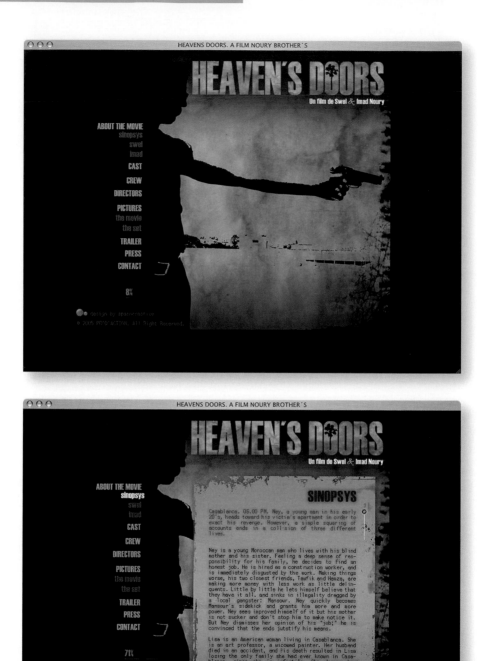

www.heavens-doors.com
D: lourdes molina
A: spaincreative M: info@antonioherraiz.com

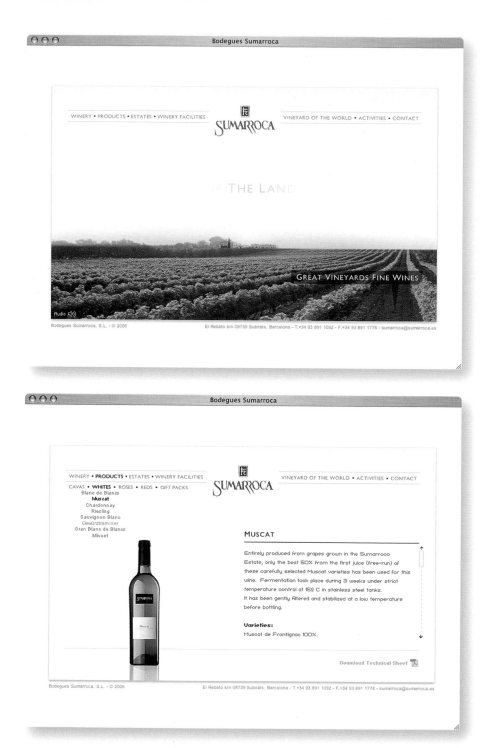

www.sumarroca.es

D: ignacio zorraquín

A: nomadesign M: www.nomadesign.info

www.genova.cl

D: nexprochile ltda.

A: nexprochile ltda. M: dcreativa@nexprochile.cl

www.bacardimojito.com

D: scott cook

A: driftlab M: www.driftlab.com

segugio

segugio

Utrechtsestraat 96
1017 VS Amsterdam
tel: 0031 (0)20 330 15 03
info@segugio.nl

KOM BINNEN
NEDERLANDS

UNDER CONSTRUCTION
ENGLISH
DOWNLOAD AND INSTALL
THE MACROMEDIA FLASH PLUGIN

design by natha@plush.nl

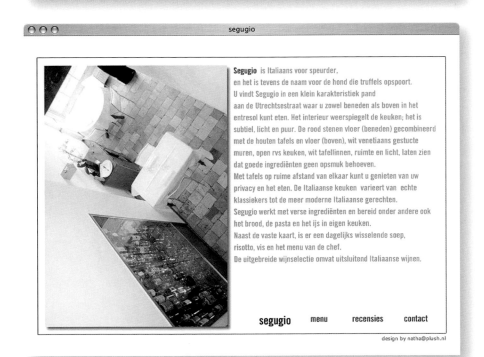

segugio

Segugio is Italiaans voor speurder,
en het is tevens de naam voor de hond die truffels opspoort.
U vindt Segugio in een klein karakteristiek pand
aan de Utrechtsestraat waar u zowel beneden als boven in het
entresol kunt eten. Het interieur weerspiegelt de keuken; het is
subtiel, licht en puur. De rood stenen vloer (beneden) gecombineerd
met de houten tafels en vloer (boven), wit venetiaans gestucte
muren, open rvs keuken, wit tafellinnen, ruimte en licht, laten zien
dat goede ingrediënten geen opsmuk behoeven.
Met tafels op ruime afstand van elkaar kunt u genieten van uw
privacy en het eten. De Italiaanse keuken varieert van echte
klassiekers tot de meer moderne Italiaanse gerechten.
Segugio werkt met verse ingrediënten en bereid onder andere ook
het brood, de pasta en het ijs in eigen keuken.
Naast de vaste kaart, is er een dagelijks wisselende soep,
risotto, vis en het menu van de chef.
De uitgebreide wijnselectie omvat uitsluitend Italiaanse wijnen.

segugio menu recensies contact

design by natha@plush.nl

www.segugio.nl
D: natha C: natha P: adriano paolini
A: plush.nl M: natha@plush.nl

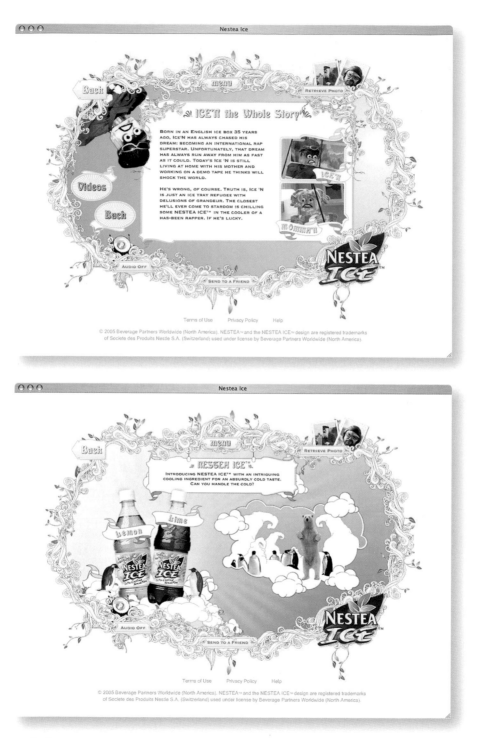

nesteaice.com

D: todd purgason, jorge calleja, ken macy, christian ayotte **P:** kristen myers

A: juxt interactive **M:** juxtinteractive.com

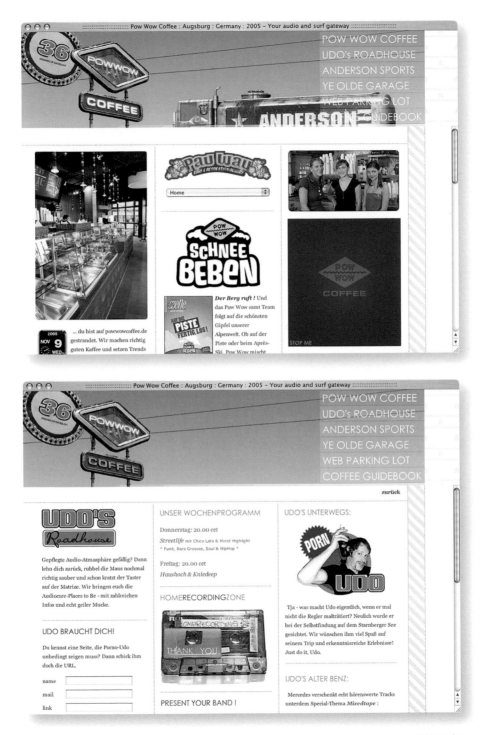

www.powwowcoffee.de

D: andreas reisewitz C: andreas reisewitz, yves vogl P: andreas reisewitz

A: compudrom creative services M: www.compudrom.de

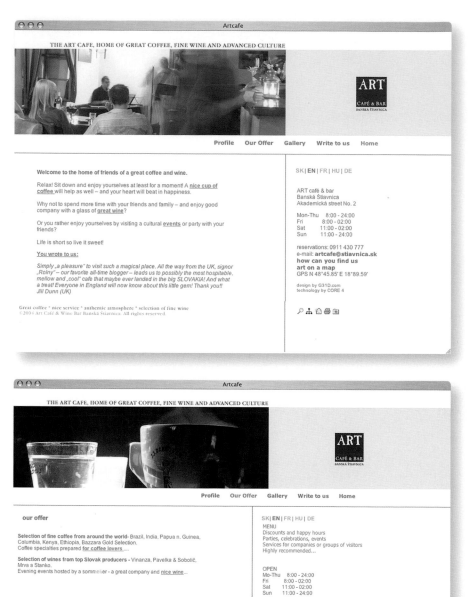

www.artcafe.sk

D: viktor kovac **C:** core 4

A: g31d.com creative agency **M:** info@g31d.com

www.dammann.fr

D: laurent chomette pour sokovision C: sokovision P: dammann frères
A: sokovision M: eric.marillet@sokovision.com

www.salotto42.it

D: molinari **C:** andrea brauzzi **P:** salotto 42
A: alchimedia srl **M:** cmolinari@alchimedia.com

www.quintaeventos.com

D: bruno silva C: sidney veiga P: bruno silva
A: arta design M: bua@arta-design.com

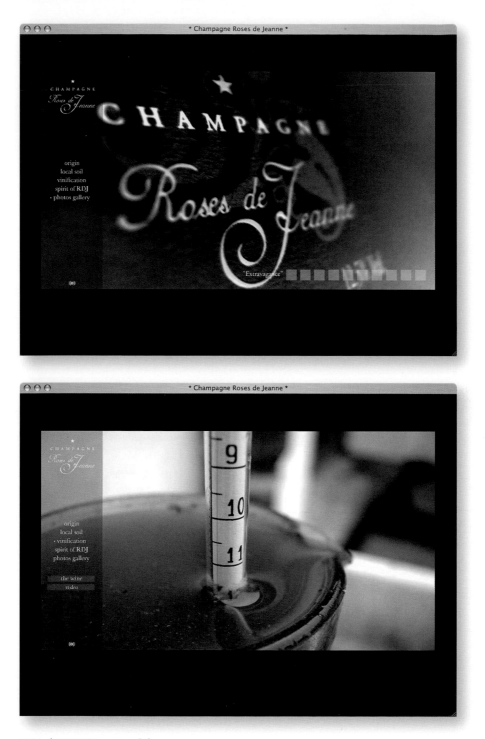

www.champagne-rosesdejeanne.com
D: fabrice corneux
A: fabrice corneux M: fabrice@nowaxx.com

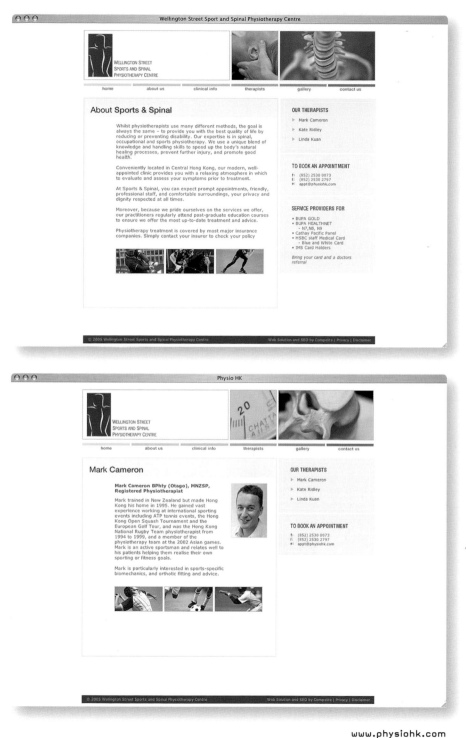

www.physiohk.com
D: michael clough C: teresa l. y. lee
A: compelite ltd M: www.compelite.net

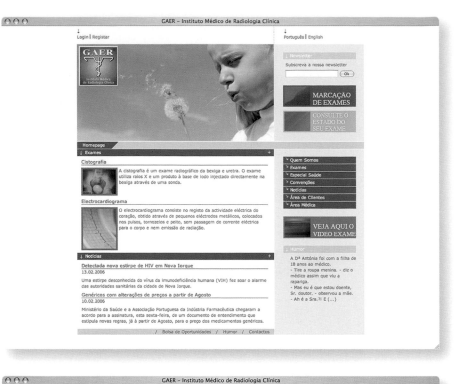

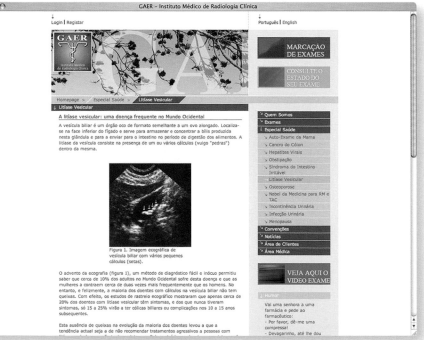

www.gaer.pt

D: nsolutions4u.com C: hélder ribeiro

A: gaer M: webmaster@gaer.pt

www.meimon.nl

D: peter visser

A: illusoft M: p.visser@illusoft.com

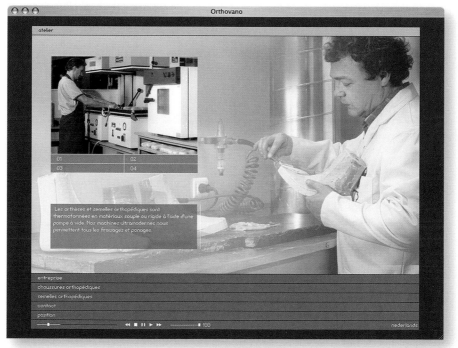

www.orthovano.be
D: laurent lampaert
A: nookyalur M: info@nookyalur.com

} andreas herrmann {

.do > (iT_design = } **andreas herrmann** { ~ spec [Patterns]. y //: **diplom-informatiker** &
list [pro]. (> **consulting**) & (> **training**) = tec [++now] * (> **software-entwicklung**) !
{ > **pdf-downloads** }. req4_ { > **support** } ~ref { > **kontakt** } .\ by { > **impressum** } + get (

consulting	training	software-entwicklung

> Technologie + Produktberatung
> Projektberatug + Coaching
> Training
> Strategieberatung + Coaching

> Sprachen
> Technologien
> Design

> Vorgehen
> Spektrum
> Referenzen

telefon [+49] = 89.27 27 3470 **telefax** [+49] = 89.27 27 3471 **mobil** [+49] = 179.11 27 505 **e-mail** [...] = info@andyherrmann.de

} andreas herrmann {

.do > (iT_design = } **andreas herrmann** { ~ spec [Patterns]. y //: **diplom-informatiker** &
list [pro]. (> **consulting**) & (> **training**) = tec [++now] * (> **software-entwicklung**) !
{ > **pdf-downloads** }. req4_ { > **support** } ~ref { > **kontakt** } .\ by { > **impressum** } + get (

Consulting

Kurzer Blick in die Kristallkugel gefällig?
Welche Technologie bestimmt unsere IT Welt von morgen? Welche Sprachen werden wir
sprechen? Welche Software wird den Ton angeben? Wenn Sie etwas über die Welt der
Zukunft und ihre Herausforderungen wissen wollen, können Sie einen Wahrsager
konsultieren. Wir aber empfehlen Ihnen einen Besuch bei uns. Denn nur wer die
Entwicklung der letzten Jahrzehnte kennt, hat den nötigen und vor allem kritischen
Überblick über die Trends in der Software. Wir setzen nicht auf den kurzfristigen Hype,
sondern - ganz die alte Schule - auf jahrelang bewährte Software ohne Kinderkrankheiten.
Die läuft auch morgen noch fehlerlos. Das sagen wir Ihnen ganz frech, ohne einmal in die
Kristallkugel zu gucken.

Eine Säule unseres Angebotes ist die Beratung rund um das Thema Software-Engineering.
Je nach Kunde und Projektsituation kann diese Beratungstätigkeit unterschiedliche
Schwerpunkte haben.

Auf den folgenden Seiten stellen wir einige typische Szenarien in Form von Fallbeispielen
vor:
> Technologie-Entscheidungen
> Projekt-Coaching
> Training
> Strategieberatung

telefon [+49] = 89.27 27 3470 **telefax** [+49] = 89.27 27 3471 **mobil** [+49] = 179.11 27 505 **e-mail** [...] = info@andyherrmann.de

www.andyherrmann.de
D: sandra leister, alexander schäfer **C:** alexander schäfer
A: 372dpi - design print internet **M:** a.schaefer@372dpi.com

browsehappy.com

D: ethan marcotte C: ethan marcotte P: ethan marcotte, stephanie troeth

A: vertua studios M: vertua.com

www.brickhousemobile.com
D: david snyder, ian coyle C: ian coyle
A: fl2 M: www.fl-2.com

www.sitevista.com

D: paul farnell C: david smalley P: paul farnell
A: salted M: paul@salted.com

www.clearleft.com
D: andy budd C: jeremy keith P: richard rutter
A: clearleft ltd M: www.clearleft.com

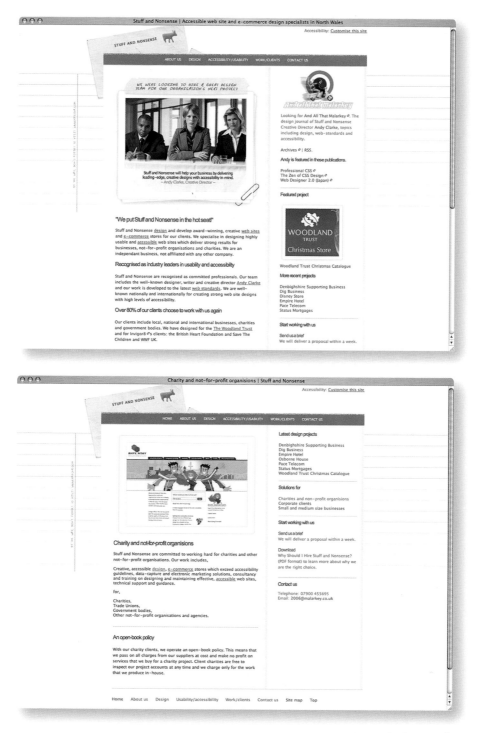

www.malarkey.co.uk

D: andy clarke

A: stuff and nonsense ltd. M: www.stuffandnonsense.co.uk

○○○ Zebra Productions

Prisbelønnet webdesign

z e b r a

Zebra Productions I Om web I Om stills I Om film I Om zebraen I Kontakt

○○○ Zebra Productions

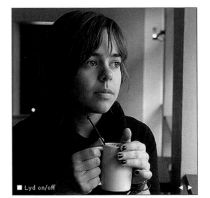

■ Lyd on/off

Billedet har indtaget billedet

Stillbilledet er blevet tidens medie. Det fortæller historie, formidler budskaber, dokumenterer begivenheder, viderebringer stemninger og følelser. Overalt ser vi billeder, der appellerer til vores opmærksomhed. Stillbilledet spejler vores liv i alle dets afskygninger og er blevet et ikon på tilværelsen.

Hvis vi skal lægge mærke til et stillbillede, skal det være det rigtige billede i situationen. Det rigtige billede indeholder tilpas megen appeal og provokation til at bære budskabet igennem.

Vi indfanger og komponerer de helt rigtige billeder til de budskaber, vi arbejder med at formidle. Det væsentlige skal fremhæves og fremtræde troværdigt – måske med en fræk vinkel eller et lækkert lys.

Zebra Productions I Om web I Om stills I Om film I Om zebraen I Kontakt

zebra-pro.dk

D: zebra productions

A: zebra productions M: zebra@zebra-pro.dk

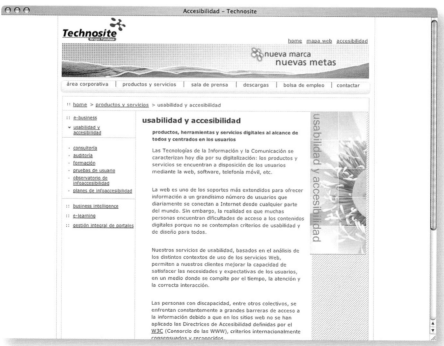

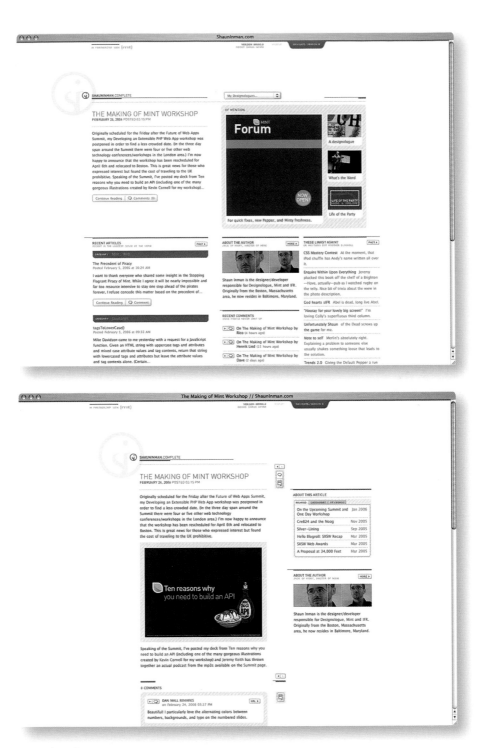

www.shauninman.com

D: shaun inman

A: shaun inman design & development M: www.shauninman.com/contact

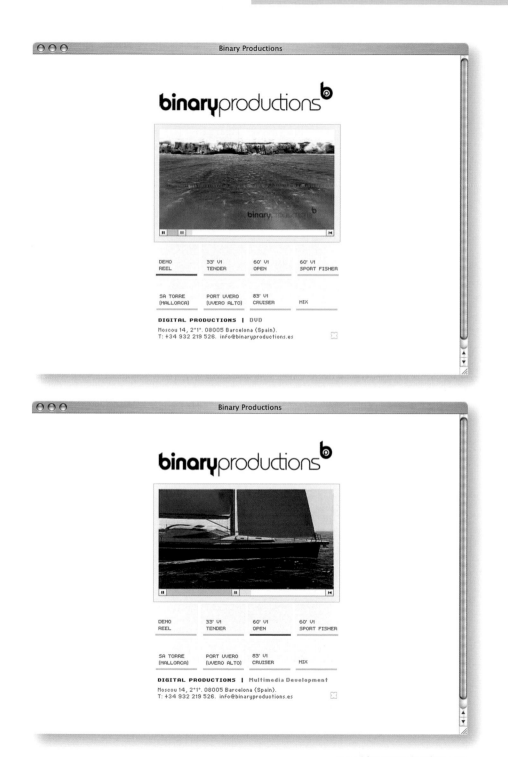

www.binaryproductions.es
D: xavi royo C: xavi royo P: binary productions
A: xafdesign M: xavi@xafdesign.com

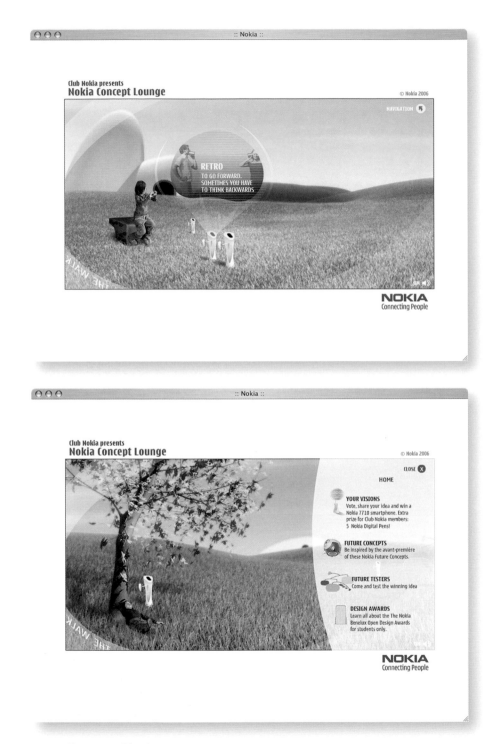

conceptlounge.nokia.nl

D: engin, beckers, van den broeck C: aallillou, verbruggen P: smith, michiels

A: these days M: www.thesedays.com

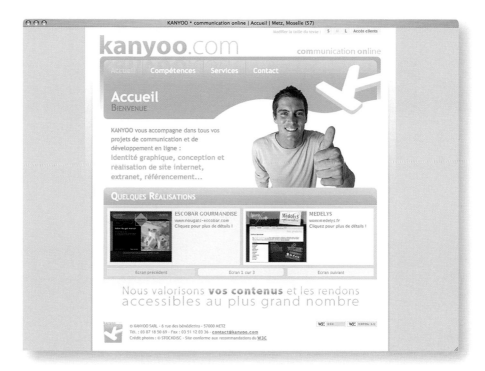

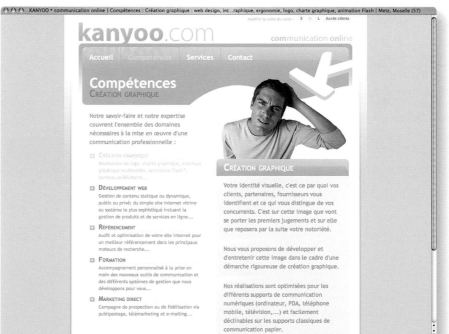

www.kanyoo.com
D: clement barlier
A: kanyoo M: clement@kanyoo.com

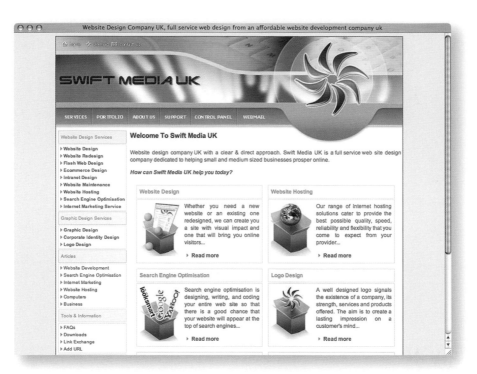

www.swiftmediauk.co.uk

D: andy macdonald

M: www.swiftmediauk.co.uk

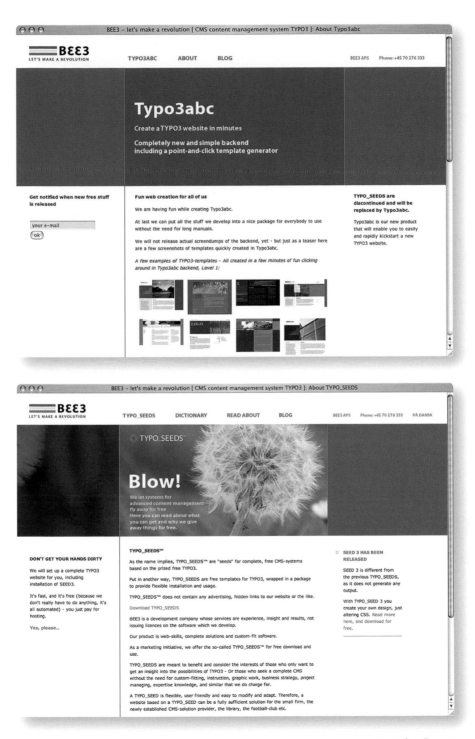

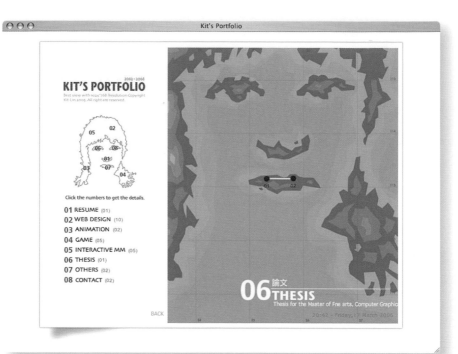

portfolio.kitlin.com
D: yi-chen lin
M: littleboww@yahoo.com.tw

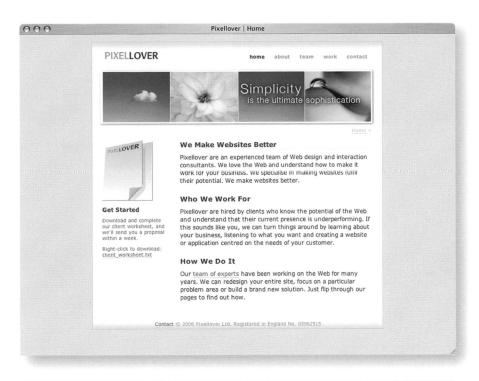

www.pixellover.net
D: timo kleemann
A: pixellover M: pizzadude81@gmail.com

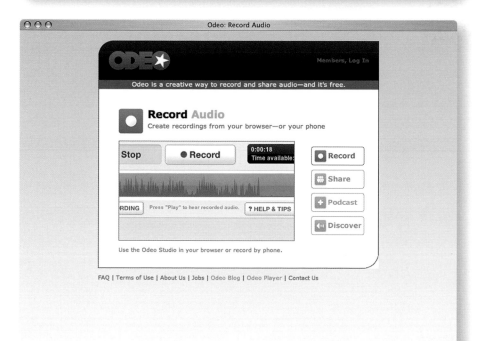

www.odeo.com

D: dan cederholm C: jack dorsey P: biz stone

A: simplebits M: biz@odeo.com

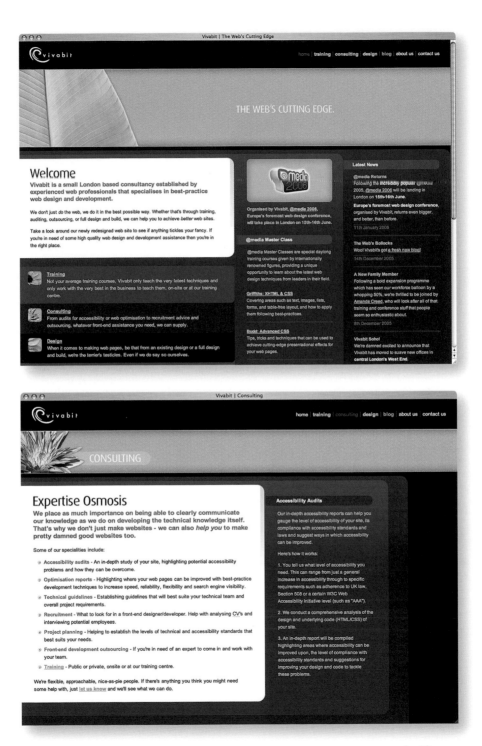

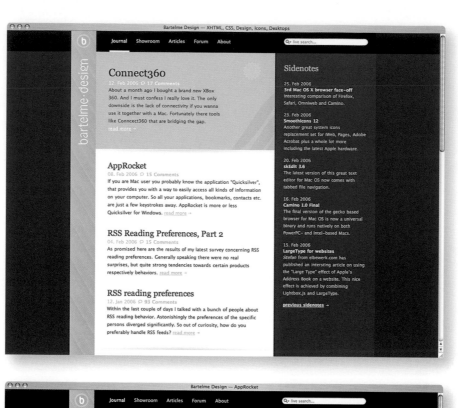

bartelme.at

D: wolfgang bartelme

M: design@bartelme.at

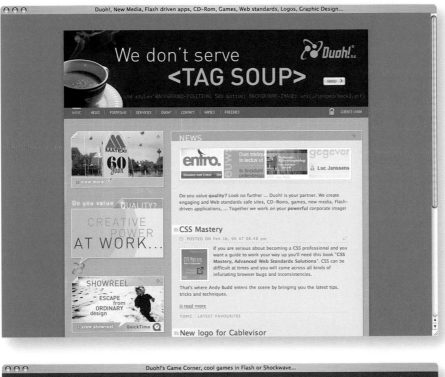

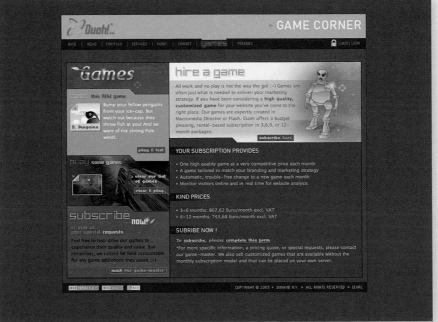

www.duoh.com

D: veerle pieters **P:** geert leyseele

A: duoh! n.v. **M:** info@duoh.com

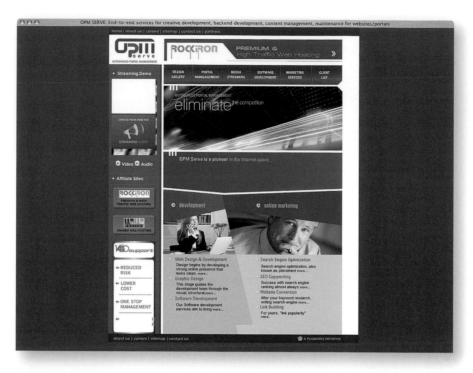

www.opmserve.com

D: kushal grover P: pugmarks

A: liquid designs india M: www.liquiddesignsindia.com

cannibal.illusoft.com
D: pieter visser
A: illusoft M: p.visser@illusoft.com

www.fantasy-interactive.com

D: david martin, krister karlsson C: hakim elhattab P: david martin

A: fantasy interactive M: interact@fantasy-interactive.com

www.alvit.de/handbook

D: vitaly friedman

A: vitaly friedman M: web-dev@alvit.de

www.myphorum.net

D: gajendran somasundaram C: invision power services P: invision power services

A: www.somasundaram.net M: www.somasundaram.net

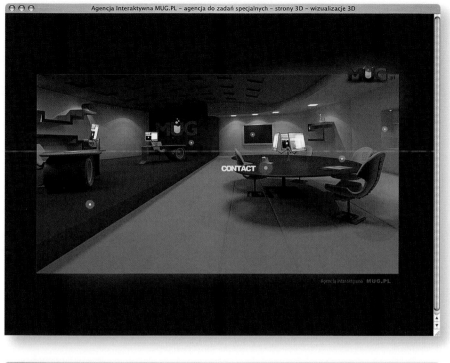

www.mug.pl

D: pawel rebisz, dariusz polarczyk C: dariusz polarczyk

A: interactive agency mug.pl M: office@mug.pl

kottke.org :: home of fine hypertext products

kottke.org home of fine hypertext products

ARCHIVES + XML ABOUT CONTACT

I stumbled into an arcade this weekend for the first time in years, and it wasn't pretty: Lots of untranslated Japanese games, lots of Street Fighter clones (and lots of overlap between the two), only one game with a copyright date later than 2002, most much older than that. Might as well stay home. -- GK #

Like any good father, I'm trying to pass my values along to my children -- simple moral truths like: DC is better than Marvel. It turns out, that battle has already been fought. Spoiler results. It's a sick, sad world we live in. -- GK #

People are still getting AOL CDs. I got one recently, included in the box with a new printer, and A) it had Windows 3.1 installation instructions and B) the password was "GUSH-TEEN." Which pretty much sums up the reason for subscribing to AOL right there. -- GK #

As part of kottke.org's efforts towards the multi-David utopia of Way New Journalism (Note: ghost site), we proudly bring you the kind of original reporting that could only come from the blogosphere: We didn't find out what happened to TV shows that air at 2:00am during the time change because we fell asleep again. Windows (XP Home) Task scheduler skips tasks set for 2:30, though, while Linux's (Fedora Core 3) default cron executes them immediately after the adjustment, at the new 3:00. Take that, MSM! -- GK #

It's Daylight Saving Time time and early Sunday morning clocks should be moved forward, from 01:59:59 to 03:00:00. But what happens to all the television shows that start at 2:00? Or to computer tasks scheduled during the missing hour? Tomorrow: The Kottke Investigative Journalism Team reports. Blogs: Asking the questions those cowardly tratiors of the MSM consider far too stupid bother with. -- GK #

TooVooRadia. I administer the machine that TooVoo runs on, and my

Jason Kottke and kottke.org, About | Contact me

Remaindered links
I read books and watch movies
Photography (@ Flickr, kottke tag)
Silkscreen font

RSS: Main weblog | Remaindered links

sites I've enjoyed recently

Airbag	990000
Anil Dash	Adam Greenfield
Blue Jake	Andre Torrez
Bluishorange	Andrea Harner
Boing Boing	Bitter Pill
Collision Detection	Black Belt Jones
Cynical-C	Caterina
Daring Fireball	Dooce
Design Observer	Google News
Flickr blog	Hchamp
Flickr friends	Ikeepadiary
Goldenfiddle	John Battelle
Gothamist	Justin Blanton
Greg.org	Lisa Whiteman
Gulfstream	Magnetbox
Hello, typepad	McSweeney's Lists
Lightningfield.com	Mighty Girl
Marginal Revolution	NYC Escorts Conf.
Matt's a.whole	Onfocus
Megnut	Paranoidfish
Morning News, The	ReBlog
Plasticbag	Scribbling.net
Slashdot	Signal vs. Noise
Slower	Sippey
The Superficial	Steven Johnson

About Jason and kottke.org (kottke.org)

kottke.org home of fine hypertext products

ARCHIVES + XML ABOUT CONTACT

About Jason Kottke

Jason is currently dissatisfied with this page and writing about himself in the third person. Both will hopefully be remedied soonish. And something needs to be done about the outdated FAQ as well.

If you need to get in touch with me, here's what you need to know.

A reverse chronology of my life, intended to be less boring than the icky third-person "professional" bio above (updated 1.11.2005)

2006: Currently happening...

2005: In many ways, the opposite of sucked.

2004: Sucked, sucked, sucked, sucked, sucked, sucked, sucked, sucked, sucked, sucked, sucked, sucked, sucked, sucked, sucked, sucked, sucked, sucked, sucked, sucked.

2003: I'm having performance anxiety about this whole year summary thing...

2002: Crikey, now I'm in New York. Can't quite figure out how I got here. Not exactly a point A to point B kind of thing.

2001: Despite much interest, I'd never been to Europe before this year, when I went three times in the span of 6 months. Paris and Antwerp in May, London in July, and Berlin in October. I would like very much to live in Europe.

2000: Finally made the move to San Francisco after thinking about it for a couple years. Definitely a big change for a small town boy like myself.

1999: I think this was the year I really and truly discovered the joys of sour cream. I never used to like sour cream....and then I started eating a little on baked potatoes every once and a while. Now, it's practically

What kottke.org might be, a list:

- The personal site of Jason Kottke. But also his full-time gig.

- A weblog, which is a frequently updated, chronologically ordered collection of hypertext fragments. You'll find the most recent posted stuff on the front page and many ways to get at the older posts on the archive page.

- My wunderkammer. Wunderkammer is a German word meaning, roughly, "cabinet of wonders" or "cabinet of curiousities". Julian Dibbell wrote about weblogs as wunderkammers for the dearly-departed Feed.

- Updated almost daily since March 1998.

- Incomplete.

- Bigger than Jesus and the Beatles put together.

POWERED BY
MOVABLETYPE

- An attempt to track and make sense of "material that connects the insights of science and culture, rather than using one to dismantle the other" (as Steven Johnson puts it).

- Sheer egoism, aesthetic enthusiasm, historical impulse, and even a bit of political purpose. (after George Orwell)

- Small pieces, loosely joined (after David Weinberger's book of the same name).

- Chock full of "wussy PoMo Sedaris-wannabe attitude" (source)

- Speed 3: The Weblog. If I stop writing, the bus will blow up. (source)

- A giant RFC document.

- Not all that it could be.

- Slashdot for the literati (comment via AIM).

www.kottke.org

D: jason kottke

M: jason@kottke.org

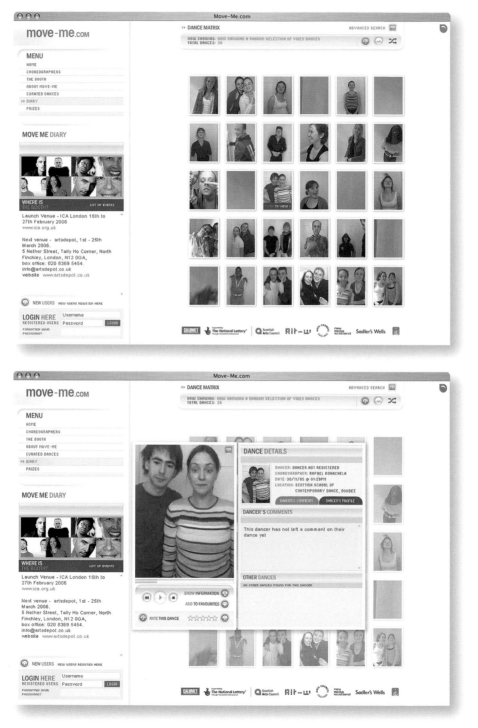

www.move-me.com

D: peter barr C: douglas noble P: ricochet dance productions, goat media ltd

A: amberfly ltd M: enquiries@amberfly.com

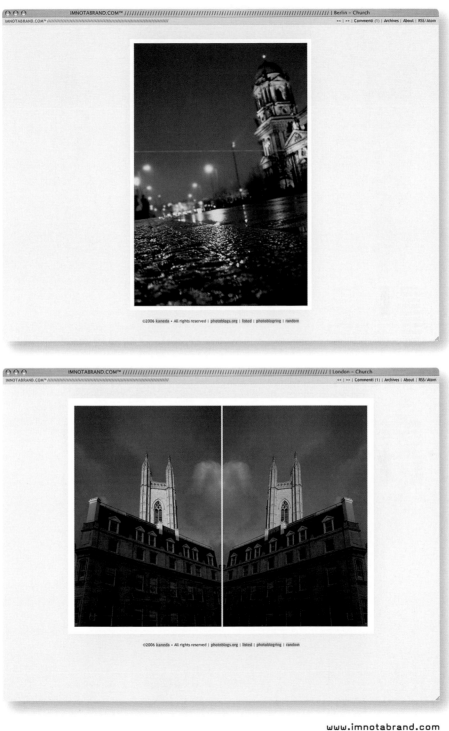

D: kaneda C: pixelpost P: kaneda
A: nosurprises M: kaneda@nosurprises.it

joshuaink.com

D: john oxton, denis radenkovic **P:** john oxton

M: mail@johnoxton.co.uk

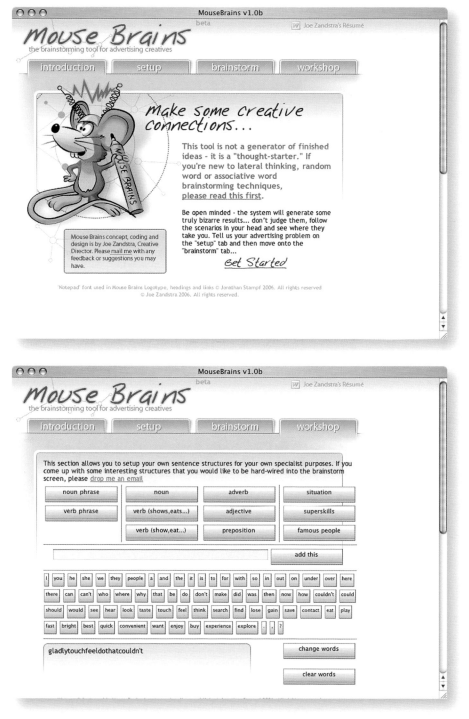

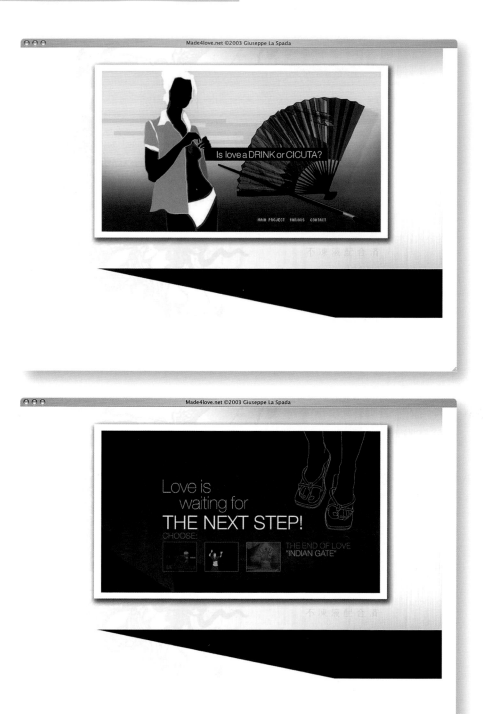

www.glsdesign.it/made

D: giuseppe la spada

A: gls design M: info@glsdesign.it

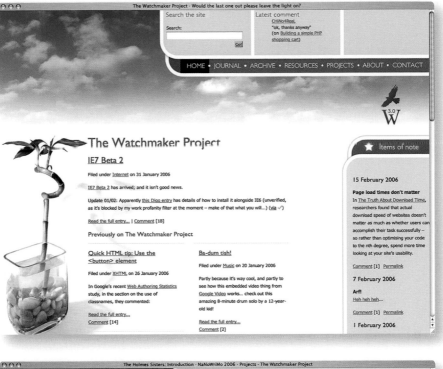

The Watchmaker Project · Would the last one out please leave the light on?

Search the site

Search:

Go!

Latest comment
CHiNo4Real.
"ok, thanks anyway"
(on Building a simple PHP shopping cart)

HOME • JOURNAL • ARCHIVE • RESOURCES • PROJECTS • ABOUT • CONTACT

The Watchmaker Project

IE7 Beta 2

Filed under Internet on 31 January 2006

IE7 Beta 2 has arrived; and it isn't good news.

Update 01/02: Apparently this Digg entry has details of how to install it alongside IE6 (unverified, as it's blocked by my work profanity filter at the moment – make of that what you will...) (via ✓)

Read the full entry... | Comment [18]

Previously on The Watchmaker Project

Quick HTML tip: Use the <button> element

Filed under XHTML on 26 January 2006

In Google's recent Web Authoring Statistics study, in the section on the use of classnames, they commented:

Read the full entry...
Comment [14]

Ba-dum tish!

Filed under Music on 20 January 2006

Partly because it's way cool, and partly to see how this embedded video thing from Google Video works... check out this amazing 8-minute drum solo by a 12-year-old kid!

Read the full entry...
Comment [2]

★ Items of note

15 February 2006

Page load times don't matter
In The Truth About Download Time, researchers found that actual download speed of websites doesn't matter as much as whether users can accomplish their task successfully – so rather than optimising your code to the nth degree, spend more time looking at your site's usability.

Comment [1] Permalink

7 February 2006

Arf!
Heh heh heh...

Comment [1] Permalink

1 February 2006

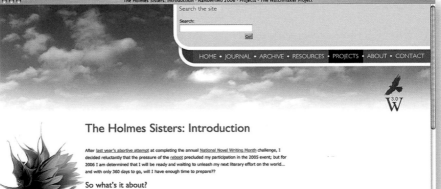

The Holmes Sisters: Introduction · NaNoWriMo 2006 · Projects · The Watchmaker Project

Search the site

Search:

Go!

HOME • JOURNAL • ARCHIVE • RESOURCES • PROJECTS • ABOUT • CONTACT

The Holmes Sisters: Introduction

After last year's abortive attempt at completing the annual National Novel Writing Month challenge, I decided reluctantly that the pressure of the reboot precluded my participation in the 2005 event; but for 2006 I am determined that I will be ready and waiting to unleash my next literary effort on the world... and with only 360 days to go, will I have enough time to prepare??

So what's it about?

Glad you asked! ;)

'The Holmes Sisters' (working title only, very likely to change on a weekly basis) will be a teen-sleuth adventure in the mold of classics such as Nancy Drew and The Hardy Boys, starring the three Holmes sisters. The eldest – by a couple of years – is mature and sensible, looking out for her younger twin sisters; the youngest (by 10 minutes) is beautiful but has a knack for getting into trouble, while the middle sister is shorter, bookish and impulsive.

After being told by their grandfather that they are descendants of Sherlock Holmes, the three sisters decide that they too will be detectives; much adventure and peril ensues.

Anyone who knows me will probably recognise that the three main characters are modelled somewhat on my three young daughters. In fact, the entire idea grew from an idle conversation with my wife, speculating on what our girls would be like when they grew up; I commented that our pretty, blonde eldest and youngest would be leggy models, while our bull-in-a-china-shop middle daughter, Emily, would probably grow up into Velma from Scooby Doo – a thorn between two roses.

After being roundly berated for daring to imagine that any of our children would

www.thewatchmakerproject.com
D: matthew pennell
A: 29digital M: www.thewatchmakerproject.com/contact

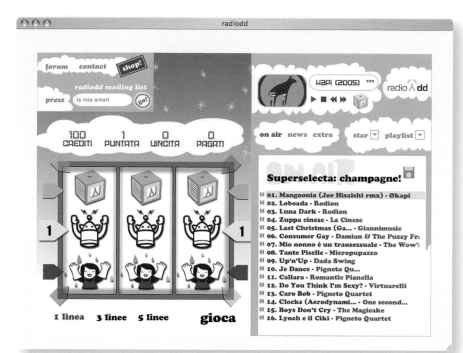

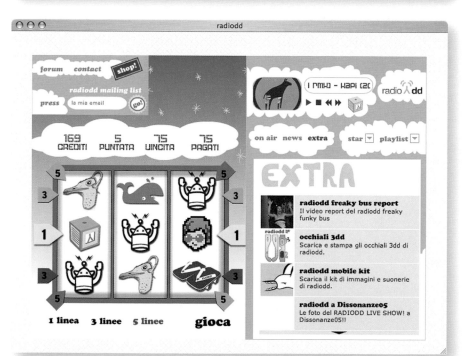

www.radiodd.com
D: digitaldelicatessen
M: contact@digitaldelicatessen.com

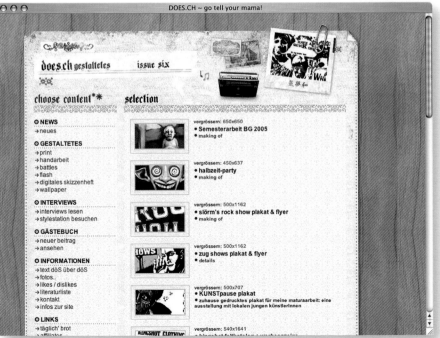

www.does.ch
D: dorian iten
M: dorian@does.ch

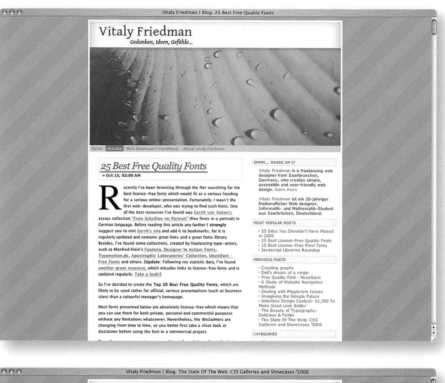

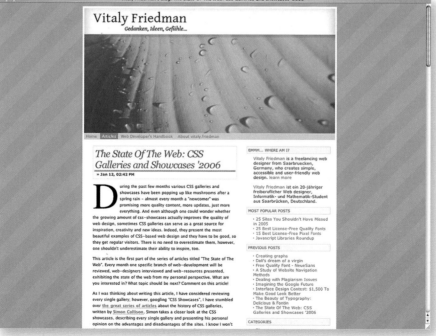

www.alvit.de/blog

D: vitaly friedman

A: vitaly friedman M: web-dev@alvit.de

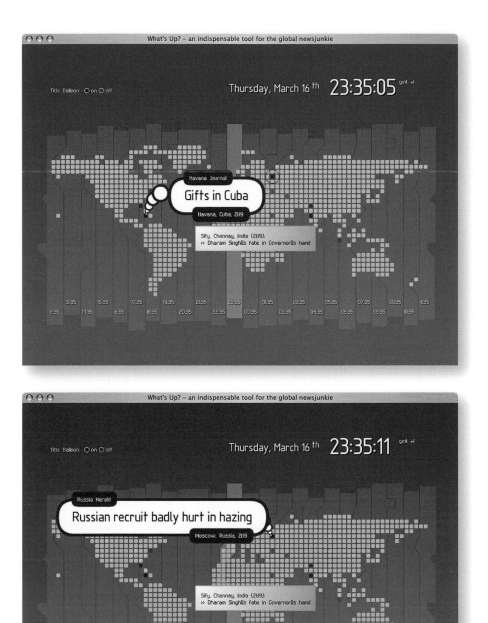

www.jeroenwijering.com/whatsup

D: jeroen wijering

M: mail@jeroenwijering.com

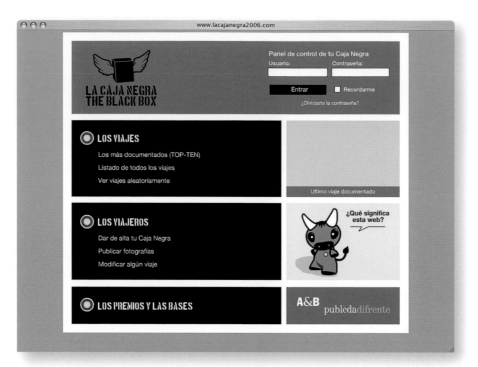

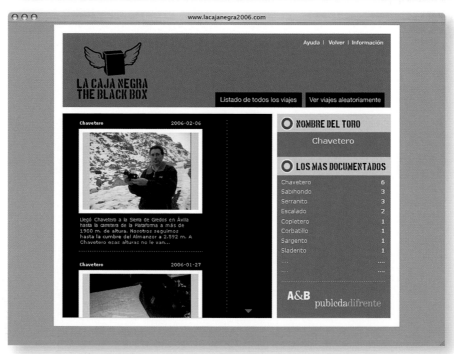

www.lacajanegra2006.com
D: javier gonzalez **C:** magalí piterman
A: arrontes y barrera, estudio de publicidad **M:** www.estudiodepublicidad.com

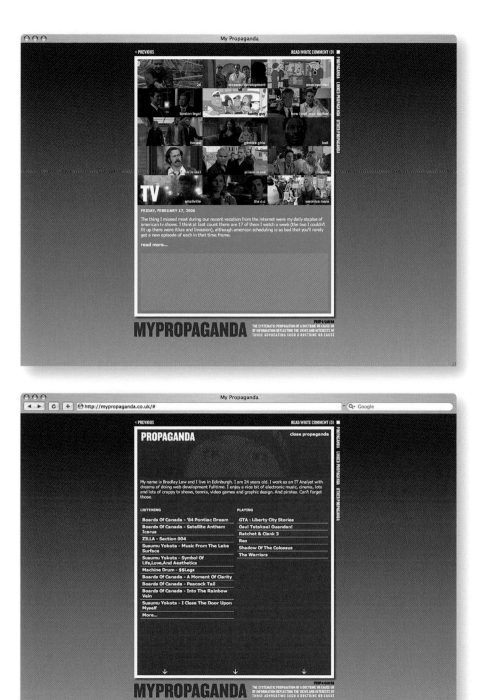

mypropaganda.co.uk
D: bradlay law
M: bradlaylaw@gmail.com

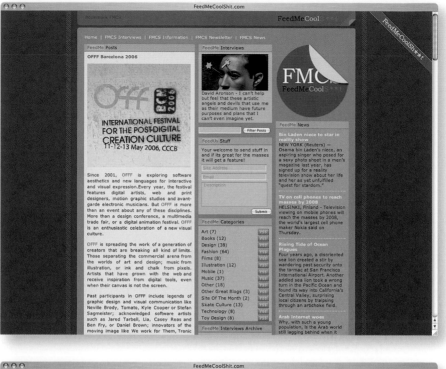

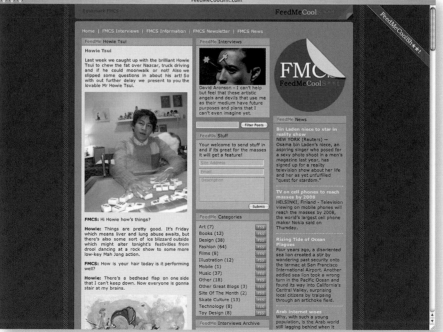

www.feedmecoolshit.com

D: johnny huntington **C:** z gavars

A: feedmenetwork **M:** johnny.huntington@gmail.com

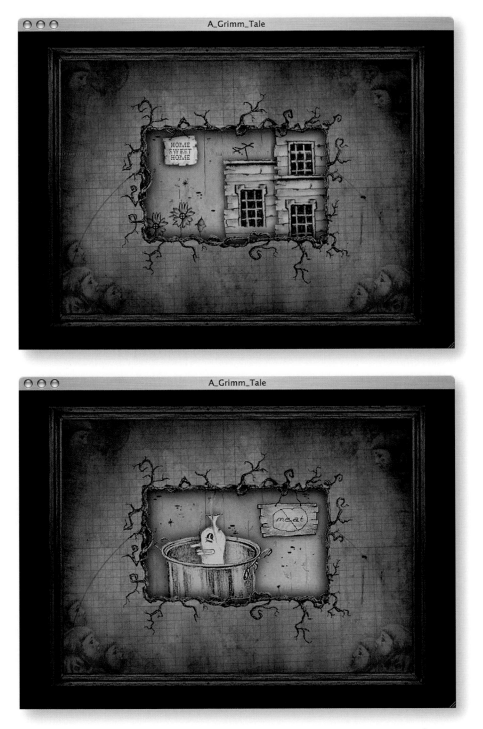

www.muttink.com/grimm
D: michael erazo-kase, jeremy holmes
A: mutt ink M: contactmutt@muttink.com

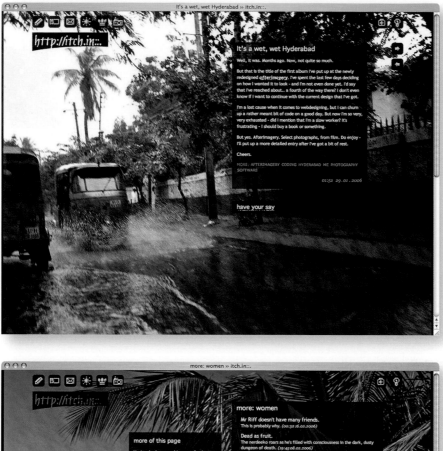

itch.in

D: arifuddin rahimi

A: nerdeeko labs M: mr.riff@itch.in

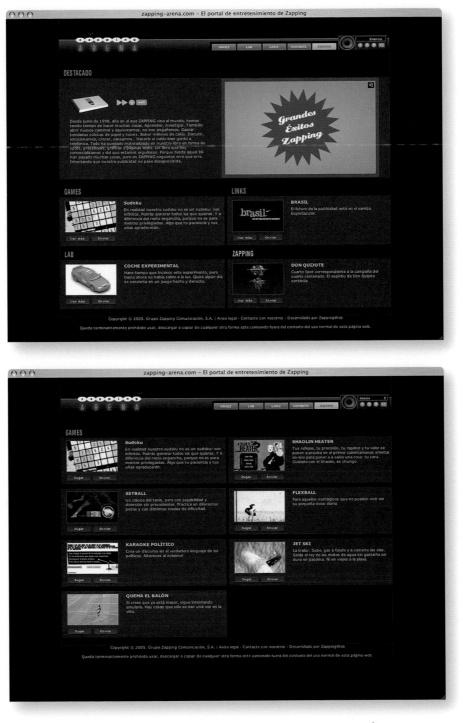

www.zapping-arena.com

D: zapping C: santiago rey P: juan searle

A: zapping M: jsearle@zaping.es

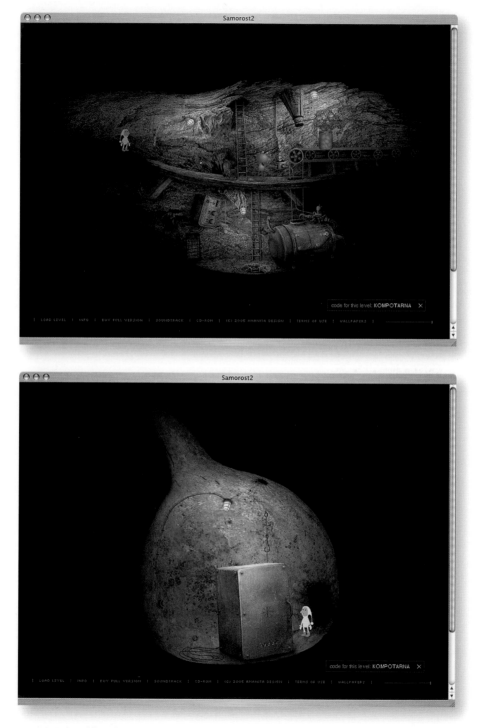

www.samorost2.net
D: amanita design
M: contact@amanitadesign.com

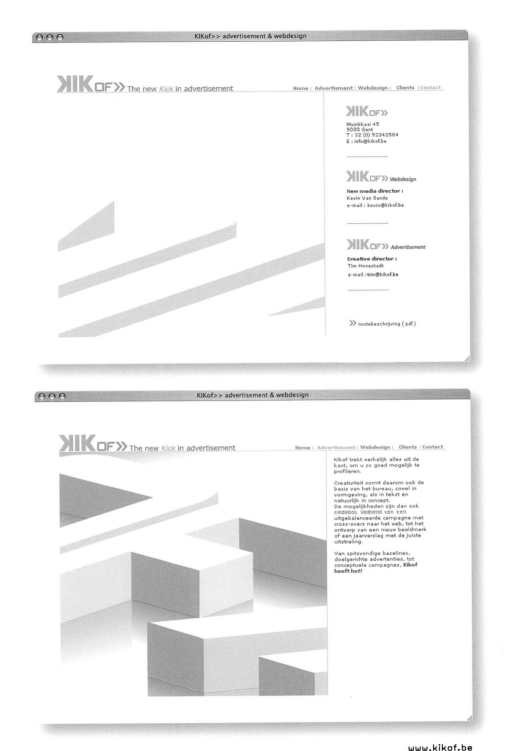

2FRESH | Best Practices in Communication Design for the New Communication Age.

2FRESH

Corporate
Creative Process
Portfolio
Contact

Our process consists of four three major phases.

1. *First* is pre-design phase where we **listen**, **understand**, or **define** communication problems. The focus in this phase is on creating the ground which will function as the base of our design.

2. *Second* comes developing best fitting design solutions to defined problems in form of **creative idea** or **concept**. Then, client is given with appropriate **style** choices in accordance with concept(s).

3. *Third* phase, as concept and style are set, is **production**. First comes **visual design**, then **pre-implementation** (page layouts, animatics, etc.) and finally **implementation**. We also give room for an **adjustment** step where we play around with small things.

Actually there exists also a last and enduring phase where we keep **continuous communicaton** and **relation** with the client to **feed**, **develop** and **enhance** project we created over time.

2FRESH | Best Practices in Communication Design for the New Communication Age.

2FRESH

Corporate
Portfolio
Static
Contact

Project	Client	Format
Urbanism	-	Artwork
Abstractions	-	Artwork
Cities on Walls	-	Artwork
Dreams	-	Artwork
Economics Days	Galatasaray University	Logo
Economics Days	Galatasaray University	Invitation
Economics Days	Galatasaray University	Poster
RH+	Rotham Halas	Logo
RH+	Rotham Halas	Stationary
Love is in the Air	Sex Book Project	Artwork
The X	Sex Book Project	Artwork
Studying Abroad: Get Out!	DAAD	Poster
Record '03	Boğaziçi University	Book

www.2fresh.com
D: 2fresh
A: 2fresh M: contact@2fresh.com

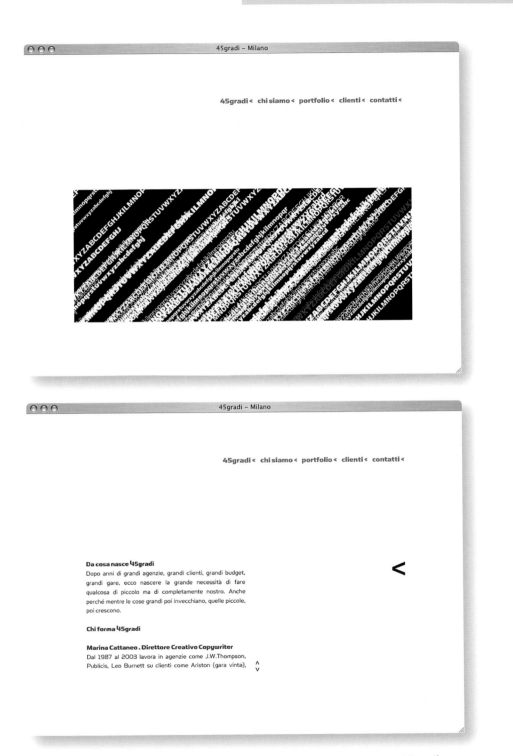

45gradi – Milano

45gradi < chi siamo < portfolio < clienti < contatti <

45gradi – Milano

45gradi < chi siamo < portfolio < clienti < contatti <

Da cosa nasce 45gradi
Dopo anni di grandi agenzie, grandi clienti, grandi budget, grandi gare, ecco nascere la grande necessità di fare qualcosa di piccolo ma di completamente nostro. Anche perché mentre le cose grandi poi invecchiano, quelle piccole, poi crescono.

Chi forma 45gradi

Marina Cattaneo . Direttore Creativo Copywriter
Dal 1987 al 2003 lavora in agenzie come J.W.Thompson, Publicis, Leo Burnett su clienti come Ariston (gara vinta),

www.45gradi.com
D: silvia grazioli C: andrea rincon ray P: marina cattaneo
A: 45gradi M: marina.cattaneo@45gradi.com

D: stephan de graaf **C:** stephan de graaf **P:** johan den heijer, moses
A: pixelfarm **M:** info@moses.nl

www.greenpanther.at/2005

D: nina markart, spreitzer & friends, c. poltensteiner C: p. wagner P: wukonig.com

A: wukonig.com M: joerg@wukonig.com

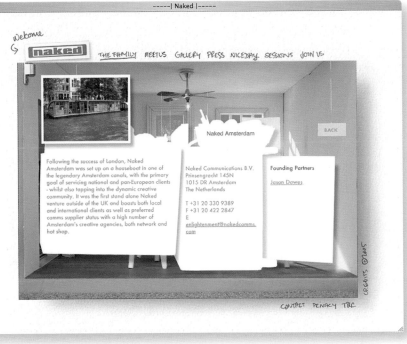

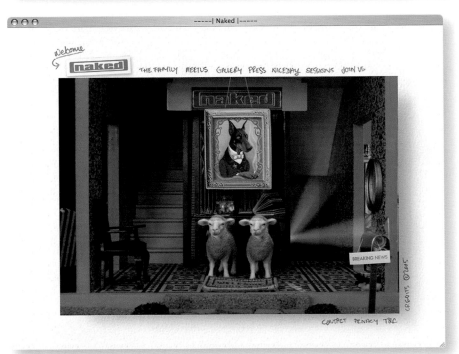

Following the success of London, Naked Amsterdam was set up on a houseboat in one of the legendary Amsterdam canals, with the primary goal of servicing national and pan-European clients - whilst also tapping into the dynamic creative community. It was the first stand alone Naked venture outside of the UK and boasts both local and international clients as well as preferred comms supplier status with a high number of Amsterdam's creative agencies, both network and hot shop.

Naked Communications B.V.
Prinsengracht 145N
1015 DR Amsterdam
The Netherlands

T +31 20 330 9389
F +31 20 422 2847
E
enlightenment@nakedcomms.com

Founding Partners

Jason Dowes

Naked Amsterdam

BACK

www.nakedcomms.com

D: carl burgess, marc kremers, brie wohler C: nils millahn P: nicky cameron
A: hi-res! M: www.hi-res.net

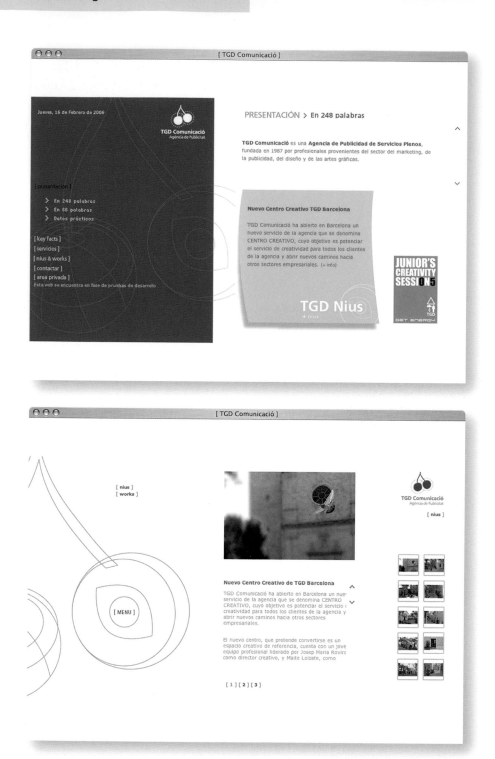

www.tgd.info

D: intercatius tgd

A: tgd comunicació M: sbuyo@tgd.es

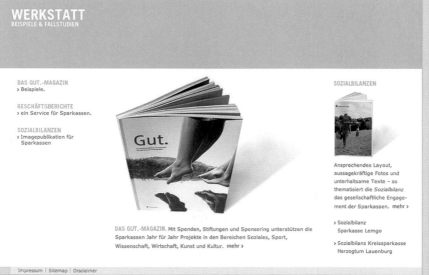

www.am-com.com

D: am | corporate & creative

A: am | corporate & creative M: koeln@am-com.com

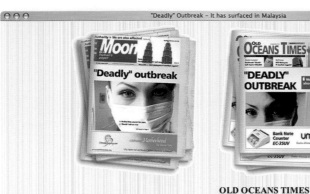

"Deadly" Outbreak – It has surfaced in Malaysia

theMoon

PUTRA JAYA:
"Deadly"outbreak has surfaced in Malaysia. Authorities eagerly searching for cure to prevent more casualties . Outbreak "death" toll on rise all over the world. Authorities have release a statement that they are also affected. There is a question whether Malaysia's IT market will bounce back

OLD OCEANS TIMES

KUALA LUMPUR - Malaysia has been affected by the mysterious "deadly" outbreak. It has already spread all over the world yet no cure has been found. Local authorities have urged for any scientific research to halt this outbreak. A statement released on Sunday said they are also affected. "We have no guarantee that either Malaysia's IT market will bounce back or even survive " the spokeperson added.

Click here for full report...

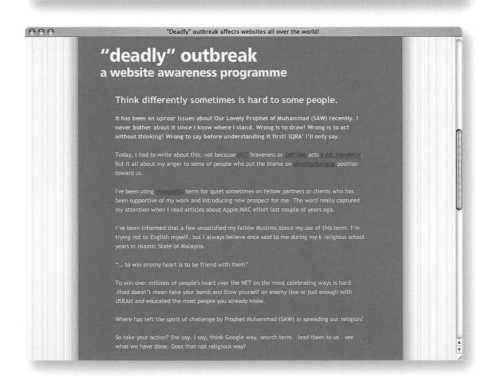

"Deadly" outbreak affects websites all over the world!

"deadly" outbreak
a website awareness programme

Think differently sometimes is hard to some people.

It has been an uproar issues about Our Lovely Prophet of Muhammad (SAW) recently. I never bother about it since I know where I stand. Wrong is to draw! Wrong is to act without thinking! Wrong to say before understanding it first! IQRA' I'll only say.

Today, I had to write about this, not because JIST braveness or Jeff Ooi acts V for Vandetta. But it all about my anger to some of people who put the blame on UmmiKuSayang position toward us.

I've been using evangelist term for quiet sometimes on fellow partners or clients who has been supportive of my work and introducing new prospect for me. The word really captured my attention when I read articles about Apple MAC effort last couple of years ago.

I've been informed that a few unsatisfied my fellow Muslims about my use of this term. I'm trying not to English myself, but I always believe once said to me during my 6 religious school years in Islamic State of Malaysia.

"... to win enemy heart is to be friend with them"

To win over millions of people's heart over the NET on the most celebrating ways is hard. Jihad doesn't mean take your bomb and blow yourself on enemy line or just enough with USRAH and educated the most people you already know.

Where has left the spirit of challenge by Prophet Muhammad (SAW) in spreading our religion?

So take your action? She say. I say, think Google way, search term - lead them to us - see what we have done. Does that not religious way?

www.deadlyoutbreak.com

D: mohd hisham saleh **C:** roby **P:** ian h. chris

A: wahaza extra design studio **M:** www.wahazaextra.com

⊖ achterdeck

home
agentur
leistungen
projekte
kontakt

team kundenliste jobs

Die Mannschaft macht das Schiff.

Wir betreuen den Marktauftritt unserer Kunden in allen relevanten Bearbeitungsphasen. Unsere Stärken sind die Innovationskraft und Geschwindigkeit, mit der wir gute Ideen umsetzen und auf Kundenwünsche eingehen sowie, ganz klar, unser höchst motiviertes, professionelles Team.

Wir verstehen unseren Beruf als Handwerk. Dieses hat viele Facetten und muss wie jedes andere gelernt werden, um hochwertige Lösungen für Internet und Druck garantieren zu können.

Kompetenz durch Erfahrung. Durch unsere bisherigen Arbeiten konnten wir die wichtigen, praktischen Erfahrungen sammeln, die man, wie auch in vielen anderen Bereichen, hier unbedingt benötigt.

Ende 2004 wurde beschlossen, die Fähigkeiten, die uns in den verschiedenen Bereichen auszeichnen, zu bündeln und von nun an offiziell als Team aufzutreten.

Impressum | © achterdeck

MAMBO AWARDS

Mamboaward: Winner for best content and best design with mambo open source is achterdeck.com

⊖ achterdeck

home
agentur
leistungen
projekte
kontakt

Die Werbewerft.

Wir, die Werbeagentur achterdeck aus Uelzen, haben uns auf die Realisierung umfassender Projekte der visuellen Kommunikation spezialisiert. Diese beinhalten das Corporate Design (z.B. Logo, dynamische Websites, Geschäftsausstattung), aber auch klassische Werbung (z.B. Flyer, Plakate, Mailings, Broschüren).

Besuchen Sie unsere Projektbeispiele, um einen Eindruck zu erhalten, was wir für Sie tun können. Hier unser aktuelles Projekt:

Praxis für Therapie & Training

Impressum | © achterdeck

MAMBO AWARDS

Mamboaward: Winner for best content and best design with mambo open source is achterdeck.com

www.achterdeck.com
D: lars wendlandt C: stefan große
A: achterdeck M: www.achterdeck.com

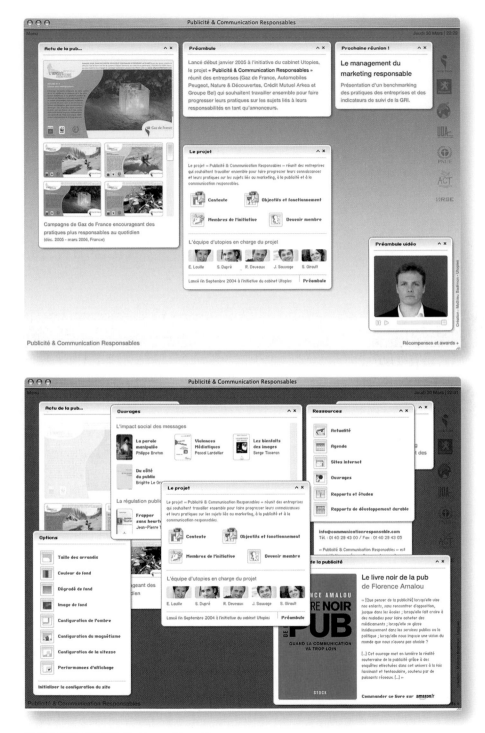

www.communicationresponsable.com

D: mathieu badimon

A: mathieu badimon M: contact@mathieu-badimon.com

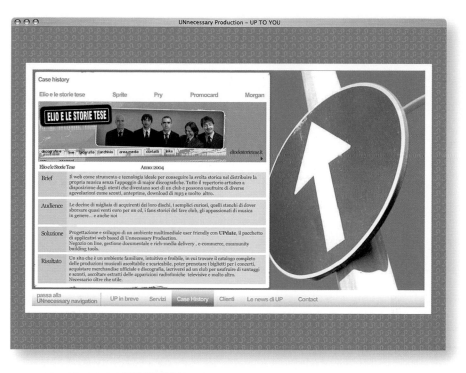

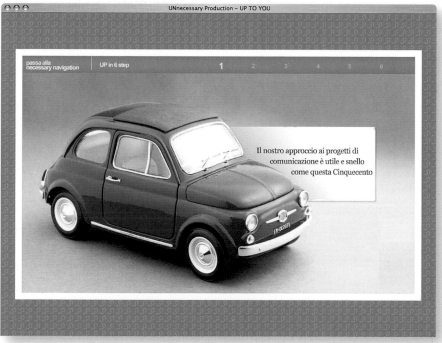

www.unnpro.com

D: fabio berton C: christan giordano P: stefano stella

A: unnecessary production M: sstella@unnpro.com

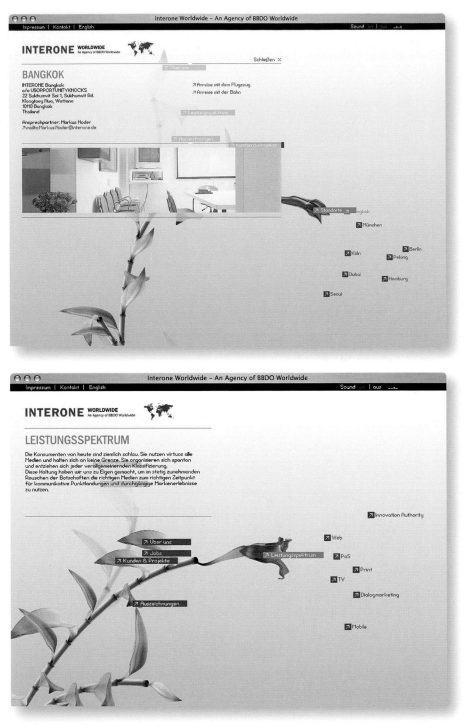

www.interone.de

D: mike john otto, thorben cording, f. genzmer C: l. gerckens P: c. bauer, m. j. otto

A: interone hamburg M: info@interone.de

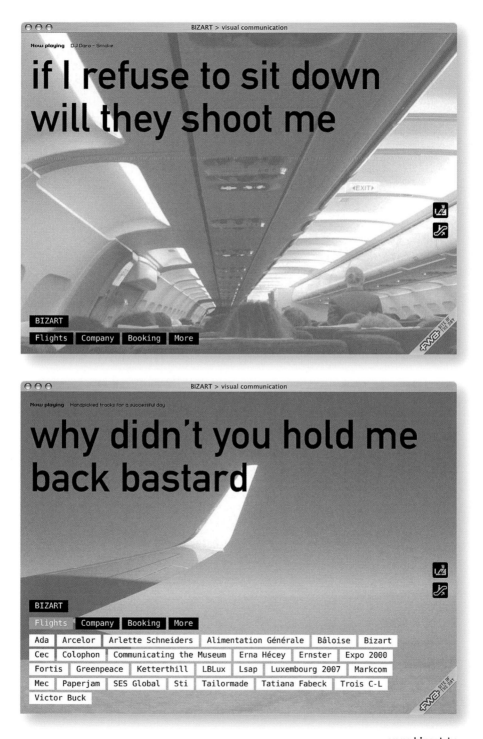

www.bizart.lu
D: laurent daubach C: viktor dick P: raoul thill
A: atelier graphique bizart M: contact@bizart.lu

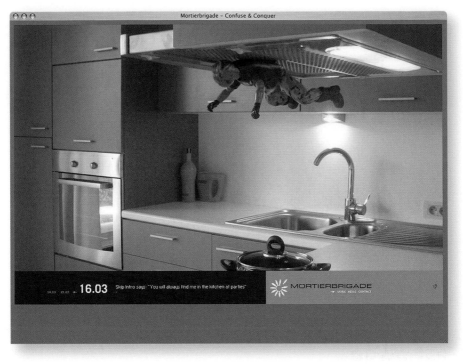

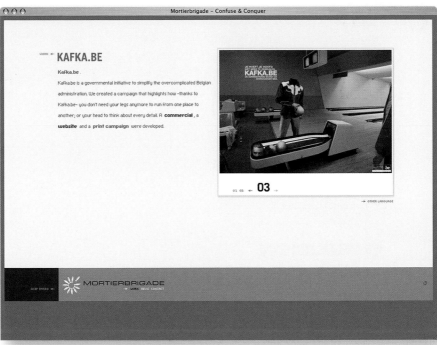

www.mortierbrigade.com
D: group94 P: mortierbrigade
M: info@group94.com

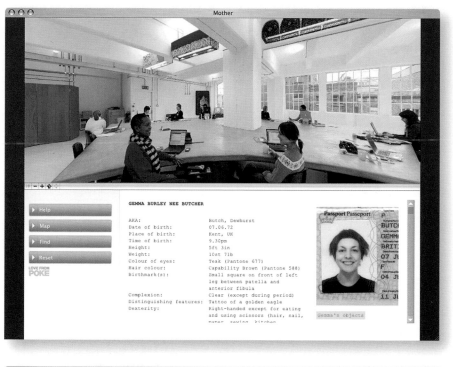

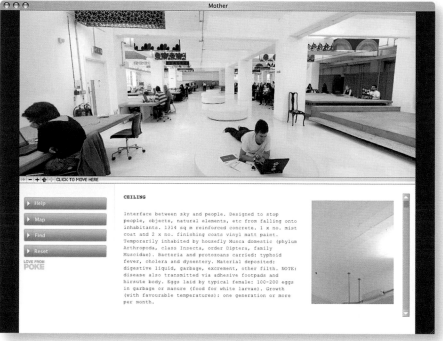

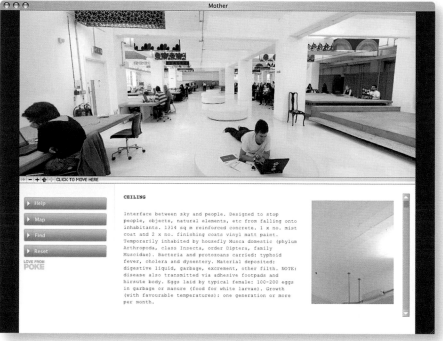

www.motherlondon.com

D: steve pearce, nico nuzzaci C: simon kallgard P: tom hostler

A: poke M: www.pokelondon.com

www.donaireydelaplaza.com

D: marc schmitt

A: donaire y de la plaza M: donaireydelaplaza.com

www.denk.be

D: kenny from denk! **C:** hans van de velde **P:** denk!

A: denk! **M:** hans@novio.be

www.kamikadze.sk
D: brano pepel, vilo csino C: brano pepel
A: kamikadze M: info@kamikadze.sk

www.unart.ch.vu

D: dominik buser

A: 19m2 atelierkollektiv M: dominik@19m2.ch

www.trustinwax.de
D: christian heidemann
A: christian heidemann - media design M: www.still-alive.de

www.soundfell.com

D: davy van den bremt

A: davy van den bremt M: www.davyvandenbremt.be

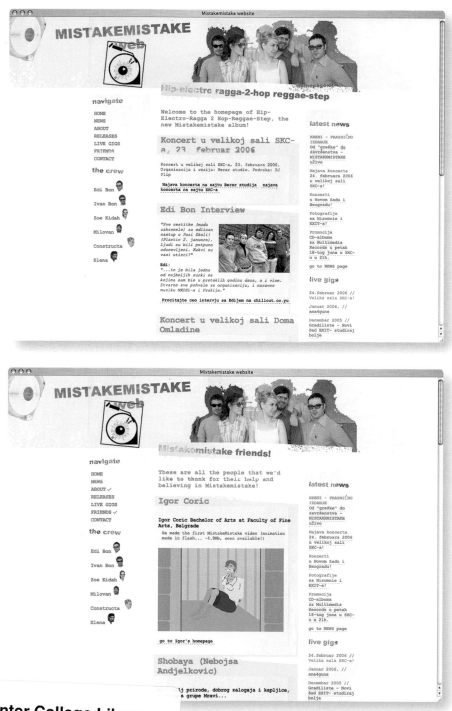

www.mistakemistake.com
D: denis radenkovic
A: 38one M: denis@38one.com

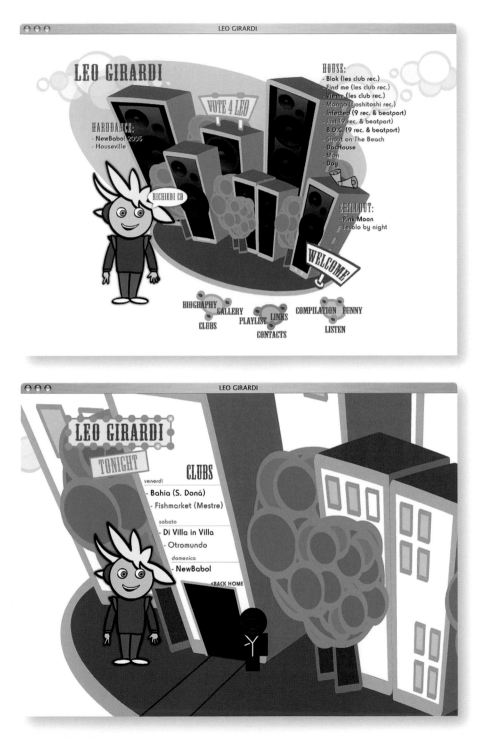

www.leogirardi.com
D: davide g. aquini
M: davide.aquini@libero.it

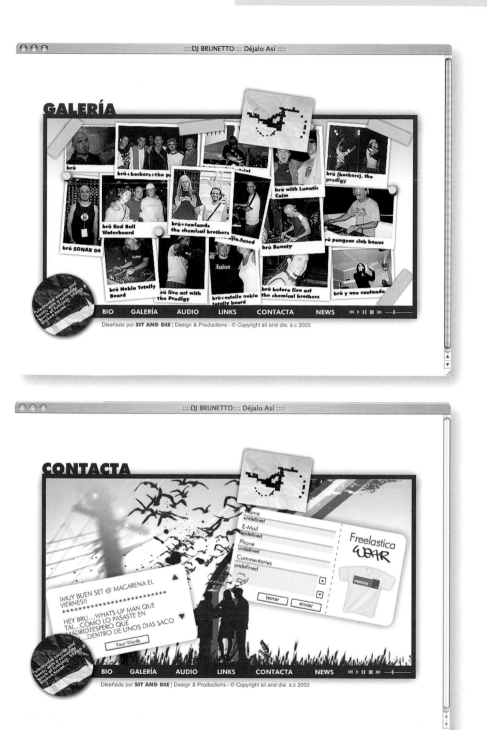

www.djbrunetto.com

D: pedro j. saavedra C: pedro j. saavedra P: irene novo
A: sit and die M: sitanddie@sitanddie.com

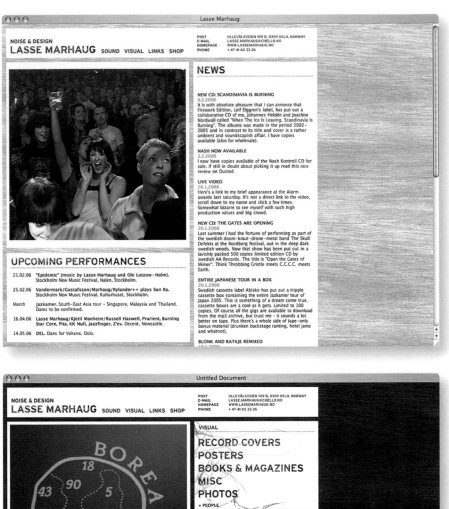

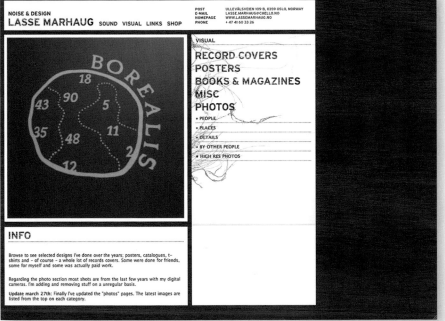

www.lassemarhaug.no

D: håvard gjelseth

A: this way design M: hgjelseth@thiswaydesign.com

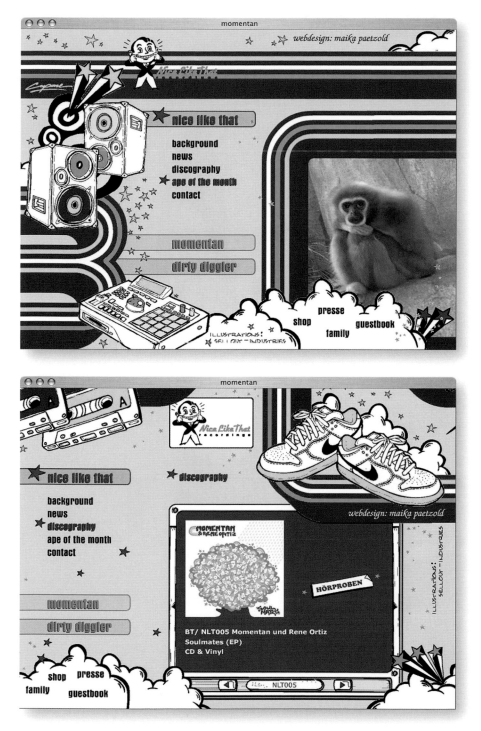

www.nicelikethat.de

D: maika paetzold

A: mettage design M: www.mettage-design.de

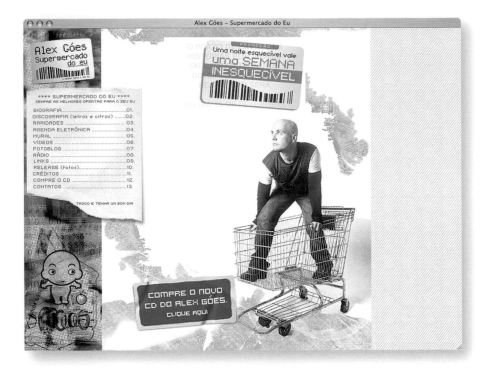

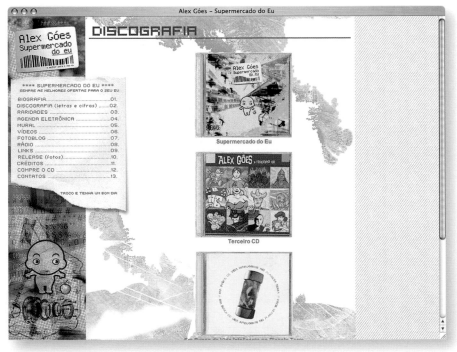

www.alexgoes.com.br

D: kaike C: max capellani P: kaike

A: elipse comunicação de marketing M: kaike@elipseweb.com.br

www.thebellemusic.com
D: alejandro ochoa alonso
M: contacto@thebellemusic.com

justforthefofit.com

D: todd purgason, brian miller C: casey corcoren P: sean gibson

A: juxt interactive M: juxtinteractive.com

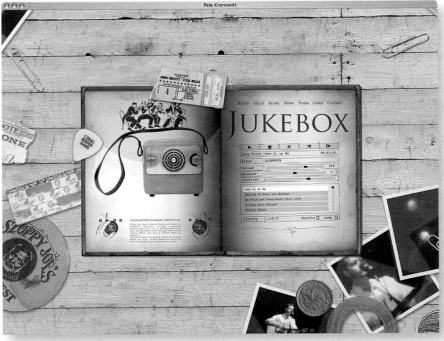

www.petekronowitt.com

D: cristian strittmatter C: gabriel toledano P: sandra strittmatter

A: from scratch design studio M: contact@fromscratch.us

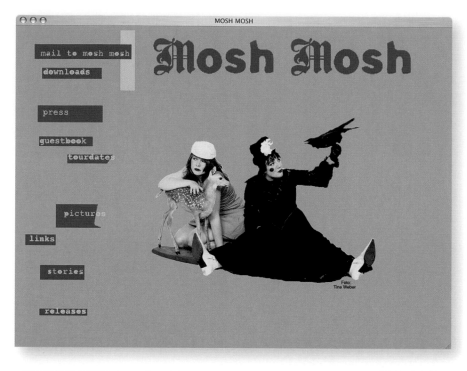

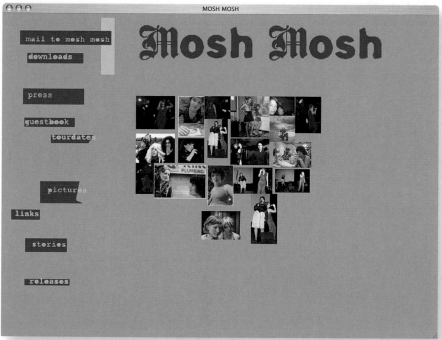

www.mosh-mosh.com

D: lady mosh

A: mosh art M: info@mosh-mosh.com

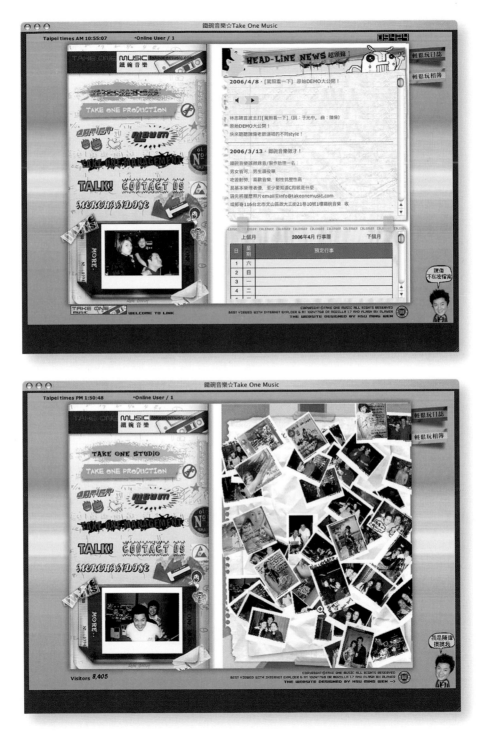

www.takeonemusic.com

D: ming-wen hsu

A: ming-wen hsu, design workshop M: dylan@mingwen.idv.tw

www.dj-fudido.com

D: mathieu saudel

A: mathieu saudel M: mathieu.saudel@wanadoo.fr

www.elstarmusic.com

D: bas boerman

A: adibas.nl M: info@adibas.nl

www.projekt67.com

D: simon van weelden

A: reddogproducts M: simon@projekt67.com

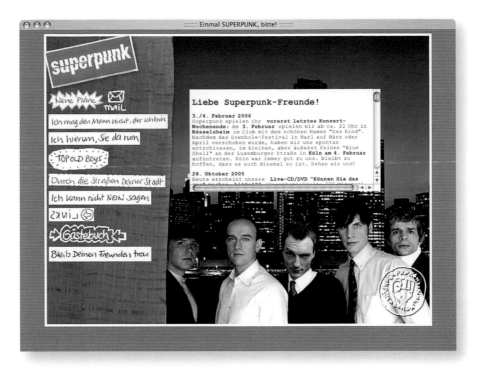

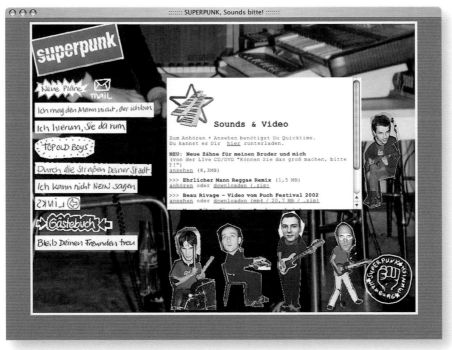

www.superpunk.de

D: kerstin holzwarth

A: kerstin holzwarth graphic design M: www.kokong.de

www.way-of-orient.com

D: rémy rey de barros

M: remy.reydebarros@caramailmax.com

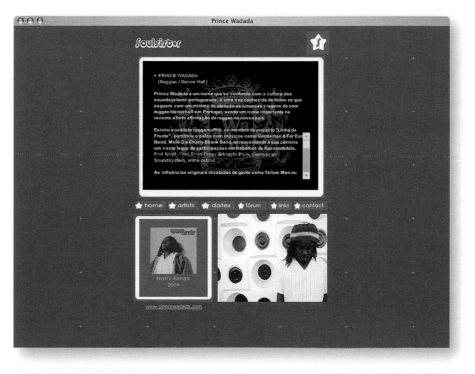

www.soulsistar.com

D: joana inês souza dias

M: joaninex@hotmail.com

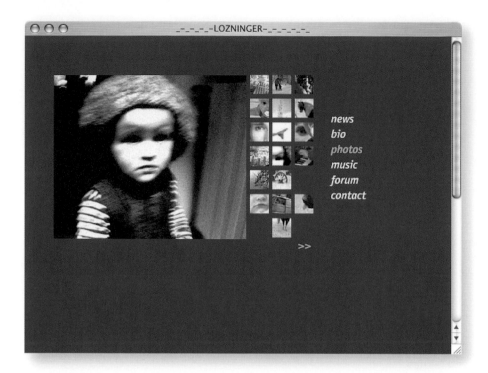

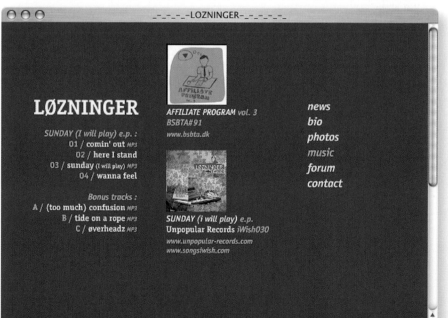

www.the-asura.com
D: andre weier
A: nalin-design M: www.nalin-design.com

www.mosesmusic.nl

D: stephan de graaf, johan den heijer C: s. de graaf P: j. den heijer, pauline schöder

A: pixelfarm, moses.music M: info@mosesmusic.nl

www.mangalavallis.it
D: max cavalli cocchi
M: max.cavallicocchi.it

www.headlokk.com

D: alexander preböck

A: artefuck't M: headlokk@gmx.com

www.300yearslater.com
D: sam hayles C: joolz P: sam hayles
A: dose-productions M: www.dose-productions.com

www.wodb.ru

D: timoshenkov **C:** timoshenkov **P:** oding

A: artcifra **M:** www.artcifra.com

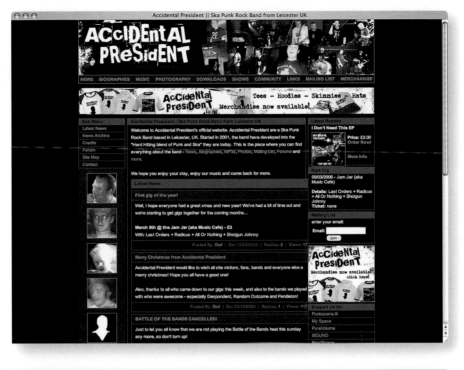

www.accidental-president.co.uk

D: stefan ashwell

M: band@accidental-president.co.uk

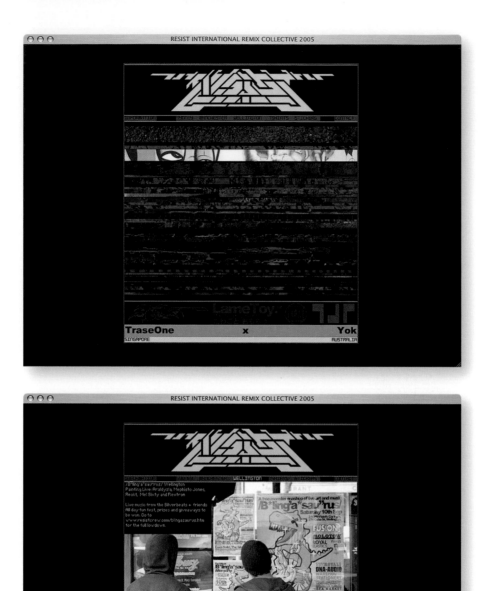

www.resistcrew.com
D: tom painter
A: tdpstudio M: info@tdpdesign.com

::: cleanoceanproject :::

There's no need to explain the irreversible impact pollution has on our environment.
Unfortunately, it's very obvious. But there is definitely a need for action. And this change
of attitude has to start at home, not only at the beach. The Cleanoceanproject lives this idea.
And you're welcome to help. All it needs is a decision. <click para continuar>

www.CLEANOCEANPROJECT.org
<skip intro>

::: cleanoceanproject :::

04.12.2005 v
13.03.2005
27.11.2004
25.09.2004
05.09.2004
29.08.2004
06.06.2004
25.04.2004
30.11.2003
16.11.2003

beach clean up at the still virgen north shore of fuerteventura,
aprox. 100 big 100 liter bags and 2 tons of big items!!
many thanks to all people helping us out that day...

news

events

friends of cop

ocean care clothes

links

contact

press

newsletter

more pictures >

www.CLEANOCEANPROJECT.org
<home>

www.cleanoceanproject.org
D: rafaela stattmiller
A: www.oceano-digital.com M: info@oceano-digital.com

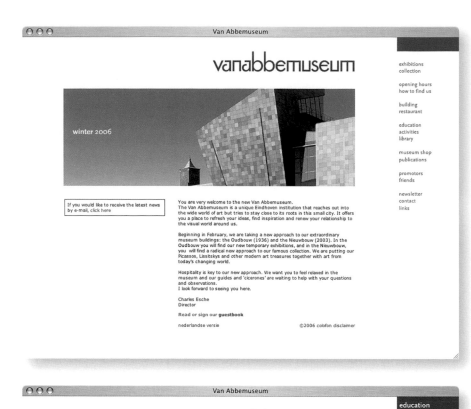

vanabbemuseum

exhibitions
collection

opening hours
how to find us

building
restaurant

education
activities
library

museum shop
publications

promotors
friends

newsletter
contact
links

winter 2006

If you would like to receive the latest news by e-mail, click here

You are very welcome to the new Van Abbemuseum.
The Van Abbemuseum is a unique Eindhoven institution that reaches out into the wide world of art but tries to stay close to its roots in this small city. It offers you a place to refresh your ideas, find inspiration and renew your relationship to the visual world around us.

Beginning in February, we are taking a new approach to our extraordinary museum buildings: the Oudbouw (1936) and the Nieuwbouw (2003). In the Oudbouw you will find our new temporary exhibitions, and in the Nieuwbouw, you will find a radical new approach to our famous collection. We are putting our Picassos, Lissitskys and other modern art treasures together with art from today's changing world.

Hospitality is key to our new approach. We want you to feel relaxed in the museum and our guides and 'cicerones' are waiting to help with your questions and observations.
I look forward to seeing you here.

Charles Esche
Director

Read or sign our **guestbook**

nederlandse versie ©2006 colofon disclaimer

Van Abbemuseum

vanabbemuseum

education

exhibitions
collection

opening hours
how to find us

building
restaurant

education
activities
library

museum shop
publications

promotors
friends

newsletter
contact
links

• information in the museum

• infotexts

• novel

• El Lissitzky site

• [activities]

Education

The Education and Interpretation Department offers a wide range of activities to match the tastes of a diverse museum audience. The museum has special programmes for schools and its own courses for adults and children. These are all in Dutch.

Various types of guided tours are offered, including an architectural tour of the new building and a tour of masterpieces in the collection. For groups, guided tours are offered in Dutch, French, German and English. Click Guided Tours for more information.

The Getty Research Institute has produced an excellent website presenting the life and work of the artist El Lissitzky. Together with the Getty Research Institute, the Van Abbemuseum has made a Dutch translation of the website. This can be accessed through the Dutch-language section of the Van Abbemuseum's website.

More information

For questions on special programs and guided tours, please contact the Education and Interpretation Department, PO Box 235, 5600 AE Eindhoven, the Netherlands, e-mail: educatie@vanabbemuseum.nl

www.vanabbemuseum.nl

D: bic multimedia

A: bic multimedia M: www.bicmultimedia.nl

www.camaranavarra.com

D: david alegria C: spi P: camara navarra

A: ken M: www.ken.es

fame.ifdep.pt

D: filipe cavaco, adriano esteves, a. r. gomes **C:** alexandre r. gomes

A: bürocratik **M:** alex@burocratik.com

○ ○ ○ Seeing is believing.ca

seeingis**believing**

using new technologies to change the world

Joey's BLOG:
A video activist's diary from the ground in the Philippines.

Teachers' E-ZINE:
Study guides for understanding human rights and new technologies.

SEE the film:
Check out when the film "Seeing is Believing" is playing in your town.

video
Double bill in our video screening room. Explore the film online and recap the history of the handicam revolution.

CONTRIBUTE to Nakamata's campaign to reclaim ancestral lands in the Philippines.

WRITE a letter:
Join our campaign to demand justice in Nakamata territory.

BUY THE FILM:
Get your own VHS copy of "Seeing is Believing".

NEW DVD IN RELEASE!:

support fund
Joey Lozano — star of *Seeing is Believing* film — died on September 16, 2005. Friends and colleagues have created the Lozano Support Fund for his family...

Participate:
Join our FORUM and read the transcript of the WEB CHAT.

PRESS KIT:
Background information about the film, high-res photos and more.

NEW FEATURE:
New technologies in the hands of indigenous people.

technology
Discover how new technologies are causing revolutions around the globe.

Produced by Necessary Illusions in association with CBCnewsWORLD and SRC/RDI

with the participation of THE CANADIAN INDEPENDENT FILM & VIDEO FUND

Canadä

We acknowledge the financial support of the Government of Canada through the Human Rights Program, a program of the Department of Canadian Heritage.
Nous reconnaissons l'appui financier du gouvernement du Canada par le biais du Programme des droits de la personne, un programme de Patrimoine canadien.

○ ○ ○ Seeing is believing: Indigenous/new Tech

seeingis**believing** episode 1: autumn 2002

video campaign technology

indigenous/new tech

- GPS mapping: Risking lives
- The news source of Indian Country
- Tracking moose with GPS
- Red indgena wires Latin America
- Reznet fills journalistic void
- The battle over maps and names
- Native technology: A two-way street
- New tech: A matter of survival!

When New Technologies are powered by Indigenous knowledge, the results can be amazing.

In this special collection of stories, we focus on how Indigenous Peoples around the world are picking up a multitude of new technologies to defend their rights, and protect their communities. From GPS mapping in dangerous conditions in the Philippines, to giving voice to young Aboriginal journalists in North America.

Select any of the eight stories in the left sidebar, and begin exploring the possiblities.

technology
cell phone indigenous/new tech

teachers' e-zine | forum | chat | credits | about the film | press room | resources and links

www.seeingisbelieving.ca
D: eric smith **C:** christopher murtagh **P:** katerina cizek, sandra dametto
M: kcizek@yahoo.com

www.pan-belgium.be

D: vizzini romy C: serge de wever, j-f collier, d. küppers, r. vizzini P: pan belgium
M: info@romy-vizzini.be

www.constructiondurable.com

D: mathieu badimon P: utopies

A: mathieu badimon M: contact@mathieu-badimon.com

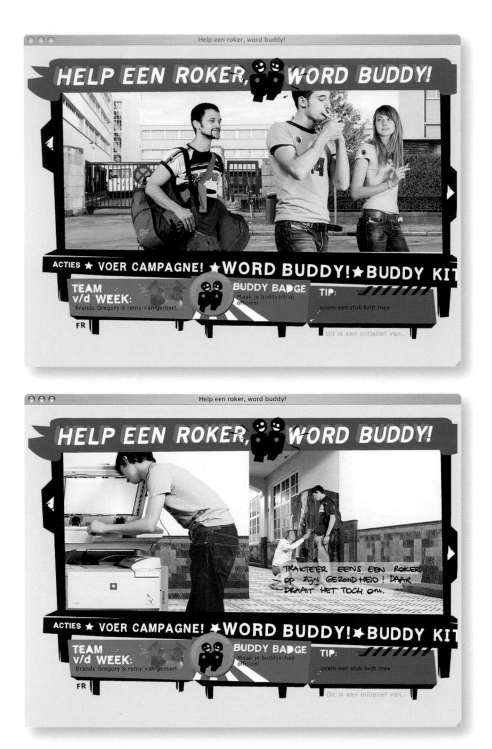

www.helpeenroker.be
D: ilse pierard C: nascom P: carl de mey
A: snow M: www.snowbylgf.be

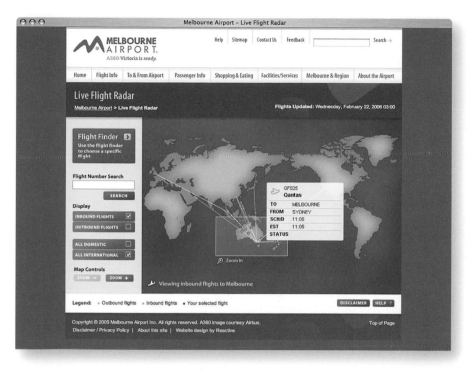

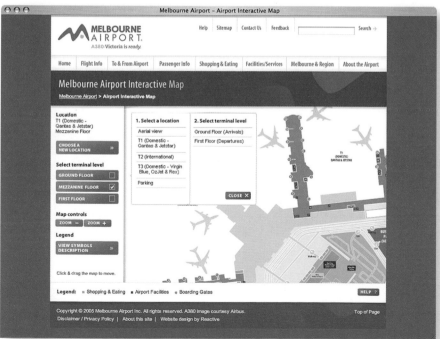

www.melbourne-airport.com.au
D: abby kelly C: ross richard, dan oxnam P: tim o'neill
A: reactive media M: chrisf@reactive.com

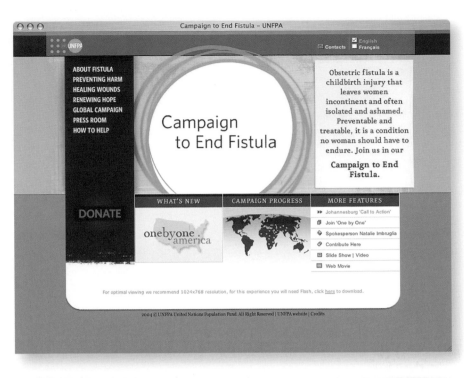

www.endfistula.org

D: allysson lucca P: micol zarb, saira stewart, alvaro serrano

A: unfpa M: www.unfpa.org

www.unfpa.org/ms
D: allysson lucca P: alvaro serrano
A: unfpa M: www.unfpa.org

www.ateliersteiner.de
D: patrick steiner C: sebastian petters
A: 4wd media M: kontakt@4wdmedia.de

Mathieu Bernard–Reymond

subscribe / inscrivez-vous

disparitions, sans titre, n°75, 2003 Previous | Next

MBR: newest

www.monsieurmathieu.com
D: mathieu bernard-reymond
M: info@monsieurmathieu.com

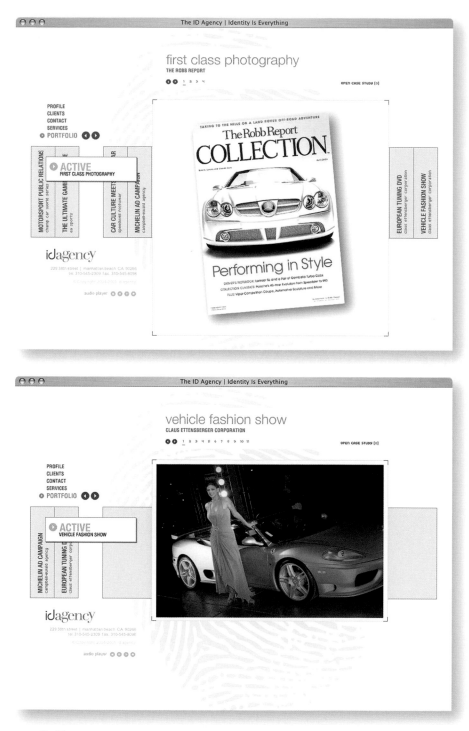

www.theidagency.com
D: greg huntoon C: jesse white-cinis P: greg huntoon
A: go farm M: www.gofarm.la

somemightsay.at

SIGURD BUCHBERGER
Neuhauserweg 29
4040 Linz
Austria

Wedekind
Wedekind Opiates Presentation
Chelsea, Vienna

somemightsay.at

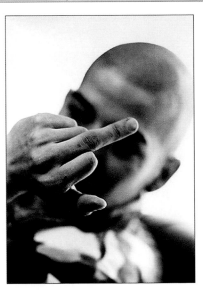

SIGURD BUCHBERGER
Neuhauserweg 29
4040 Linz
Austria

www.somemightsay.at
D: sigurd buchberger
A: webapplikationen.at M: sigurd@somemightsay.at

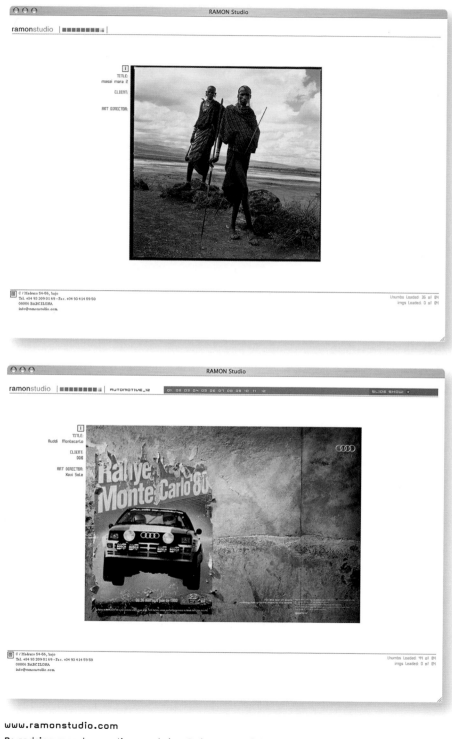

www.ramonstudio.com

D: rodrigo mendoza, eliana sobrino C: jorge agudelo P: s3design-studio
A: s3design-studio.com M: s3@s3design-studio.com

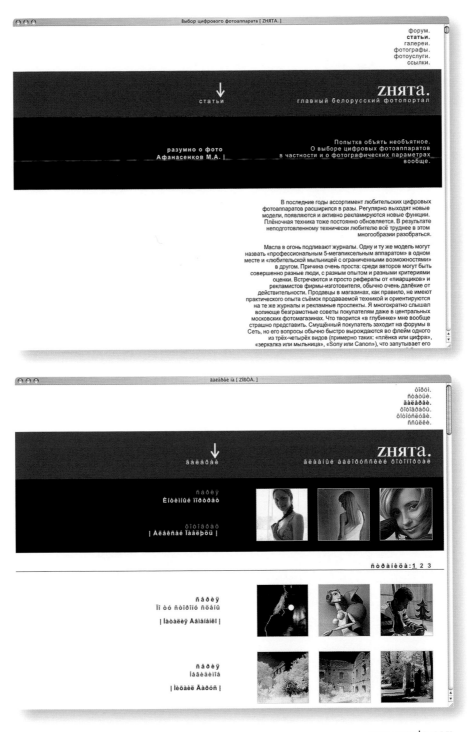

www.znyata.com

D: artur vakarov

M: sm@adliga.com

www.maaske.de

D: karolin maaske C: marc hämmerle P: karolin maaske, karsten maaske

A: ostkinder.de M: karo@ostkinder.de

www.marexx.net
D: marek böttcher
A: marexx.net M: info@marexx.net

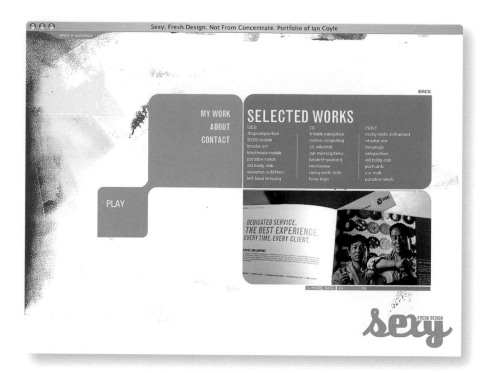

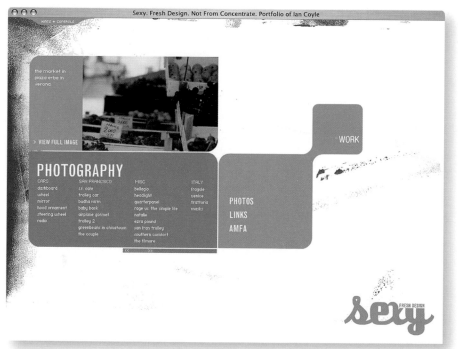

www.hello-sexy.com

D: ian coyle

A: sexy M: www.hello-sexy.com

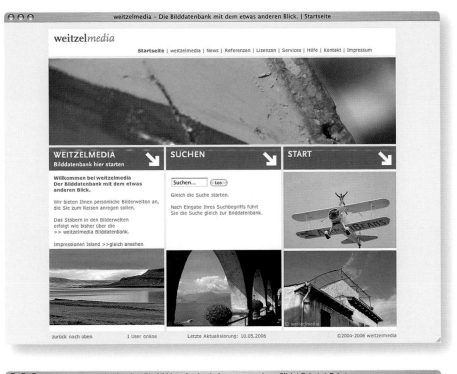

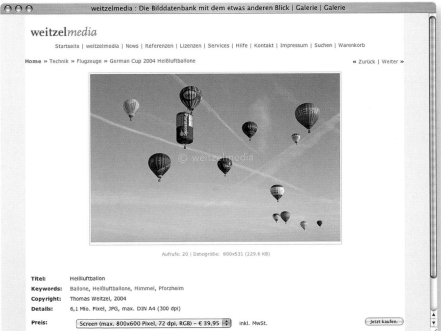

www.weitzelmedia.de

D: thomas weitzel

A: weitzeldesign M: info@weitzelmedia.de

www.studio-mandarine.fr

D: aurélien durand C: benoît germond P: aurélien durand

A: setec multimédia M: aurelien@setec-multimedia.fr

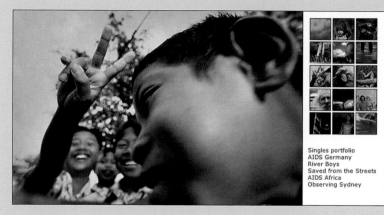

www.chechapman.com
D: karl hedner
A: julian kommunikation M: karl@julian.se

www.sonjamueller.org
D: matthias netzberger C: torsten haertel
A: less rain M: www.lessrain.com

www.kubikfoto.de

D: ole leifels, holger weber C: adrian runte
A: werberw M: info@kubikfoto.de

www.theircircularlife.it
D: lorenzo fonda **C:** davide terenzi
M: info@theircircularlife.it

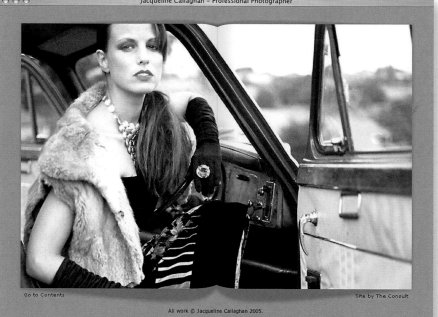

www.jacquelinecallaghan.co.uk
D: alex atkinson P: rebecca keast
M: www.theconsult.com

www.virginieblachere.com
D: sandra leister, alexander schäfer C: dorothee bächle P: virginie blachère
A: 372dpi – design print internet M: www.372dpi.com

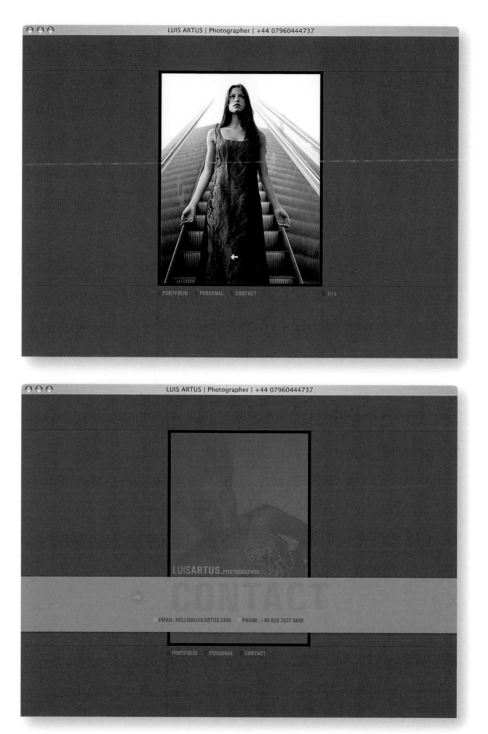

www.luisartus.com

D: eduardo de felipe

A: eduardo de felipe **M:** eduardo@elelec.com

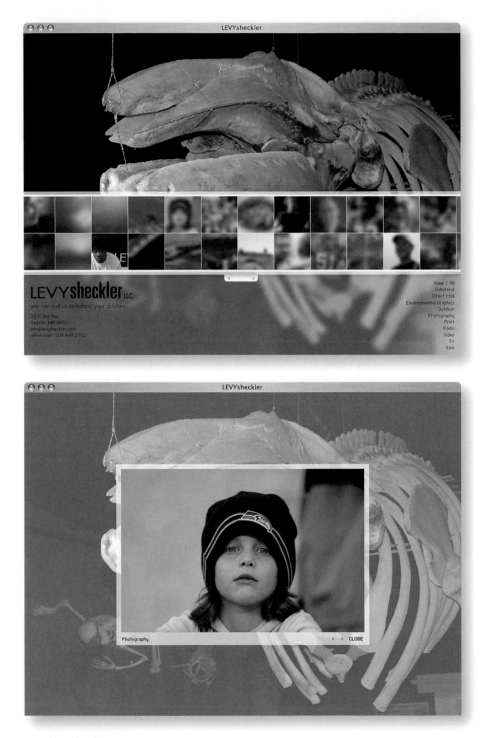

www.levysheckler.com
D: matthew fordham **C:** matthew fordham **P:** marisa mckay
A: revolver creative **M:** www.revolvercreative.com

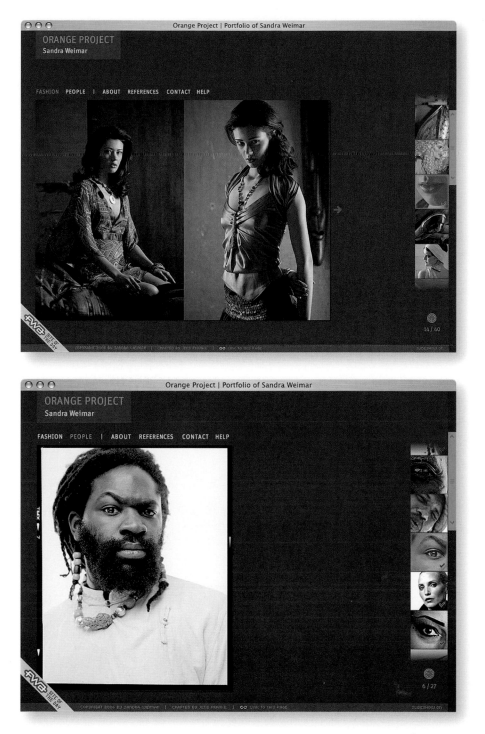

www.orange-project.com
D: jens franke
M: contact@jensfranke.com

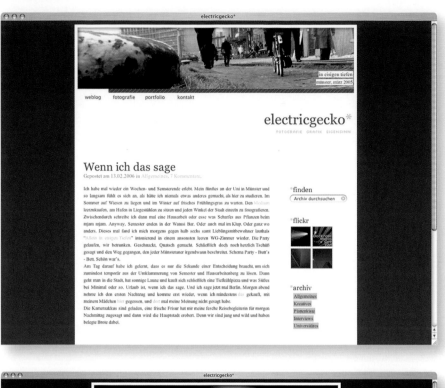

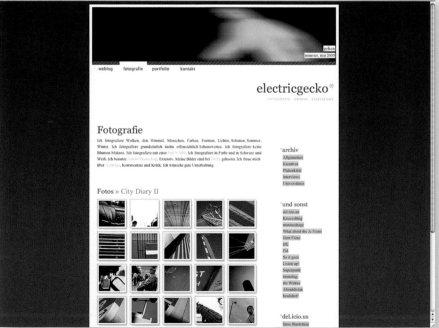

www.electricgecko.de

D: malte müller

A: electricgecko* M: info@electricgecko.de

www.jesperludvigsen.dk
D: anders ojgaard
A: anders ojgaard kommunikation M: www.ojgaard.dk

www.franciscoaguila.com
D: felipe alvarado
A: felipe alvarado M: felipealvarado@manquehue.net

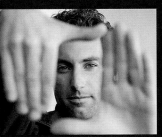

www.redpathstudios.com
D: group94 P: redpath studios
M: info@group94.com

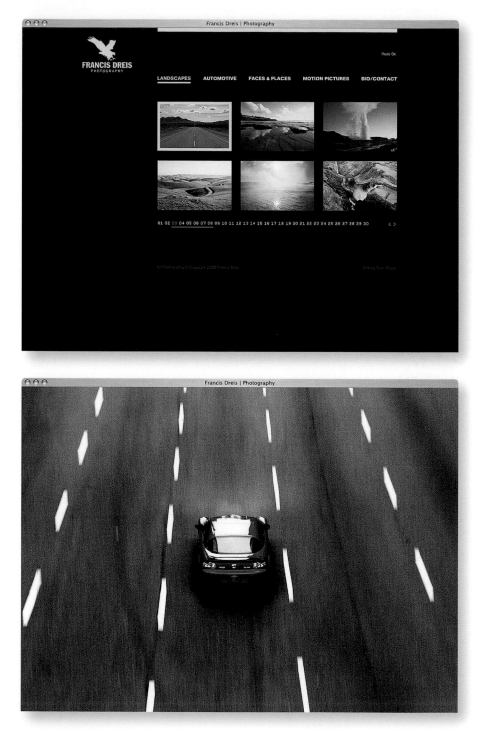

francisdreis.com
D: ozzy benn
A: toxic design **M:** toxicdesign.com

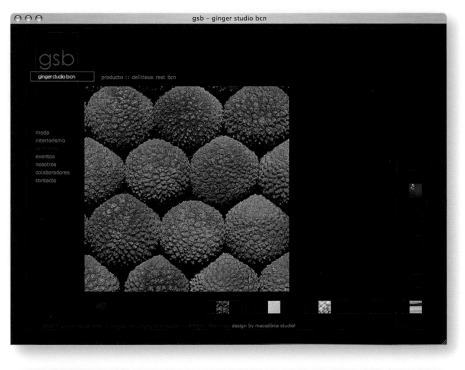

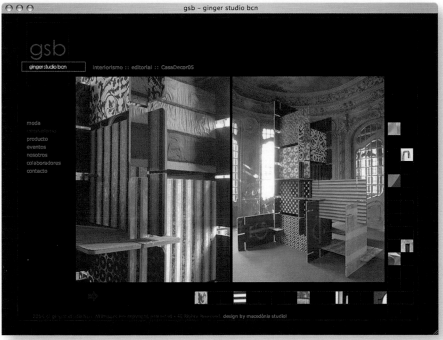

www.gingerstudiobcn.com
D: andrea llorca
A: macedònia studio! M: info@macedonia-studio.com

normajeanmarkus.com
D: curtis mcclain
A: sofierce.com M: curtis@sofierce.com

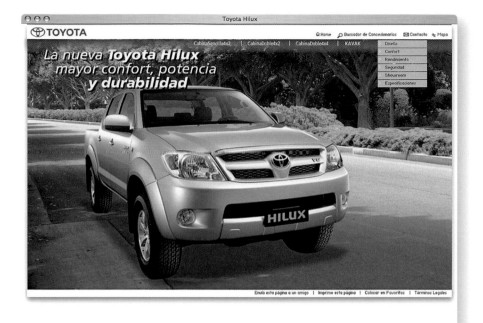

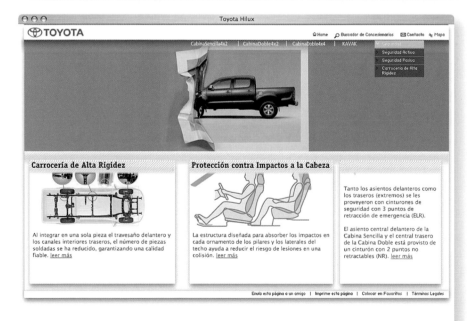

www.hilux.com.ve

D: ciro urdaneta C: luis giraldez, rodolfo sauce P: ciro urdaneta

A: image & web solution M: curdaneta@iws.com.ve

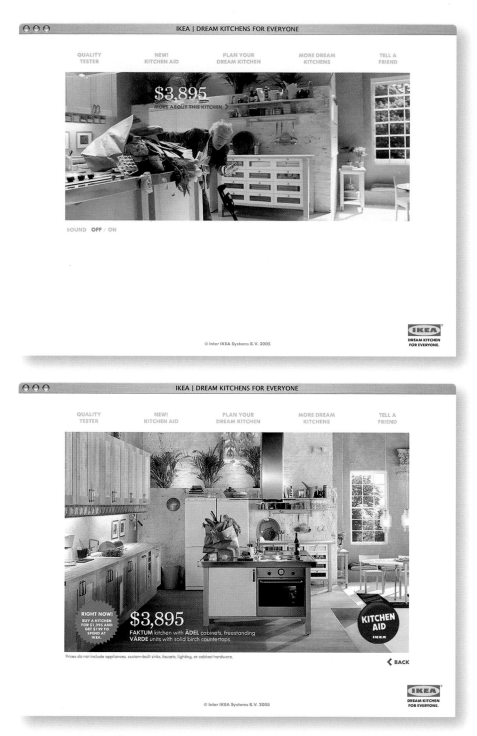

demo.fb.se/e/ikea/dreamkitchen/site/default.html
D: forsman & bodenfors
M: info@fb.se

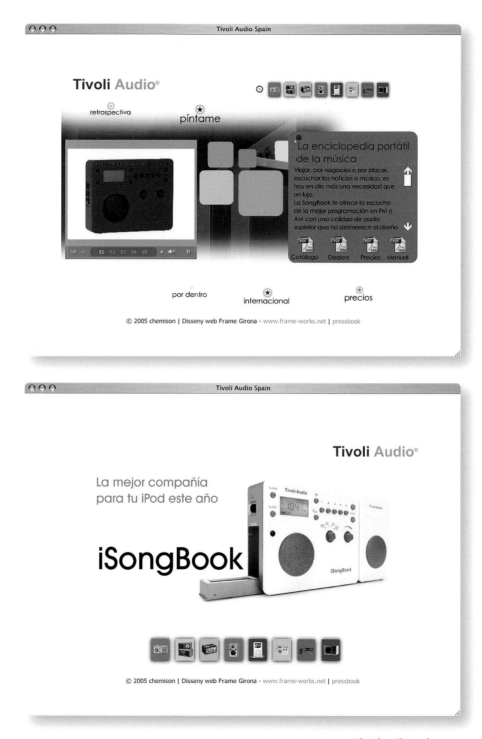

www.tivoliaudiospain.com
D: frame girona
A: frame girona M: www.frame-works.net

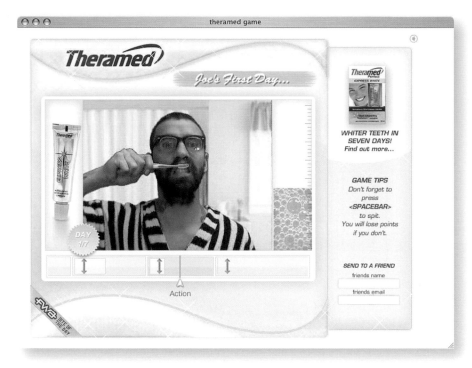

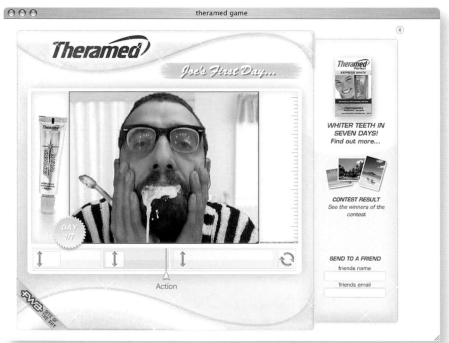

www.helpjoe.be

D: stephane leborgne, kristof saelen C: sakri rosenstrom, patrik fagard

A: nascom M: www.nascom.be

www.freedominteractivedesign.com/demos/digitas/index.htm
D: digitas **C:** shea gonyo, josh ott **P:** mark ferdman
A: digitas **M:** info@freedominteractivedesign.com

www.dnb-mag.com

D: stefan schröder C: marco matthäus

A: pixelsinmotion M: marco@pixelsinmotion.de

www.globosfestival.com
D: bibi gloaguen C: alberto álvarez
A: insane M: crash@insanelab.net

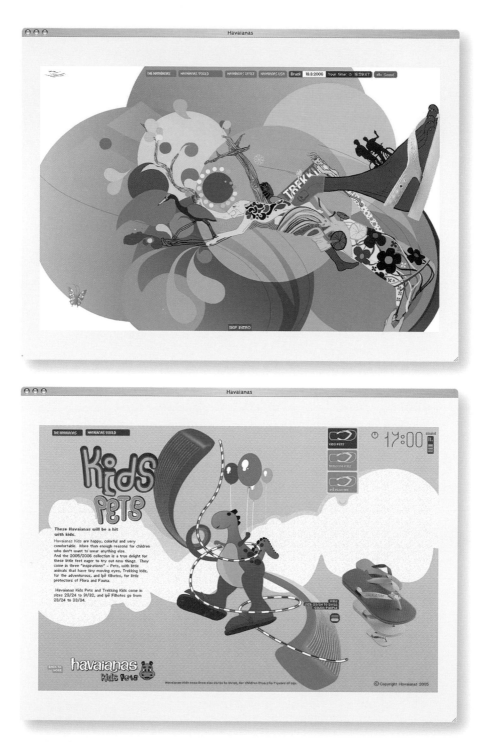

www.havaianas.com.br

D: adhemas batista C: flávio ramos P: ricardo almeida
A: almapbbdo M: www.almapbbdo.com.br

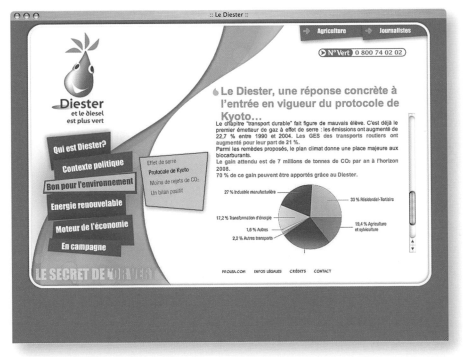

www.diester.fr

D: guillaume garnier

A: ligaris macluhan's M: contact@diester.fr

www.eurotexnastri.it

D: alessandro demicheli, nicola destefano

A: carsons&co advertising M: a.demicheli@carsons.it

www.sockmonkeydrawer.com

D: kimlan cornell C: kimlan cornell, kevin cornell P: kimlan cornell

M: info@sockmonkeydrawer.com

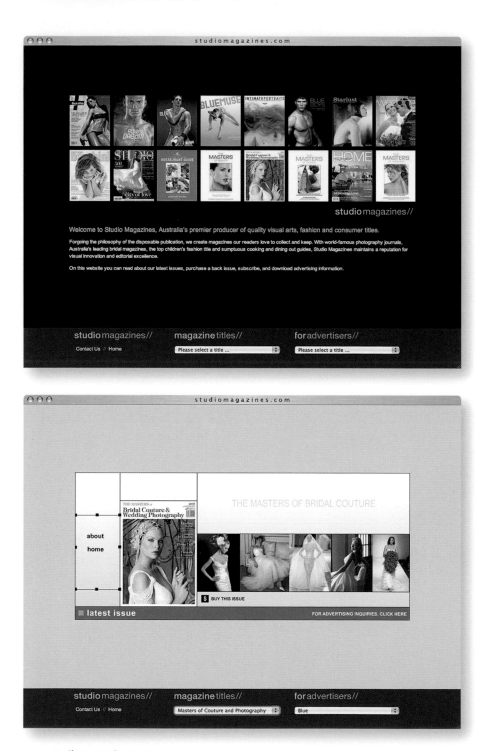

www.studiomagazines.com

D: daniel mcphee, marise watson C: daniel mcphee P: marise watson

A: soda creative M: marise@studio.com.au

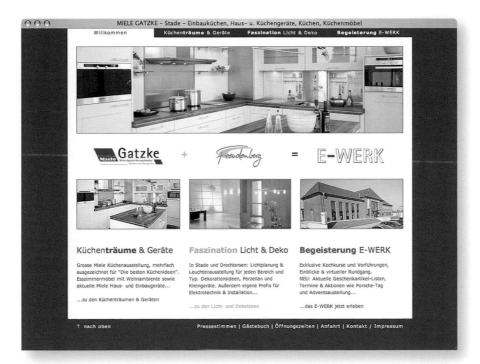

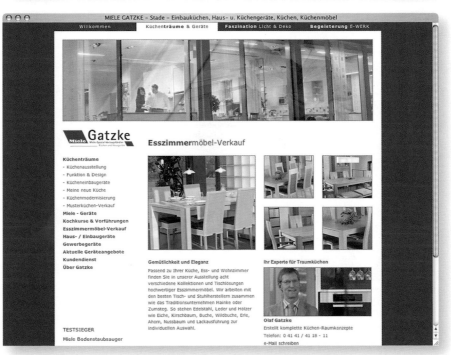

www2.e-werk-stade.de

D: konstantin minster C: konstantin minster P: markus albrecht

A: city-map stade gmbh M: info@stade.city-map.de

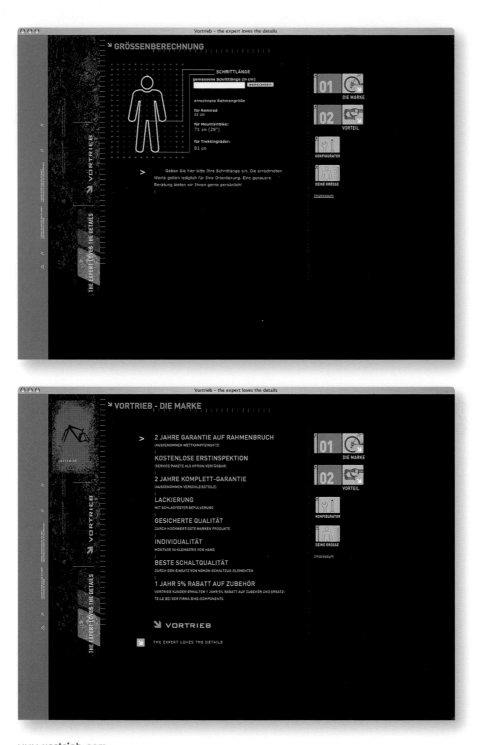

www.vortrieb.com

D: andre berkmüller

A: berkmueller visuelle kommunikation M: www.berkmueller.de

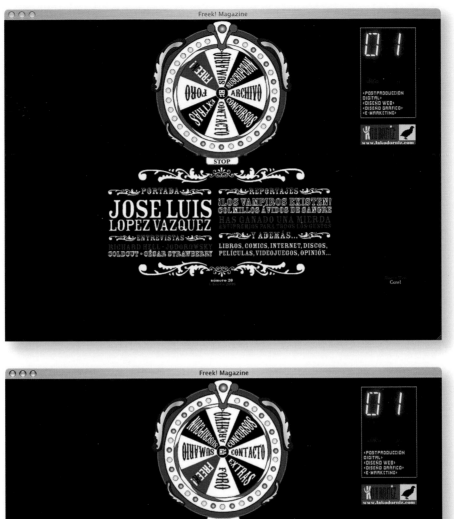

www.freekmagazine.com

D: adolfo fernandez C: adolfo fernandez P: la mota ediciones s.l.
A: cerol diseño M: info@cerol.com

ANDREA JUNGWIRTH – Neue Medien

A N D R E A J U N G W I R T H
www.einfachgesagt.com

ZUR PERSON REFERENZEN KONTAKT IMPRESSUM | PREISÜBERSICHT

Neue Medien

Digitale Texte werden nicht gelesen sondern
gescannt. Die LeserInnen überfliegen den
Text, lesen zuerst Überschriften, Einleitung und
Zwischenüberschriften und entscheiden dann,
ob der Inhalt für sie relevant ist. Information
muss zweckorientiert und leicht konsumierbar
sein, der Text gut strukturiert.

Mein KnowHow
→ Struktur → Text → Bild → Style Guide

✉ WEITEREMPFEHLEN

BY NIXDA + PARTNERS

■ Text
▶ Folder & Broschüren
▶ Neue Medien
▶ Vorträge & Workshops

■ Bild
lizenzfrei
▶ Individuelle Fotoserie
▶ Fotografie
▶ Foto-CDs (PopUp)
▶ Bildqualität

■ & mehr
▶ Ernährung
▶ Gesunde Küche

ANDREA JUNGWIRTH – Ernährung

A N D R E A J U N G W I R T H
www.einfachgesagt.com

ZUR PERSON REFERENZEN KONTAKT IMPRESSUM | PREISÜBERSICHT

Ernährung

"Frisch, bunt, abwechslungsreich und der
Jahreszeit entsprechend, das ist gesunde
Ernährung. Nehmen Sie sich Zeit zum Kochen
und Genießen!"

Ökotrophologin Andrea Jungwirth

Mein KnowHow
→ Beratung und Vorträge
→ Hilfe zur Ernährungsumstellung
→ Personal nutrition guide

✉ WEITEREMPFEHLEN

BY NIXDA + PARTNERS

■ Text
▶ Folder & Broschüren
▶ Neue Medien
▶ Vorträge & Workshops

■ Bild
lizenzfrei
▶ Individuelle Fotoserie
▶ Fotografie
▶ Foto-CDs (PopUp)
▶ Bildqualität

■ & mehr
▶ Ernährung
▶ Gesunde Küche

www.einfachgesagt.com
D: jürgen oberguggenberger
A: nixda + partners **M:** juergen@nixda.at

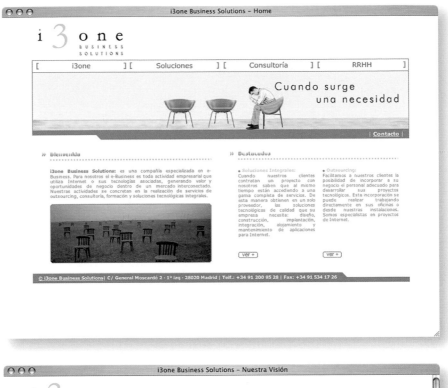

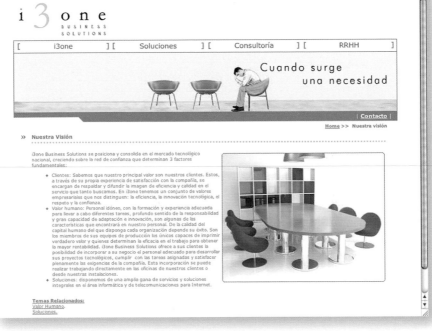

www.i3one.com

D: arturo sanz

A: i3one bussines solutions M: asanz@i3one.com

Cooking Crew | styling & food

menu

Cooking Crew &

styling & food

ⓘ klik hier voor extra informatie

Wanneer
Cooking Crew styling & food ?

* Bijvoorbeeld bij een huwelijk, een nieuw pand dat betrokken wordt, een bijzondere verjaardag, een afscheid, een zoveel-jarig bestaan, of welke gelegenheid maar denkbaar is. Met bijvoorbeeld familie, vrienden, in werkkring, met zakenrelaties, in een kleine of grotere groep. In eigen huis, in het nieuwe kantoor, op een speciale locatie, of waar dan ook (de Crew werkt voornamelijk binnen de provincie Utrecht, maar overleggen kan altijd).

* De Crew zorgt, met haar Crew-leden voor (een groot deel van) de voorbereiding en de uitvoering en de 'sores' achteraf. Geen gestress van tevoren en tijdens, en daarna het hele zaakje weer keurig op orde! Alles uit handen geven, het enige wat hoeft is aandacht geven aan de gasten.

site by frismedia.nl

Cooking Crew | styling & food

Boerenkool met kerst

Een gezond en niet-moeilijk gerecht, om lekker bij de televisie te eten, the day after....
(de hoeveelheden staan in het recept, maar het zijn allemaal ongeveer-hoeveelheden, vertrouw op je intuïtie en smaak):

Wat is er nodig voor het een:

Balsamicoazijn
Wijnazijn
Sherry
Suiker
Kaneelpoeder
Vier gedroogde vijgen

Doe 20 ml balsamicoazijn, 20 ml wijnazijn en 30 ml sherry in een pan en voeg 1 eetlepel suiker en een theelepel kaneelpoeder erbij.

lees verder 1 2 3 4 5

menu

&

Wanneer
Cooking Crew styling & food ?

* Bijvoorbeeld bij een huwelijk, een nieuw pand dat betrokken wordt, een bijzondere verjaardag, een afscheid, een zoveel-jarig bestaan, of welke gelegenheid maar denkbaar is. Met bijvoorbeeld familie, vrienden, in werkkring, met zakenrelaties, in een kleine of grotere groep. In eigen huis, in het nieuwe kantoor, op een speciale locatie, of waar dan ook (de Crew werkt voornamelijk binnen de provincie Utrecht, maar overleggen kan altijd).

* De Crew zorgt, met haar Crew-leden voor (een groot deel van) de voorbereiding en de uitvoering en de 'sores' achteraf. Geen gestress van tevoren en tijdens, en daarna het hele zaakje weer keurig op orde! Alles uit handen geven, het enige wat hoeft is aandacht geven aan de gasten.

site by frismedia.nl

www.cookingcrew.nl

D: donald harting **C:** nick bolink

A: frismedia.nl **M:** info@frismedia.nl

www.unicolab.it
D: luca vieri C: csongor nagy P: unicolab
A: unicolab M: info@unicolab.it

www.helge-haas.com

D: christopher schultz

A: liquid pixel **M:** info@liquid-pixel.de

www.northeastdomestics.com

D: sean cooke C: sean cooke, frank depino P: frank depino

A: mediaboom M: www.mediaboom.com

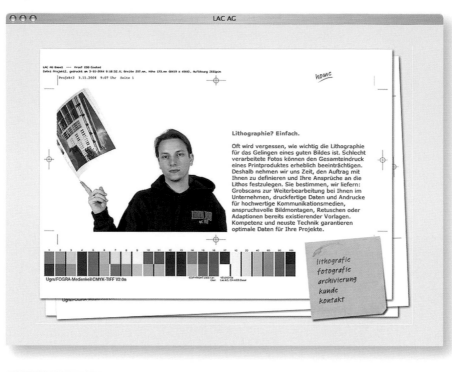

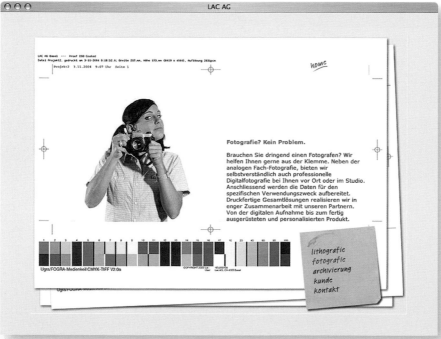

www.lac-basel.ch

D: michel seeliger

A: chameleon graphics gmbh M: www.chameleongraphics.ch

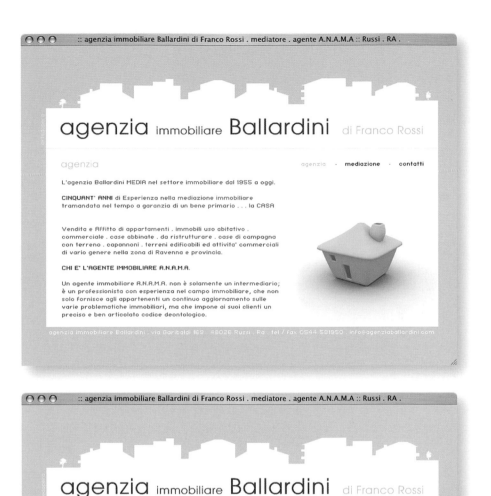

www.agenziaballardini.com
D: angelo pariano
A: angelo pariano M: info@artedopera.it

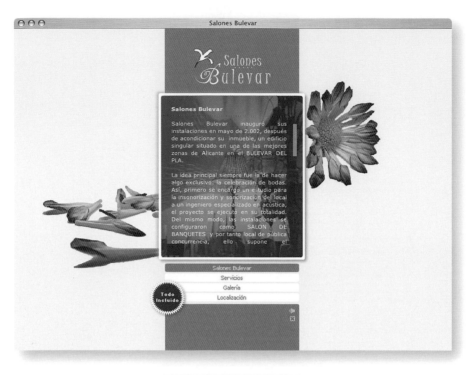

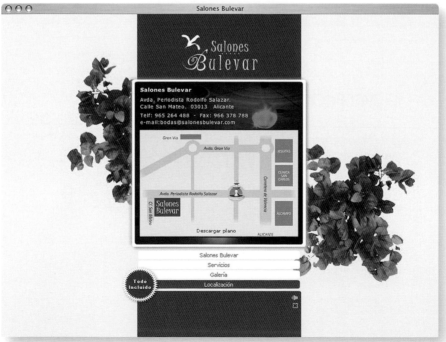

www.salonesbulevar.com

D: xavi royo C: xavi royo P: xafdesign

A: xafdesign M: xavi@xafdesign.com

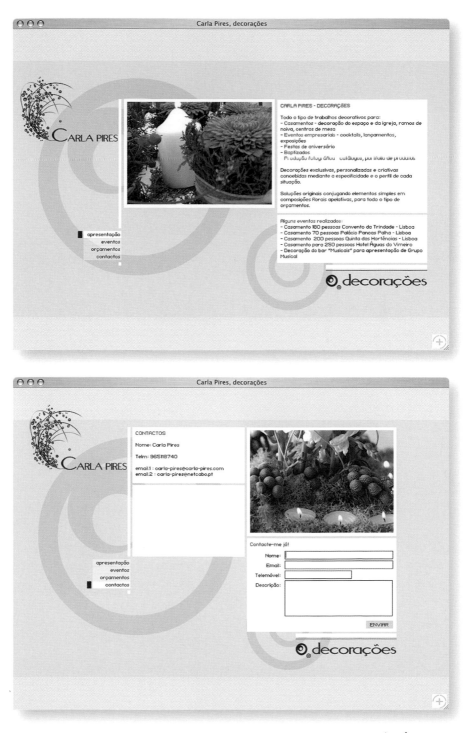

www.carla-pires.com

D: paulo afonso

A: semmais.com M: paulo.afonso@semmais.com

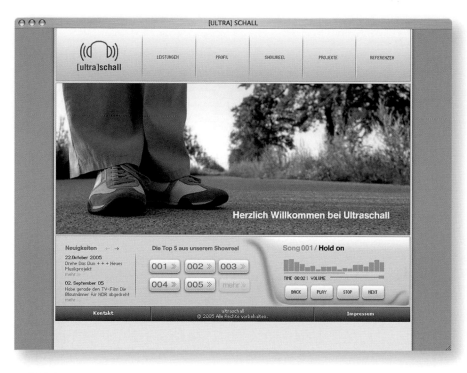

www.uschall.de

D: ali rastagar C: cinthia c. mencia, hannes höß P: ali rastagar

A: 372.com network M: a.rastagar@3-72.com

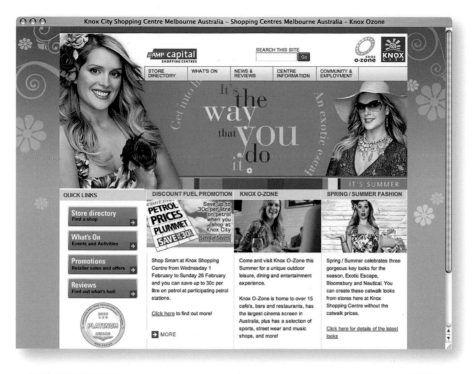

www.knoxcity.com.au

D: jonathan nicol C: skillsedit cms P: kristin mciver
A: skills media pty ltd M: www.skillsmedia.com

www.dankaschoen.de

D: daniel becker C: daniel becker P: short cuts | berlin

A: short cuts | berlin M: www.short-cuts.de

www.locteam.net

D: paco laluca C: rosa romeu P: magda garcia masana

A: locteam M: info@locteam.com

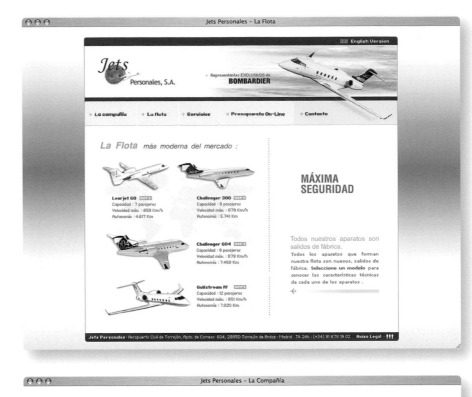

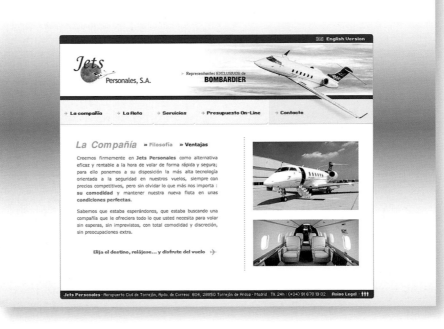

www.jetspersonales.com

D: miguel romanillos C: hamadi housami P: javier de miguel

A: dreamsite M: info@dreamsite.es

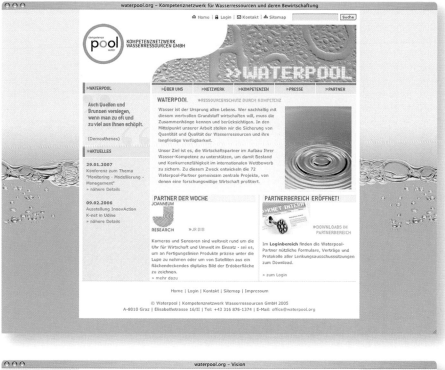

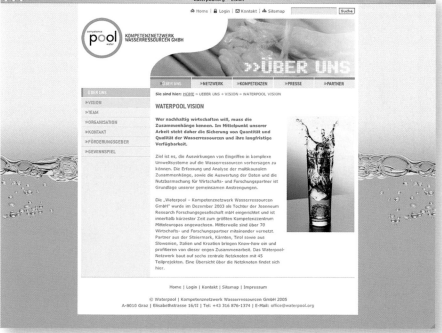

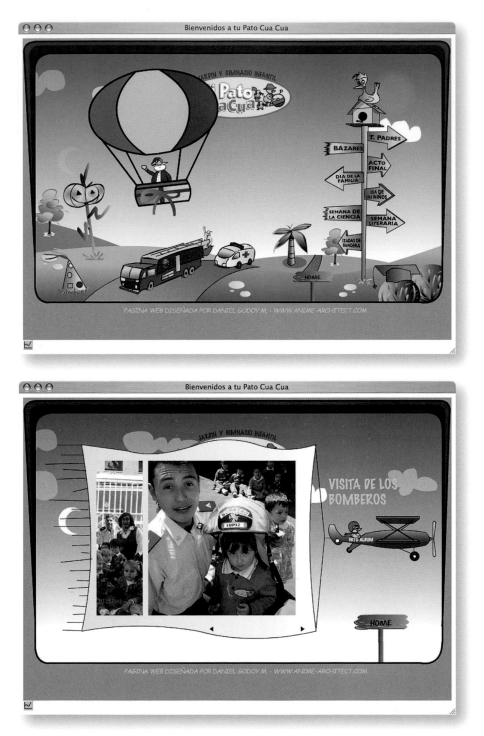

www.mipatocuacua.com
D: daniel godoy
A: daniel godoy M: danielgodoym@gmail.com

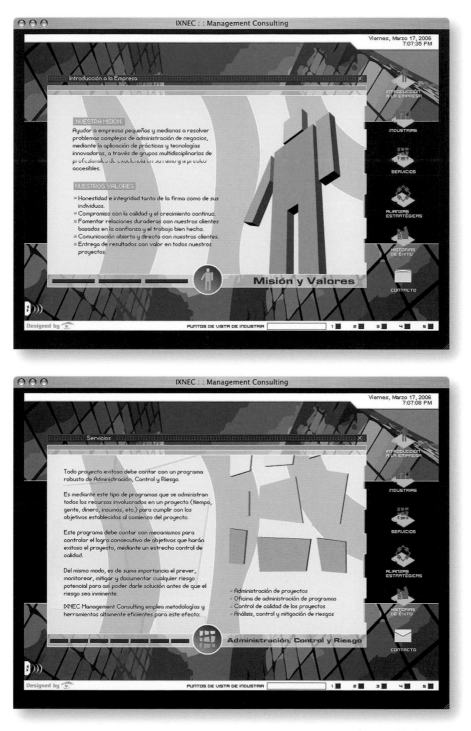

ixnec.at0mic.com
D: daniel serrano
A: at0mic **M:** darklight@at0mic.com

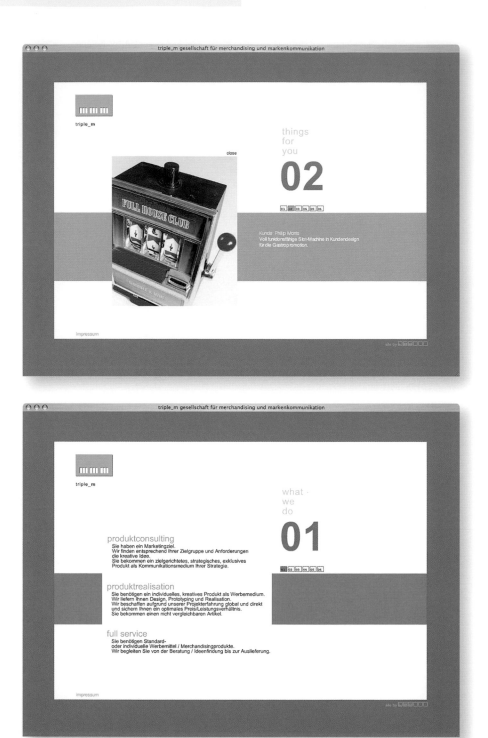

www.triple-m-gmbh.de

D: leif wasmuth

A: wasmuth.com M: www.wasmuth.com

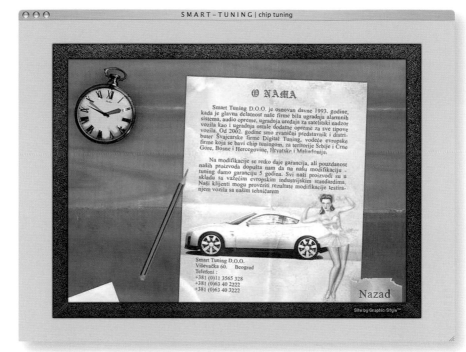

www.dans-dofna.nl

D: roy maassen

A: maassen creative studio M: www.maassencs.nl

www.scpaisajismo.com

D: martin schneider

A: hierbabuena!communications M: www.hierbabuena-communications.com

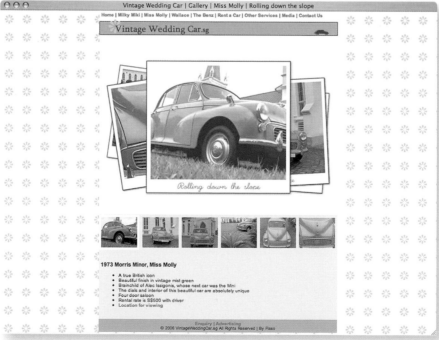

www.vintageweddingcar.sg

D: blithe koh

M: kaniza@pacific.net.sg

www.siljaklepp.de

D: matthias süßen

A: das hotel- kommunikationsstudio M: www.dashotel.net

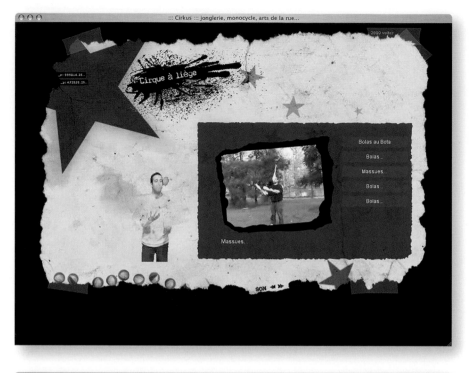

www.cirkus.be

D: joseph adam

A: visual shaker M: www.visual-shaker.be

www.designerdate.com

D: yun tan

A: zero.limits.c4 M: www.zero-limits.net

www.peterranalloproductions.com

D: flug

M: iamflug@yahoo.ca

www.westcoastchoppers.com

D: greg huntoon C: brian kupetz P: greg huntoon

A: go farm M: www.gofarm.la

www.orangebag.nl

D: jorg van keulen, emiel van wanrooij C: colin raaijmakers, bas van hout

P: loek jurres A: the cre8ion.lab - schijndel M: www.cre8ion.com

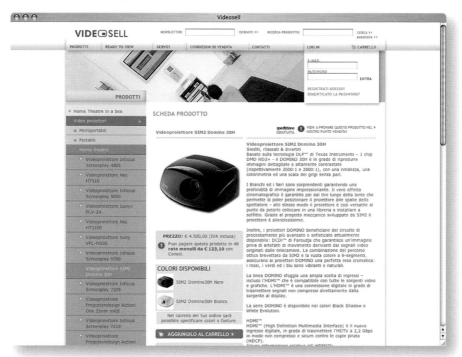

www.videosell.it

D: chiara pontiggia C: massimiliano mureddu P: carlo molinari

A: alchimedia srl M: cmolinari@alchimedia.com

www.sportscheck.com

D: fork unstable media

A: fork unstable media **M:** bundesrepublik@fork.de

www.hang-five.de

D: leif wasmuth

A: wasmuth.com M: www.wasmuth.com

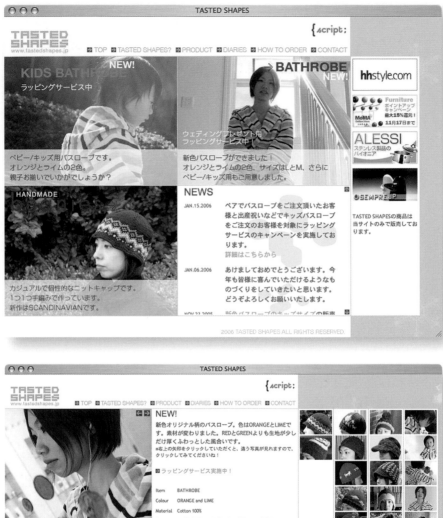

www.tastedshapes.jp

D: takehiko ichimura

A: script M: info@tastedshapes.jp

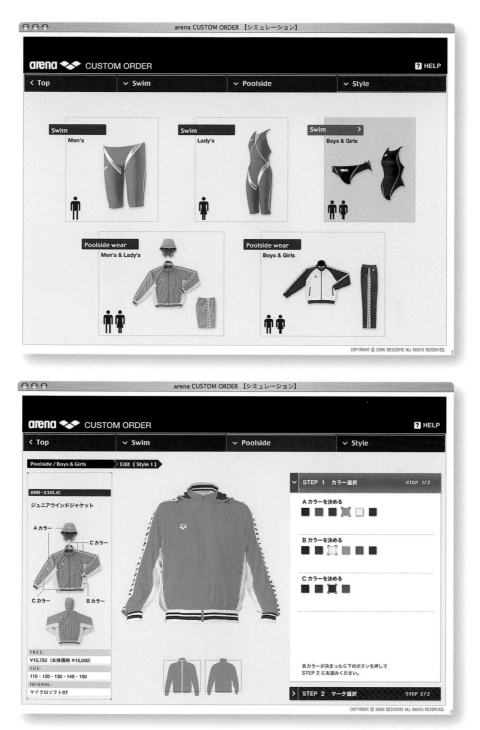

custom.arena-jp.com/simulation/index.html
D: roughark interaktiv
A: nagi **M:** info@nagi.tv

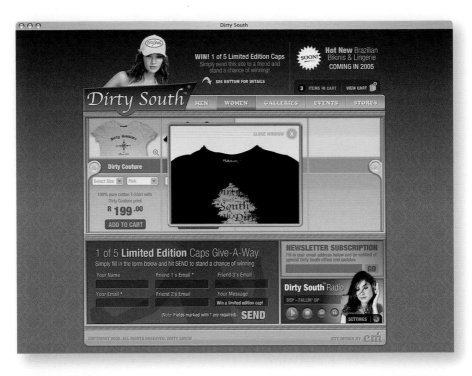

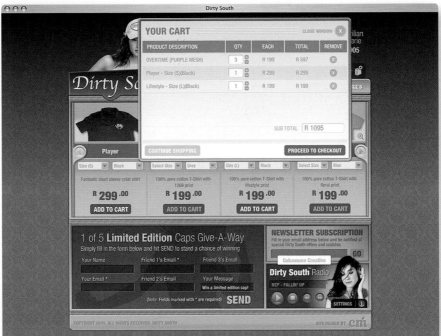

www.dirtysouth.co.za

D: jimmy caravotas

A: cubamoon creative **M:** info@cubamoon.com

www.imaginemusicstore.com
D: fx. marciat, j. veronesi C: fx. marciat P: imagine music store
A: xy area M: xy@xyarea.com

www.billabongjrpro.com

D: billabong europe, septime creation C: septime creation

A: septime creation M: stephane.tenailleau@billabong.tm.fr

Fortschrittlicher Schweizer Fussball Verband

Alternative Liga Zürich

17 febraio 2006 **FSFV seit 1977**

Meisterschaft Copa Teams Forum Archiv Login Kontakt

MODERN WIBI STARTET SAISON 2006 MIT -4 PUNKTEN
07-12-2005

Wegen unentschuldigtem Nichterscheinen der drei Schiris am Finaltag (-3 Punkte gemäss FSFV-Reglement) und zu spätem Bezahlen der Cup-Teilnahmegebühr (-1 Punkt gemäss langjähriger ZK-Praxis) muss Modern WiBi mit total -4 Punkten in die Meisterschaft 2006 starten.

FSFV/ROTOR HALLENTURNIER
22-11-2005

Am 25./26. Februar findet das FSFV-Hallenturnier in Schlieren statt. Organisiert wird es erstmals von RotoR, anmelden kann man sich mit diesem Anmeldeformular. Anmeldeschluss ist der 10. Dezember.

DIE CUPSIEGER!
10-10-2005

Devils, Cuore e sangü und Traktor Emilie - das sind die Cupsieger der Saison 2005, die mit dem «letzten Kick» im Letzi endete. Finalberichte gibt's auf der Startseite, Bilder vom «letzten Kick» hier. Mit dem wunderbaren Abschluss von gestern entlassen wir euch in die Winterpause. Bis im Frühling!

Habemus Cupsieger!

Im Vorfeld der Cupfinals wurde erstmals «Der letzte Kick» ausgetragen, bei dem bunt gewürfelte Mannschaften in freundschaftlichen Kalinen und bei strahlendem Sonnenschein ein letztes Mal in diesem Jahr dem Ball nachjagen konnten. Der Anlass war so toll, dass wir bereits jetzt entschieden haben, das bald wieder durchzuführen.

In einer Super Atmosphäre mal andere Spielerinnen und Spieler kennen zu lernen, das müssen wir wiederholen!

Devils - unkontrolliert züri 2:1

Devils holen ersten Titel

Im Cupfinal der Frauen standen sich die finalerprobten Devils und die Neulinge von unkontrolliert züri gegenüber. Von Beginn an machten die Devils unter der Regie von Mary grossen Druck und erspielten sich Torchancen im Minutentakt, scheiterten aber entweder an der Torumrandung oder an Torfrau Evi, die sich in Hochform präsentierte. Völlig entgegen dem Spielverlauf ging dann unkontrolliert noch vor der Pause in Führung.
Doch die Devils steckten nicht auf und in der zweiten Halbzeit gelang ihnen der Ausgleich und kurz darauf das siegbringende 2:1.

Cuore e sangu - BSC Tram 5 3:1

Fortschrittlicher Schweizer Fussball Verband

Alternative Liga Zürich

17 febraio 2006 **FSFV seit 1977**

Meisterschaft Copa Teams Forum Archiv Login Kontakt

Dynamo Röntgen

Gegründet:	1991
Erfolge:	Meister 1993, 1996, 1997, 2002
	Cupsieger 1996, 1997, 1998, 2000
Homepage:	www.dynamoroentgen.ch
Kontakt:	Manager:
	Mämä Sykora
	Albisriederstrasse 6
	8003 Zürich
	Tel N: 079 703 25 21
	fussballgott@dynamoroentgen.ch
	Trainer:
	Peti Heggli
	Spiserstrasse 16
	8047 Zürich
	Tel P: 01 491 09 16

Dynamo Röntgen: der Name ist eine Referenz an Wacker Selnau, bei dem ein Mitbegründer 1990 als rechter Aussenverteidiger sein Debüt in der alternativen Liga gab - um ab 1991 im neu gegründeten Dynamo als Stürmer die gegnerischen Verteidigungen in Angst und Schrecken zu versetzen.

Obwohl der erfolgreichste Club der Liga: Harmonie war in der Dynamo-Historie so selten wie ein vollzähliges Training. Ideologische Differenzen um das ausgewogene Verhältnis zwischen fussballerischem Ehrgeiz und Teamgeist führten zu permanenten Debatten und prominenten Abgängen (Bruno Ziauddin, Chiarelotto-Brothers). Weitere Kaderveränderung erforderten ausgelaufene Bandscheiben (Michael Krobath) und zerfetzte Kniegelenke (Ruedi "Comeback" Bösiger), so dass heute von der Meistermannschaft 1993 gerademal noch 4 Spieler mit dabei sind, vom Siegerteam 1997 immerhin noch 10.

Doch trotz aller Krisen raufen sich die elf Dynamos auf dem Rasen immer wieder zusammen, um ihr gemeinsames Ziel zu verfolgen: ein Spiel ohne Schnörkel, aber mit viel Schmankerln in Form von Doppelpässen und Absatztricks garniert mit vollem Einsatz und Respekt vor dem Gegner. Kurz: den gepflegten Fussball. Das Ziel ist dann erreicht, wenn ein Schiedsrichter anerkennend in der Pause meint: "...das hat mich stark an Fussball

EUROPAMEISTERSCHAFTSSIEGER-BESIEGER
05-9-2005

Erfolg sättigt. Nach dem EM-Titel wurde RotoR von Dynamo gleich mit 6-2 vom Platz gefegt. Nach dem Fairplay-Titel streben wir nun das Double an.

EIN TITEL!
12-7-2005

Im Finale waren wir zwar nur Zuschauer (ausser unser Schiri-Trio - danke!), aber einen Titel haben wir 2005 nun doch noch gewonnen: den Fairplay-Preis! Wir danken unseren Gegnern für die faren Spiele und die Stimmen und versprechen, auch in Zukunft so zu spielen.

PEKKA BESIEGT SPUTNIK
17-6-2005

Mit einer wahrlich unmenschlichen Leistung hielt Dynamo-Keeper Pekka auch im vierten Spiel sein Tor rein und liess die Sputniks reihenweise verzweifeln. Zudem konnte er sich auf seine Torpfosten verlassen, die gleich viermal retteten. Sputnik hat wohl alles Pech für diese Saison aufgebraucht, Dynamo steht nach diesem 4:0 im Viertelfinale.

Das Lokal ganz nah

D: marc rinderknecht **C:** cyrill von planta **P:** marc rinderknecht

A: kobebeef **M:** mr@kobebeef.ch

www.fautquecabouge.com

D: laurent chomette C: eric marillet P: danone

A: sokovision M: info@sokovision.com

www.shorebreak.be
D: pieter deschutter C: rafaela stattmiller P: rafaela stattmiller
A: www.oceano-digital.com M: info@oceano-digital.com

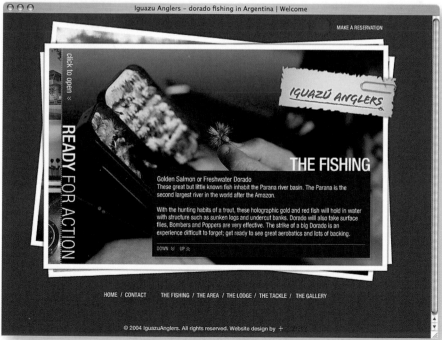

www.iguazuanglers.com

D: claudio lucero

A: 25diez M: www.25diez.com

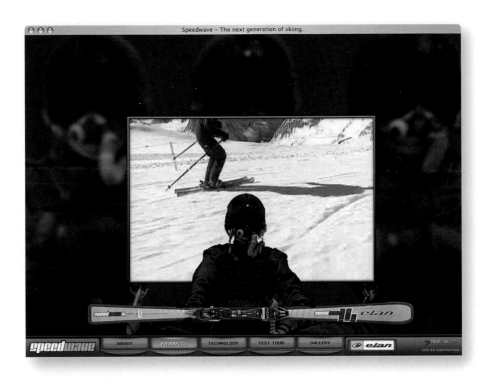

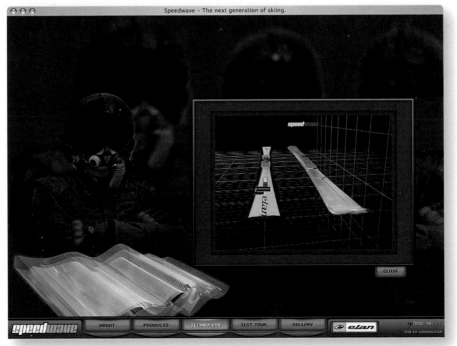

speedwave.elanskis.com
D: webshocker
M: www.webshocker.net

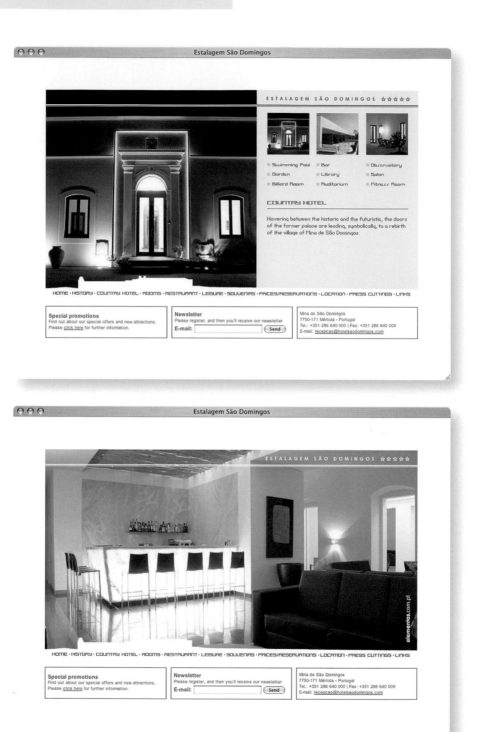

www.hotelsaodomingos.com

D: ronald de moraes C: josé de oliveira P: bernardo lúcio, ronald de moraes
A: elementos - publicidade e design M: www.elementos.com.pt

Entertainment

Entertainment activities Kids World

| HOME
| RESORT
| ENTERTAINMENT
| TRAVEL INFORMATION
| RATES & BOOKING
| CLUB VACACIONES PLUS

PLAYA MONTROIG
CampingResort

Activities for everyone

To complete a magnificent holiday, our monitors organise all kinds of artistic and cultural activities for both adults and children. If you take part in any of these complete entertainment programmes, we are sure that you won't have time to feel bored.

[press room] [downloads] [employment] [links] [site map] [privacy & legal terms] [contact us]

Travel information > GPS coordinates

[Location] [Climate] [GPS coordinates]

| HOME
| NUESTRA FILOSOFÍA
| RESORT
| ENTERTAINMENT
| TRAVEL INFORMATION
| RATES & BOOKING
| CLUB VACACIONES PLUS

PLAYA MONTROIG
CampingResort

Just let yourself be brought to us

Thanks to the new navigation systems available, reaching Playa Montroig will be a really easy matter. Just enter the co-ordinates in your gps navigator and forget all about your old road map.

Our GPS co-ordinates are:

Lat: 41.02.00.N Lon: 000.58.04.E

[press room] [downloads] [employment] [links] [site map] [privacy & legal terms] [contact us]

www.playamontroig.com
D: interactius tgd
A: tgd comunicació M: sbuyo@tgd.es

www.natur-hotels.com

D: christian baumann C: emanuel ulses P: natur hotels see

A: ccb baumann communication gmbh M: www.tiroldesign.at, www.ccb-baumann.at

www.gopalermo.com.ar

D: bruno coppola, fabian garcía C: pablo gillari P: sergio ciaravino

A: cero uno M: info@cerouno.com

www.zollverein.de

D: karsten blaschke, theis müller **C:** lars wöhning, marcel dickhage
A: v2a.net **M:** md@v2a.net

www.taiwanstoryland.com

D: wu-chi-pei C: lin-bor-way P: denis t.l. lin

A: www.eyewasabi.com M: denis0516@gmail.com

www.peregrineadventures.com

D: abby kelly C: alex williams, dan oxnam, kamil gottwald P: carl panczak

A: reactive media M: chrisf@reactive.com

www.centralparkhotel.com.hk
D: teresa l.y. lee C: yat-yu wu
A: compelite ltd M: garry@compelite.net

www.centralpark.com

D: aric boyles

A: centralpark.com M: erin@centralpark.com